CREATE YOUR OWN PHOTO BLOG

Catherine Jamieson

WILEY

John Wiley & Sons, Inc.

Create Your Own Photo Blog

Published by
Wiley Publishing, Inc.
111 River Street
Hoboken, N.J. 07030
www.wiley.com

Copyright © 2006 by Wiley Publishing, Inc., Indianapolis, Indiana

Published simultaneously in Canada

ISBN-13: 978-0-471-76774-9

ISBN-10: 0-471-76774-3

Manufactured in the United States of America

10 9 8 7 6 5 4 3 2 1

IK/SS/QT/QW/IN

For general information on our other products and services or to obtain technical support, please contact our Customer Care Department within the U.S. at (800) 762-2974, outside the U.S. at (317) 572-3993 or fax (317) 572-4002.

Wiley also publishes its books in a variety of electronic formats. Some content that appears in print may not be available in electronic books.

Library of Congress Control Number: 2005938262

about the author

Catherine Jamieson is a photographer and writer who lives in Winnipeg, Canada, with her two college-aged children, a pair of spoiled cats, and every CD The Tragically Hip ever recorded. She has published her multi-award-winning photo blog Utata since the mid nineties and is the founder of the Utata: Tribal Photography community website. She is an active member of the photo blogging community, and in 2004, Forbes Magazine selected Catherine's site as one of the top photo blogs on the internet.

credits

Acquisitions Editor
Mike Roney

Project Editor
Tim Borek

Technical Editor
Irina Souiki

Copy Editor
Kim Heusel

Editorial Manager
Robyn Siesky

Business Manager
Amy Knies

Vice President & Executive Group Publisher
Richard Swadley

Vice President & Publisher
Barry Pruett

Book Designer
LeAndra Hosier

Project Coordinator
Maridee Ennis

Graphics and Production Specialists
Lauren Goddard
Jennifer Heleine
LeAndra Hosier
Barbara Moore

Quality Control Technician
Charles Spencer

Media Development Specialist
Laura Atkinson

Proofreading
Henry Lazarek

Indexing
Steve Rath

*This book is dedicated to my children, Alexander and
Danielle, who are the light and joy of my life,
and to Marya Figueroa (emdot) who
believed in me at exactly the right
time. You're my heroes.*

preface

This book was written with two purposes in mind: to help you publish your own first photo blog or to help you make changes to improve the performance of your existing photo blog. A photo blog is the natural end result of owning a digital camera, much like a photo album with plastic pages was the natural end result of a snapshot taken with a film camera. All the cool kids are getting one these days.

All you need to get started is a computer, an Internet connection, a camera, and this book. You don't need special software or experience with Web publishing, and you don't need to be a professional photographer. Using the instructions contained here — and the support information on the companion site, www.createyourownphotoblog.com — you can, after reading the entire book, have your own domain, your own photo blog, and a wealth of information about maximizing the experience.

Whether you want a photo blog to share pictures with your friends and family, further an artistic or professional career, or create a site on which to publish your club or group's projects, you will be able to do so with the material in this book. This book gives you valuable resources, whether you already have a blog and simply want to expand your audience or you're looking for fresh ideas for making photographs to display or want to understand the market better.

Part I of the book introduces you to the world of photo blogs, shows you some of the most popular and often-visited blogs on the Web, and gets you started with both a Web host and a content-management system. Even if you already have a photo blog, this section contains an excellent overview of what's out there and provides a wealth of ideas for things you can do with your own blog.

Part II gets you up and running with your own photo blog using the included template system; even if you elect to use your current blog setup or use another template system, Part II contains design and content tips you can apply to any Web publication.

Part III contains tips and instructions that improve your photography skills, aid you in selecting the right photographs to display on your blog, and enhance your market savvy so that you can show up in all the right places to get noticed. No matter what template or management system you use or whether you have a free blog or your own domain, the information in the third section is critical to a successful publication. We prepared this book not only to make the experience of creating your own blog as easy and rewarding as it can be but also to make it as successful as it can be.

As an aid to ensure that you can close this book and have an operational photo blog, I have prepared for your use a set of templates that will create an actual working photo blog site that is complete with archives, galleries, an About page, and an automatically generated syndication feed. Based upon my own personal site, which was selected by Forbes as one of the top photo blogs in 2004, these templates are professionally designed, fully debugged, and ready to use. You can use or modify any of the included design skins or create your own, integrate your flickr photographs into your blog, and even find out how to publish a project or collaboration.

Using the Movable Type content-management system and in partnership with Nexcess, a premier Web-hosting company, this book not only offers you valuable information about blogging and photography but also provides all of the tools required to post pictures to your very own blog on your very own domain.

Photo blogging has not only been a richly rewarding experience for me in both a professional and a personal context, it has also improved me as a photographer and an artist. Frequency and creative freedom, a large, enthusiastic audience pool, and a supportive community are all elements that are universal to environments where the arts flourish. Photo blogging offers that precise environment, and I have seen many "point and shooters" turn into people who say things like, "I'm having a show this weekend." Whether it's folk art or fine art, whether you switch lenses between shots or never move the dial off the "auto" position, it's just plain fun to publish your photography to your own personal public space.

contents

chapter **2 Exposing Your Style 21**

Chapter **3 Finding a Home for Your Photo Blog 47**

Part II Setting up 65

chapter 4 Build Your Blog: The Toolkit 67

chapter **6 The Design Studio: Skins and Customizing** **125**

Part III working with photographs **139**

chapter **7 The Photographs That Work 141**

chapter 8 From Camera to Blog: Making the Magic Happen 175

chapter **9 100 Photo Ideas to Get You Shooting 207**

chapter **10 Letting People Know You've Arrived 231**

chapter **11 flickr 251**

chapter **12 Doing Cool Things with Your Blog 273**

GETTING STARTED

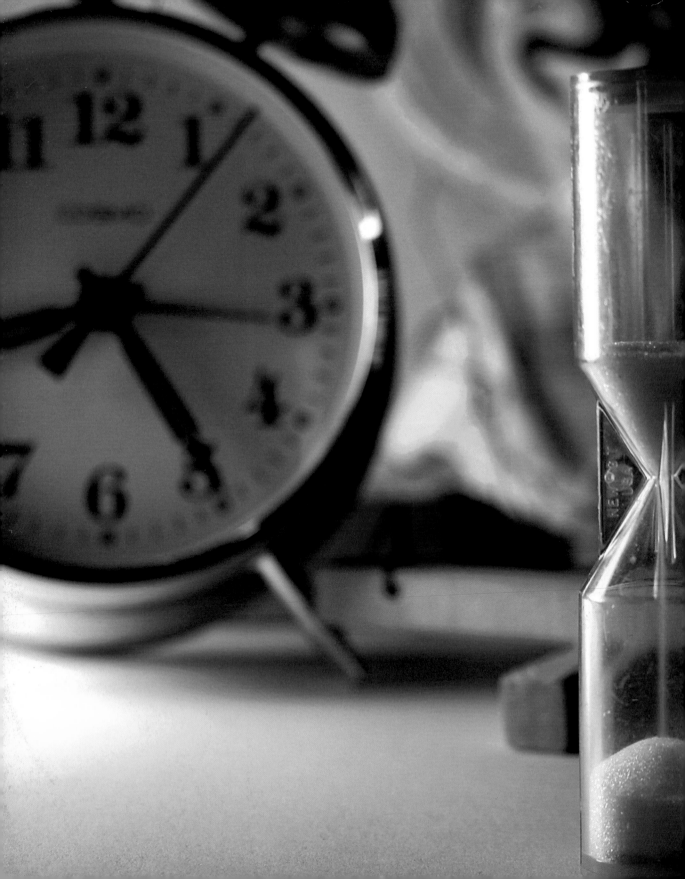

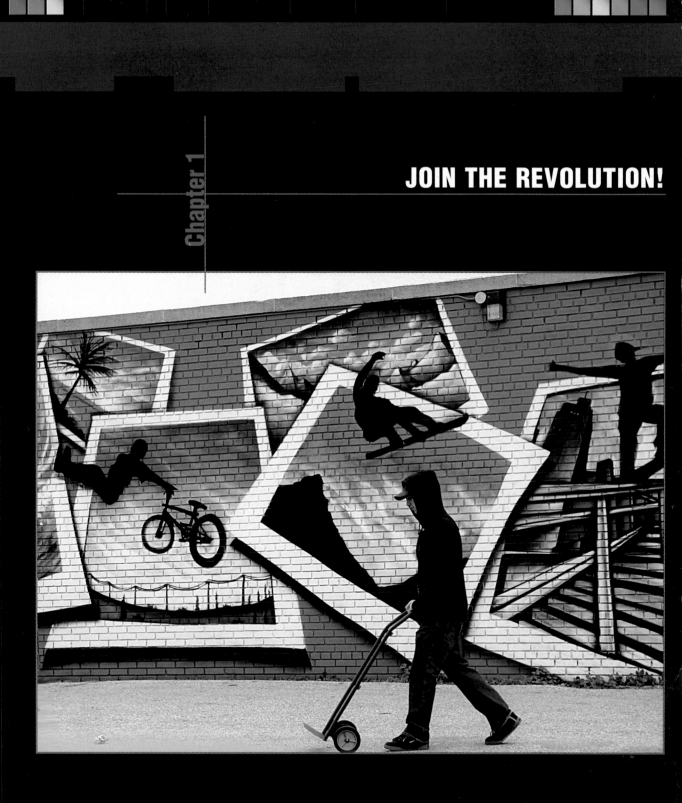

Chapter 1

JOIN THE REVOLUTION!

It is a revolution! In 2004, more than a half-million digital cameras were sold. A little photo storage service called Flickr took the online world by storm and signed up more than a half-million subscribers in its first year in business. Oh, it's very exciting. It's every good television channel, every good movie, every good book of pictures, and every good magazine all rolled into one. "It" is called photo blogging, and I believe it is not only one of the most compelling forms of human communication to come along in ages, but one of the most important.

From photography that could properly be considered art to snapshots of the puppy's first bath or the morning dew on your wife's favorite tea rose, the world of photo blogging has it all (Figure 1-1). Sharing your photos is just plain fun, and millions of people across the globe are starting to realize that they don't have to be artists or poets, writers or journalists to be able to speak the universal language of photography.

In fact, you don't even have to be an avid photographer.

Do you own a camera? Have access to a computer and an Internet connection? Then you have what it takes to be a photo blogger, and by the time you close this book, you will know how to make your own photo blog, how to upload pictures to it, and how to make the really cool shots that attract viewers and keep them coming back again and again. If you already have some photography experience, you can join the hundreds of award-winning, photo-blogging photographers and artists out there, some of whom got their big breaks through their photo blogs. Many use their blogs to advance their art careers and showcase their professional work. Some photographers, such as Sam Javanrouh of Daily Dose of Imagery, are asked to show their photography in galleries and at art shows and regularly sell prints from their blogs (Figure1-2).

On the surface, the photo blog appears to be the upstart child of the Web log, but in terms of hierarchical human response, the photo blog could be rightfully considered the parent. Our visual senses are developed well before our speech

1-1

1-2

capability, and spoken language is a construct that is not universal in delivery or comprehension. In other words, we don't all speak the same one.

Pictures, on the other hand, are the common ground with which every one of us, from Baja to Vancouver, can identify. A "red boat" might be any number of things in any number of languages, but "red" and "boat" are universal ideas, and a photograph of a red boat requires no translation or even context for it to be appreciated for precisely what it is. Similarly, the word "California" conjures up a certain sort of mental image which may or may not be the same as the 6 photographs tagged with the word "California" in Figure 1-3, which I located in just a few seconds with a simple search.

1-3

There is a universal language and a means with which to speak it, a method with which to disseminate it. The universal language is photography, and the means to speak it is the photo blog. The Internet spreads these modern, personal anthologies, and people around the world are sharing wordless stories and textless information. You can see for yourself through the eyes of everyday people what it's like in Capri this time of year (Figure 1-4) or whether the wildflowers are blooming in Greece (Figure 1-5). It is nothing short of a communications revolution. And people are joining in droves, anxious to share, to see, to be part of the community ... part of the revolution.

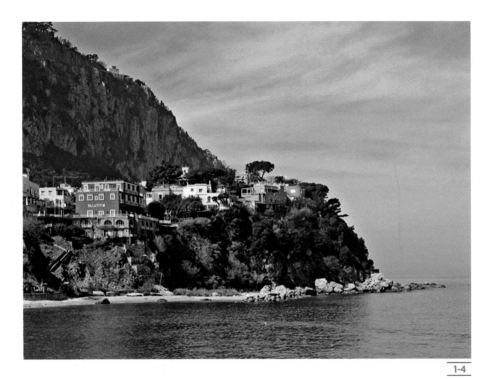

1-4

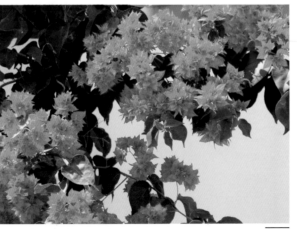

1-5

What's A Blog?

On January 3, 1995, Carolyn Burke, a woman who was involved with Project Gutenberg (distributing the literary classics as electronic texts) started a personal website. On it she wrote about her daily life. Her observations and her ruminations made for interesting reading, and she gathered an audience. Soon others became enamored of the concept, and personal websites called online journals began popping up all over the Internet.

The members of the population that wanted to publish and talk and share information but did not want to share their personal, intimate lives started a similar revolution, and the Web log was born. Quickly thereafter, these pages, usually full of links and narrative and often specializing in a topic like politics or technology, came to be called blogs, and they started springing up all over the Internet. In 1997, for example, Dave Winer started Scripting News. One of the longest-running blogs on the Internet, it is still published today in a format very similar to the original.

What's A Photo Blog?

In the late 1990s, digital cameras became affordable and widely available, and we started seeing photographs popping up here and there, both in online journals and on blogs. At first they were small, grainy snapshots of family outings on online journal pages. Others were more journalistic in nature, such as those that bloggers tended to use to illustrate their written points — taken with single- and then dual-megapixel cameras. As the journal writers had done, and then the pundits, so did the photographers: They built their own better mousetrap, and the result is the photo blog.

Dedicated to photography for the love of photography, some of these sites can be, quite literally, mind blowing. In 2004, the staff at Forbes magazine got together to pick the best of the blogs; for the first time since its inception, the photo blog was recognized by the mainstream press as not only a bona fide category of personal publishing but one in which talented people were participating (see Figure 1-6). Shortly thereafter, the venerable Shutterbug magazine published an article ("Blog, Blog, Blog, Blog, Photoblog — How Photographers Are Making the Internet Work for Them," January 2005) that paid homage to the photo bloggers and their contribution to the craft of photography. As I said to a newspaper reporter who interviewed me shortly after my site was named by Forbes on that first list, "These are not your grandmother's photo albums." And although this is true, they can certainly contain some of your grandmother's photographs, as Carl Johnson, one of my favorite posters to Flickr, proves time and time again with scanned photographs that he adds regularly to a set he calls "Family Heirlooms" (see Figure 1-7).

There are many ways to define a photo blog. I found no less than 10 definitions while researching, but there seem to be only two common threads woven throughout:

> The main content is photographs.

> Entries can be navigated one after the other, in chronological order (a "log").

There are no rules of content or even quality and, indeed, searching around the Internet will yield hundreds of examples of sites that meet each of the criteria here but have little else in common, such as brownglasses.com (see Figure 1-8) and exposur3.com (see Figure 1-9), both of which are highly respected and well-visited photo blogs. In Chapter 2 you can explore the many different types and styles of blogs that exist or that could be made, but to be a "proper" photo blog, all a site needs is photography as its primary content.

Are My Photographs Good Enough?

I get a lot of email through my site, and over the years I have amassed quite a collection of words and thoughts on the topic of photo quality. Though it's very hard to

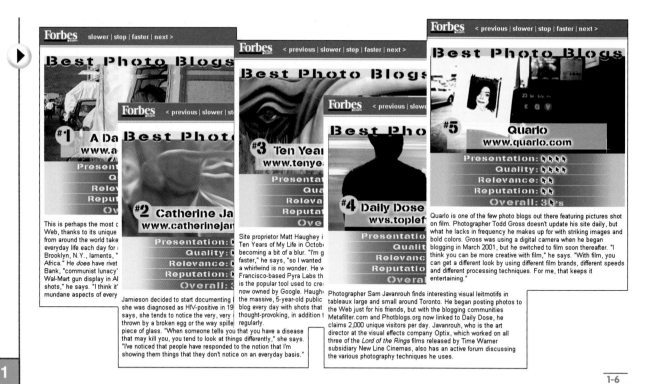

1-6

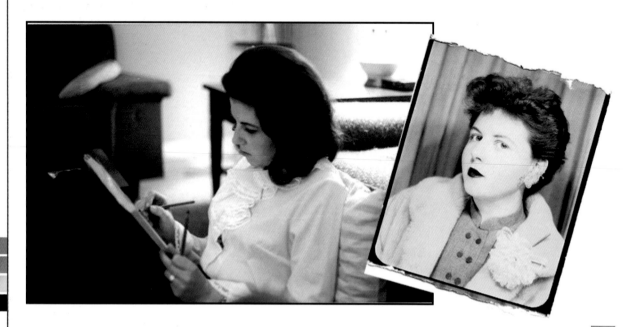

1-7

1-8

1-9

encapsulate, I would say that the most often expressed notion is that the person's photographs are "not good enough" to publish on the Internet. Though it's equally hard to encapsulate my answers into a single one, I would say that my most common answer is that "of course they are good enough," but if you think they're not, I do not know of a better way to improve them.

I asked several of my friends who put photographs on the Internet to give me examples of their first pictures and the ones they're taking now. From a variety of time frames, months to years, Figure 1-10 shows a few of the examples they gave me and illustrates much better than I can tell you how much of an improvement shooting frequently and having a place to put your photographs can make in your finished results. And what determines "good" anyway? My first posted photograph was a grainy, softly focused set of three pears on a windowsill that I cannot include in this book because it is so tiny in resolution that you'd need a magnifying glass to see it!

It might not have been very good as photographs go, but I loved that picture, and I'd post it today if I could fit it in. It made me feel good to post it on my site, to have people see it, to share that moment with others — even if it was only, at that time, my mother and closest friend who were reading my fledgling blog. I am often accused of being hokey, and I suppose I

am, but I honestly believe that storytelling is the most important thing we can do as human beings, and photography is, to my mind, simply a way to tell a story (or part of a story) visually.

I want everyone to have a camera and a photo blog because not only do I want to see all these amazing stories from around the world come to life in front of me, I want you to see them, too. How does your garden grow down there in Knoxville, and how many feet can fit onto a sidewalk in Brooklyn? Doesn't matter if the photograph is grainy, whether the camera is the latest in digital SLR (single lens reflex) technology, a point-and-shoot, or a cellular telephone — most viewers are after the story, not the technical specifications (Figure 1-11).

Are your photographs good enough? I can say, without even looking at them, "Of course they are, and if you think they aren't, I do not know of a better way to improve them." Photography is like virtually any other skill — the more you do it, the better you become. As people come to your blog and look at your images, you will be able to tell, from the number of people who view individual photos and the comments they leave, which images resonate with the viewing public. Whether it's another photographer commenting on a lighting technique or a viewer commenting on the overall appeal of the image, you will learn a great deal from being a part of the blogging community.

1-10

1-11

DESIGNER TIP

The best way to get comments is to make them on other blogs.

WHO KEEPS PHOTO BLOGS?

There is no short answer to this question, except for the obvious "everyone." Lawyers, rodeo clowns, and radio announcers keep blogs, as do housewives and students and retired exotic dancers. But we must add to that grandmothers, shoe salespeople, acrobats, and volunteer firefighters. I've seen great photography from set designers, graphic artists, fast-food cooks, high school students, and gym teachers. There are professional photographers and photojournalists and even celebrities who keep photo blogs and many who keep text-based blogs but who regularly post photographs. Recently Wil Wheaton of Star Trek: The Next Generation fame posted a photograph to his blog and assured us that the problem was "lighting" and not the need for a shave. The photography on photo blogs ranges from snapshots of Uncle Ben's retirement party in Plum Coulee to the burlesque of New York. The real answer is "anyone" (Figure 1-12).

1-12

Truthfully, I love it all. On my daily list of sites that I visit there are those whose work hangs in galleries and who make their income from selling prints from their blogs and those who post pictures of their teenager's latest unsettling haircut and Fuzzy the cat's recent adventures with Rover the dog. Whether they are polished images from high-end prosumer cameras or snapshots taken with palm-sized digital point-and-shoot cameras, they all perform the same magic — they all tell different chapters of the same universal story.

WHO VISITS PHOTO BLOGS?

There are two basic groups of people that view photo blogs on the Internet. The first group consists of other photographers — those other people like you and me who have cameras and are interested in photography. These people tend to be interested in the technical aspects of the image — what exposure did you use, what camera are you

1-13

shooting with, how did you light it, is the grain visible, what did you do to it after you took it? They leave comments about the composition and ask questions about the lighting and sometimes even offer advice on how to improve the exposure or the richness of the color. If they like your work, they may add your blog to their list of links or mention you on one of their blog entries. In either case, a great number of your visitors can come to your photo blog through other photo bloggers who take a shine to your work.

A good example of this dynamic is an experience I had in early 2004. A widely read Hungarian blog called szanalmas took a liking to a particular picture of my daughter (see Figure 1-13) that I had posted to my blog and linked to it. By the end of that day I had more than 3,000 hits (a hit is when someone loads your page into his or her browser) from that link.

Many of those viewers come back time and time again and some have even become regular readers who visit each time I update.

The other way photographs are viewed is by those without cameras or an interest in photography, per se, but who are interested in the photographs. They want to see the pictures and the stories they tell. These people don't care what the ISO setting was or whether you manually focused it or whether your camera allows a bulb setting and has removable lenses. They care how the photograph makes them feel, how they connect with it visually. They will leave comments like "wow," "great shot," or "pretty colors" or tell you how or why it resonates with them. If they like your work, they tell their friends and contacts and your blog's name spreads in the best way that it can: personal recommendations.

WHAT CAN I DO WITH A PHOTO BLOG?

Whether you want to share images of your first child's first year with her grandparents in a far-off land or you want to sell framed prints of your photographic artwork and end up working for National Geographic, the photo blog is the right tool. It can be either a scrapbook or a portfolio, a fun place to create a personal archive, or a springboard for your artistic aspirations such as for Reid Stott of photodude.com, who runs a print gallery from his site (Figure 1-14).

A photo blog enables you to do many things:

> Share your snapshots with family and friends

> Showcase your artistic photography

> Publish a regular e-zine of your club's or group's adventures

> Display your professional photography and sell your work or your services

> Create narrative to go with your pictures such as stories, poems, or even haiku

> Explore and experiment with photography as a hobby, a craft, or a profession

1-14

What Do I Need to Get Started?

You probably already have everything you need to get started with your photoblog, but just in case, here's a basic checklist:

> Camera and a basic understanding of how it operates (If you are using a digital camera, you're all set; if you use a film camera, you will also need a scanner.)

> A computer and an Internet connection

> Photo-editing software such as Adobe Photoshop, Paintshop Pro, The Gimp, or Picassa

> A text editor such as Notepad, which comes with Windows; Textedit, which comes with MAC operating systems; or a WYSIWYG (What You See Is What You Get) editor such as Dreamweaver MX or Front Page

What Do I Need to Learn?

You will be happy to know that if you know how to take photographs and load them onto your computer, if you know how to sign on to the Internet and collect your email, you are more than halfway to a photo blog of your own. The Internet is a very intuitive place, and if you can manage basic navigation, then use the information in this book and the tools from the companion website to build a photo blog. Whether you are a novice and have never published anything to the Internet before or whether you have been doing some other Web project for years and want to make a photo blog now, all the things you need to know are in this book.

There are three basic areas of a photo blog project that need to be solid in order to create a successful blog. You need a functional and attractive design, a reliable method to both publish and publicize your blog, and compelling photographs (Figure 1-15).

1-15

DESIGN

The design of a blog is simply the way it appears and functions. This book covers the following related areas:

> How to choose the right style for your blog's theme and purpose

> How to construct a well-designed, appealing blog by using an included template or by designing your own unique design based on the template

> How to efficiently manage your content

PUBLISHING

Publishing refers to the manner in which you deliver your design to the public. This book covers the following related areas:

> How to set up a home on the Internet, such as your own domain (like my eponymous site, www. catherinejamieson.com) or with a service such as Blogger where you will publish your photo blog

> How to upload and maintain files on your own server or a photo storage service such as Flickr

> How to publicize your blog so that people will know where to find it (and why they should go looking)

PHOTOGRAPHY

Photography, of course, refers to the actual work you put on your blog. This book covers the following related areas:

> How to decide which of your photographs will appeal to viewers

> How to use basic photography and digital darkroom techniques to improve existing photographs

> Ideas and tips for creating new photographs that will attract and keep an audience (Figure 1-16)

1-16

FILM, DIGITAL, OR DIGITAL SLR

You can, of course, use your film photographs on a blog. Todd Gross of www.quarlo.com, a multi award winning blog, publishes nothing but film on his much-lauded and celebrated photo blog and Adam Sabola of www.sabola.com frequently posts cross processed slides from his film cameras (Figure 1-17). However, the easiest and quickest way to publish photography to the Internet is with a digital camera.

You don't need any particular sort of digital camera, and indeed, there is an amazingly wide variety of cameras used in photo blogging, from $19.99 pencams (miniature cameras installed in the ends of actual working pens) to high-end professional camera setups that cost tens of thousands of dollars before a roll of film is bought. I'll tell you a thing I believe absolutely: The camera is irrelevant. A great photographer can make a pencam shot look like a Monet, and the worst photographer cannot pry a good shot from even a Hasselblad. Heather Champ, one of the photo-blogging community's most enduring, celebrated, and prolific publishers, sometimes uses a camera she refers to as a "crapcam," and there are more than a few shots from it in my favorites folder (Figure 1-18).

Your camera needs are dependent upon what you want to do with the finished product. If you want to make prints to store in a photo album at home or to give away, you will need at least a 3-megapixel camera to produce an adequate 5 x 7 print. If you want to use your photographs only for online sharing and display, any size of camera will do. On the other hand, if you wish to sell your photography to the public or to further your career goals in the business of photography with your photo blog, you will need at least a 5-megapixel camera and preferably one with 8 megapixels or more.

I have a 1-megapixel keychain crapcam that I bought at a local discount store for $9.99, and I carry it around in my jeans pocket. Occasionally I will take a photograph with it and upload it to my Flickr account; often, it is one of these photographs that gets the most attention or garners the most comments from viewers. Once I uploaded a carefully

The Sabola Photoblog v1.0

thumbnails | archives | about + links | << | current | >>

EXIFS: - - - - iso **Categories:** lomo lc-a | x-processed slide | kids |

Seagreen Serenades (2)
26/10/05

Not much to say today, gonna rest a bit then do some homework. A new Intr-version website went up today as well as an Avia Gardener subsite. Check it out...

1-17

Marooned, Off Octavia [Holga] LINK

<<<

RECENT THREE

smarter, faster, hotter
I'll be joining **Alexandra Samuel** and **Marnie Webb** on the **Advanced Tools** session at **BlogHer**, July 30 in Santa Clara.

FABULOUS ELSEWHERE
while seated, lead bike, dykes on bikes, pride parade

daily does of imagery, long exposed photographer

UPCOMING
7/7 SFlickr Meet
7/30 BlogHer Conference '05

SEE ALSO
JPG Magazine
The Mirror Project
Bay Area Photologgers

1-18

planned photograph next to one of my crapcam shots, and the little picture of a parking meter taken as I plugged a quarter into it was commented upon more times than the other photograph, which I eventually sold in a gallery show.

Many of my best-viewed photographs are taken with what I call the "pocketcam," which is a little 4-megapixel point-and-shoot that takes fabulous black-and-whites. Figure 1-19 is actually a photograph I took of the crapcam with the pocketcam, and not only was it viewed frequently, but a little conversation arose around it.

Except for when it comes to producing prints, the size or scope of the camera you have or choose to

1-19

purchase is not the most important factor in the success of your photo blog.

What you choose to do with the camera after you get it out of the box (or plastic bag, as the case may be) is what makes or breaks your photo blog.

WHERE ARE PHOTO BLOGS GOING?

This is like the question you hear on those old black-and-white newsreels. Some news guy with a pointy hat and a bad hairdo asking someone like Elvis or Jerry Lee Lewis, "So, where do you think this rock-and-roll thing is going?" People laughed at Elvis, you know, when he said, "It's here to stay, man."

Photography has always been about documentation. Sometimes it is artful and creative, such as one of the portraits I do for clients, and sometimes it is strictly about recording an event or moment accurately, such as some of the photographs sent home from the front of World War II. Either way, it's always about recording something that is happening, even if you made it happen yourself (Figure 1-20). Analog photography changed our lives by allowing us to see things — the Eiffel Tower and the Sistine Chapel, for example — that we may never be able to see in person. Through the lenses of such masters as Ansel Adams, Man Ray, and

Eve Arnold, we learned that photography can allow us to view not only the real, but sometimes glean a glimpse of the possible, and now and again of what appears as the improbable (Figure 1-21).

Each time we look at a new photograph we learn something, see something we've never seen before, catch a glimpse of another way of being and seeing. Without photography there would be no image of the soldiers at Iwo Jima raising the flag, no Dorothea Lange image of migrant workers during the Great Depression, and no Nat Fein's "Babe Bows Out," for these are moments that only a photograph could capture with absolute accuracy.

That was back when a good photography setup would cost you what would amount to tens of thousands of today's dollars and processing was an ongoing cost that few could bear. And if you did not have an agent or a list of clients, all that you got for your trouble was a stack of photographs that faded with time.

Now from the hands of the few and into the hands of the multitudes, photography has made the leap that all the arts do eventually. Digital science has brought photography home to the people, and the people are responding enthusiastically and energetically. They're buying cameras and camera phones and pencams and snapping pictures at the fisherman's market in Manila, the burlesque halls of New York, and everything in between. They're creating grass-roots documentaries that really do alter the way we all see things and understand the world around us. Did you know, for example, that a Javanese spider is the size of a man's hand (Figure 1-22) or that Wales has not only its own Stonehenge but a slew of interesting castle ruins as well (Figure 1-23)?

By extension, the places we put those photographs, our photo blogs, have already changed the way we live and see the world. Every day millions of people from more than 100 countries visit one or more photo blogs, and though not all of them speak

1-20

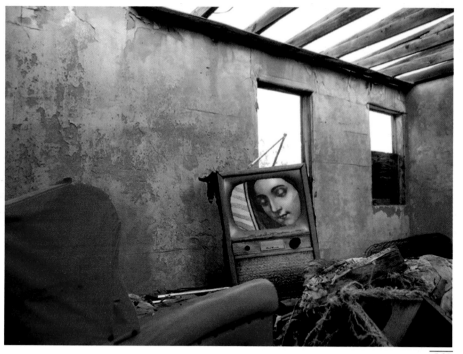

1-21

1-22

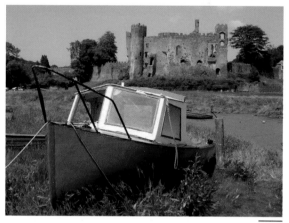

1-23

English, all of them can relate to the photographs. As I learn about Javanese spiders and New York burlesque queens, others learn about prairie sunsets (Figure 1-24) or what you might see in my town on a Sunday cruise night in the summer (Figure 1-25). It is my belief that personal photography made available on the World Wide Web is one of our society's most significant evolutionary achievements. Not only is it gratifying to the photographer to have his work viewed, he contributes to the global tapestry of visual documentation and the viewer is enriched in ways that a thousand textbooks could not manage.

Elvis was right about rock-and-roll — it's here to stay. And from the amazing number of people who are putting their photographs online I believe it's a safe prediction to say that photo blogs are here to stay, too.

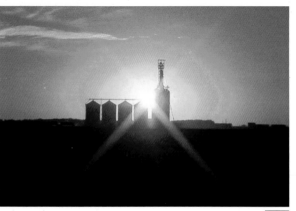

1-24

1-25

EXPOSING YOUR STYLE

mustard gas party

PHOTOGRAPHIC ESSAYS

2-1

A photo blog is a piece of dynamic art. Like the Internet upon which it resides, it's in a state of constant flux as people load pages and view your images, and you in turn upload new ones. My very first site was called Flux Redux because of my fascination with the way that I could change my design or the way I presented my photographs, or even the photographs themselves, all in the span of a few moments ... and I often did. As an early reader once wrote, "I never know what I am going to find when I come to your site! It's like a daily adventure." Though I don't recommend this approach, finding your own style is important — you want your photo blog to reflect you as a photographer and a human being.

The style of your photo blog is the combination of

> Layout

> Design

> Photography

When put together and published to the Web, these three elements are what give the viewer an idea of what you're all about, what you want to do with your photography, and, in fact, what's important to you.

This was my favorite chapter to write, because in it I get to show you some of the coolest and best photo blogs on the Internet, and you can rub your hands together and plan out the many exciting things you can do with your shiny new site. Most exciting is the fact that there is not a site in the bunch that you cannot make yourself with a little time and experience. "Cutting edge" on the Internet is not really about what tools you have, it's about how you use them, and there are at least five sites in this chapter made with just a text editor and a lot of ingenuity. And, of course, we all have text editors.

Mustard Gas Party, a gorgeous collection of photographic essays, employs a simple design consisting of a photograph on a white background with basic black text that could be made by even the most inexperienced person in just a few hours (Figure 2-1). We can learn a lot about what we might find inside this blog and the person who publishes it just by observing its style. It's

2

Exposing Your Style

22

clean and efficient, and easy to navigate. Its simplicity is both aesthetically pleasing and functional. This person wants us to pay attention to the content, thus he or she is thoughtful and probably articulate. The photograph itself, with muted dark tones and a deep patina, tells us a little of this person's sensibilities — he or she appreciates the symbolic presentation of ideas. This is that person's style. The blog speaks volumes for him or her, and yours will, too, of course, so it is very important to consider your presentation carefully, to explore your own style ideas until you can look at your photo blog and say, "Yes, that's MY style."

EXPRESSING YOURSELF

A photo blog is fundamentally about expressing yourself and the variety of ways you can do that are virtually endless. Styles range from fun and whimsical such as Andrea Sher's Superhero Designs, who says on her bio page, "I design chunky, wild, colorful jewelry for superheroes (Figure 2-2)," to philosophical and artistic like Carol of Carol's Little World, who says, "I have kind of a reputation for going off and doing 'weird' (or 'creative,' if you want to be polite) work. Stuff like Polaroid manipulations, cross processing, shooting high speed film, blurry people, and so on," (see Figure 2-3). Photo blog styles and themes are wide and plentiful, and the demand for new "reads" is very high.

As an example, I've included a bar graph of my own blog traffic over the last 24 months that shows the steady rise in daily viewers. I've reviewed the traffic on many other photo blogs and spent a lot of time talking about this with other photo bloggers, and the trend is universal: More and more people come each week to visit the sites that stand out in the crowd (Figure 2-4).

As the photo-blogging community grows, the number of viewers rises exponentially. Not only are the other photo bloggers also viewers, but every day thousands of new people sign up for Internet service and buy digital cameras. People interested in cameras are naturally interested in photography, and sooner

2-2

CAROL'S LITTLE WORLD

2-3

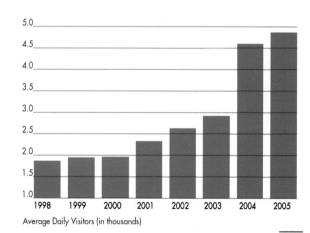

Average Daily Visitors (in thousands)

2-4

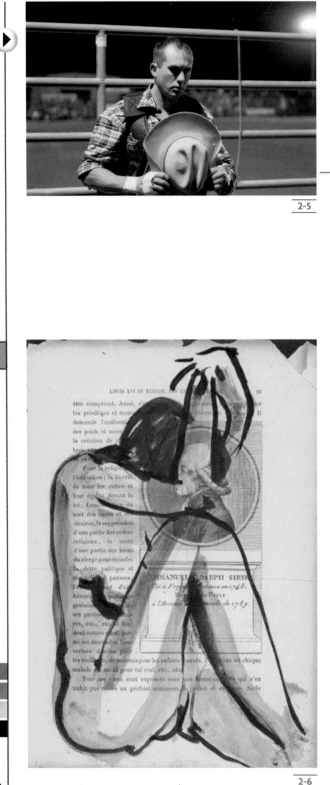

2-5

2-6

or later they will log on to their computer to "see what's out there." When they do this, they might come across your photo blog. The ease with which your layout can be understood and navigated and the appeal of your overall style will determine whether they bookmark your site or move on to the next photo blog.

STYLES GALORE: WHAT WORKS?

While selecting the layout of your photo blog is a simple matter of choosing between one of the two primary formats available, developing your style as a whole is perhaps the most exciting and interesting aspect of the entire process. Think of it: You are about to publish something to the World Wide Web where, potentially, millions of people will see it. Do you have something you think is important to show? Do you care about poverty or homelessness or cruelty to animals? Are you interested in growing orchids or raising bantam hens or riding in rodeos (Figure 2-5)? Want to show your fine art nudes to someone besides your significant other (Figure 2-6)? Are you interested in urban decay, social justice, political change? Or maybe you're overrun with four kids, two dogs, and a broken washing machine, and you take pictures of sunsets to make you feel better.

I tell you this because I have experienced it myself firsthand: There are other people out there with four kids and broken washing machines and, believe me, you will not be the first person to gain a huge audience from just this sort of sharing. Heather Armstrong of www.dooce.com, a phenomenally successful blog where postpartum depression and toddler woes are often on the agenda and who utters, possibly, the best one-liners in existence, keeps such a blog.

Marya Figueroa, a Web professional with a wide social network and a newly-found love of photography keeps two blogs, one of which is shown in Figure 2-7, on which she showcases her professional resume and another where she shares tidbits of net information and her favorite photographs. We

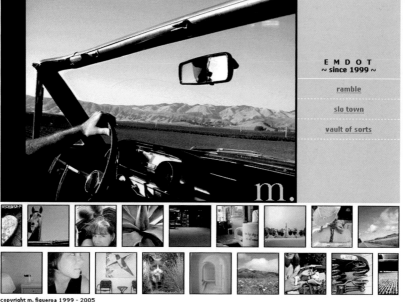

copyright m. figueroa 1999 - 2005

2-7

live in a world separated by data links and locked doors; the steam in the photo-blogging revolution is the enthusiasm with which people are embracing sharing and connecting through their photography.

Travis Ruse, a phenomenally talented photographer living in New York City, goes to work each day on the subway, and his site is primarily a truly amazing collection of photographs depicting this daily event in his life (Figure 2-8). People come to his blog and all the others in this chapter because each blog's style is appealing and distinct and interesting. Many, many styles work — the four personal photo blogs that Forbes considered the best on the Web in 2004 are all very markedly different in style, from Daily Dose's distinctive urban scenery (Figure 2-9), to the stylish personal chronicle of Ten Years of My Life (Figure 2-10), the film-only street shots of Quarlo, and my own slice-of-life blog, Utata (Figure 2-19). What works? Everything works — if it's done well (Figure 2-11).

With that in mind, let's talk layout!

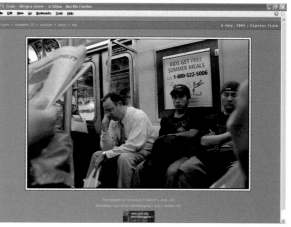

2-8

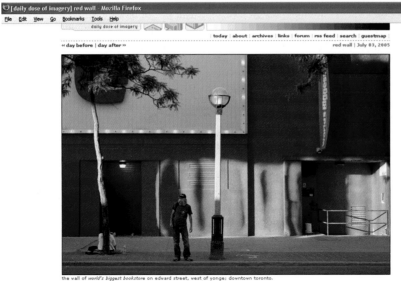

2-9

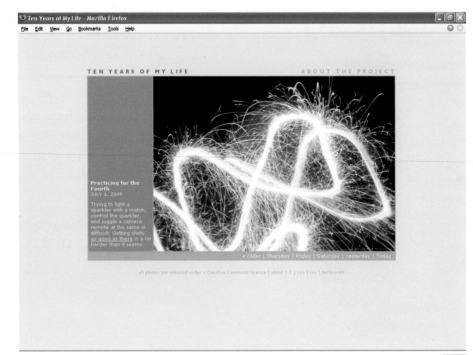

2-10

Sergio Lubezky A.

aprendiz de fotografia

| inicio | porqué | urbano | contacto |

Todas las imagenes con Derechos Reservados © 2005 Sergio Lubezky Americus.

2-11

BASIC PHOTO BLOG LAYOUTS

Your first decision, what photo-blog layout you want, is an easy one — although if you have never published on the Web before, it might seem daunting. Don't worry, because there is a thing that you must always remember about the World Wide Web: It was built to be fluid, and any decision you make with the exception of things like your domain name can usually be easily changed from the actual layout of your blog to the color of your link text.

Layout is distinct from design — either of the blog layouts described here can be made to look almost any particular way and can be designed using any color palette. Layout is the basic format that is used; it is the architecture of a photo blog and defines how it functions rather than how it looks.

When you build a house, you meet with the architect before the interior designer, and it is much the same with a photo blog. You must first determine how your blog will function and what you want to do with it.

Although there are many variations thereof, there are only two basic layouts that a photo blog can take. Though they are very similar, each one has a unique set of characteristics and qualities and each is suited for a slightly different purpose.

The two basic layouts are

> Photo A Day, such as is shown in Figure 2-12, the multi-award-winning Snowsuit Effort photo blog

> Blog Style, such as is shown in Figure 2-13, the 2 Girls and the World photo blog

27

2-12

2-13

PHOTO A DAY LAYOUT

The Photo A Day layout is, as the name implies, a blog that is characterized by the publication of a single large photograph per day with links to the items before and after it or rows of recent thumbnails such as Anne Archambault uses on her blog wideangle (Figure 2-14). Although this photo blog layout can and often does contain other pages, such as links, and information about the photographer and the photographer's equipment (Figure 2-15), it does not usually contain much more in the way of content than a daily photograph and a few details about the photograph itself. This layout could actually be called the "One Photo At A Time" layout because there is nothing to prevent you from posting 50 photographs a day — just one at a time. James posts pictures from his walks around Sydney, Australia (Figure 2-16), in his very elegant photo blog JiMagery, which is an excellent example of the Photo A Day layout.

The primary characteristic of a Photo A Day layout is that it contemplates a blog where you almost always let the photograph do the talking, such as Irina Souiki of Still Memory (Figure 2-17), who keeps a separate text blog for when she feels like writing. A Photo a Day layout presumes in its design that you will not often want to make text entries or write narrative to go with your photographs. This is not to say that you cannot make text pages, write essays, or add other narrative such as I do on my site, which is really a hybrid of the two layouts (Figures 2-18 and 2-19), or as James Lomax does on his site (Figures 2-20 and 2-21), but this blog layout is really best used to showcase individual photographs in a large format with only a small amount of text accompanying the image itself. Jasmin, a young woman living in Singapore, says in her bio that she likes to take pictures and write, and her blog, Vignette, is a wonderful example of a single large photograph (Figure 2-22) with a few paragraphs of accompanying text.

2-14

2-15

2-16

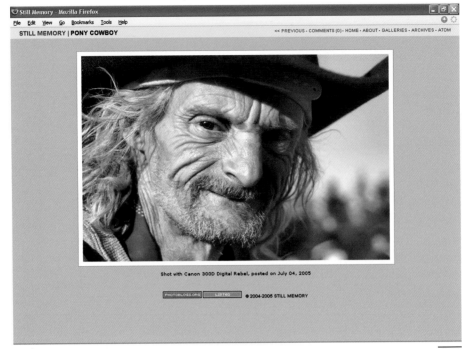

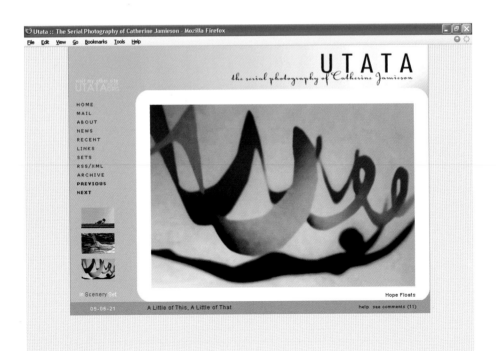

2-19

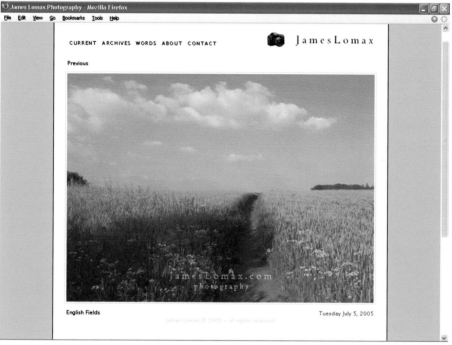

2-20

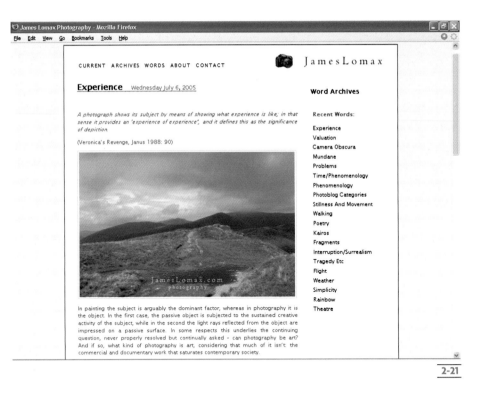

CURRENT ARCHIVES WORDS ABOUT CONTACT James Lomax

Experience Wednesday July 6, 2005

A photograph shows its subject by means of showing what experience is like; in that sense it provides an 'experience of experience', and it defines this as the significance of depiction.

(Veronica's Revenge, Janus 1988: 90)

In painting the subject is arguably the dominant factor, whereas in photography it is the object. In the first case, the passive object is subjected to the sustained creative activity of the subject, while in the second the light rays reflected from the object are impressed on a passive surface. In some respects this underlies the continuing question, never properly resolved but continually asked – can photography be art? And if so, what kind of photography is art, considering that much of it isn't: the commercial and documentary work that saturates contemporary society.

Word Archives

Recent Words:

Experience
Valuation
Camera Obscura
Mundane
Problems
Time/Phenomenology
Phenomenology
Photoblog Categories
Stillness And Movement
Walking
Poetry
Kairos
Fragments
Interruption/Surrealism
Tragedy Etc
Flight
Weather
Simplicity
Rainbow
Theatre

2-21

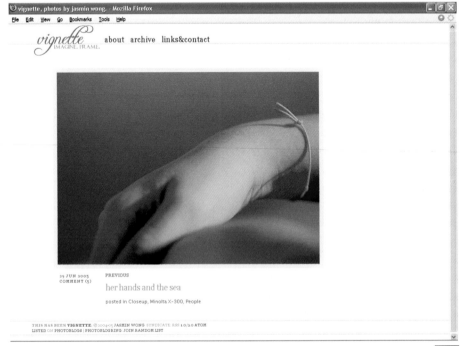

vignette
IMAGINE. FRAME. about archive links&contact

29 JUN 2005
COMMENT (5) PREVIOUS

her hands and the sea

posted in Closeup, Minolta X-300, People

THIS HAS BEEN **VIGNETTE**. © 2004-05 JASMIN WONG SYNDICATE RSS 1.0/2.0 ATOM
LISTED ON PHOTOBLOGS | PHOTOBLOGRING JOIN RANDOM LIST

2-22

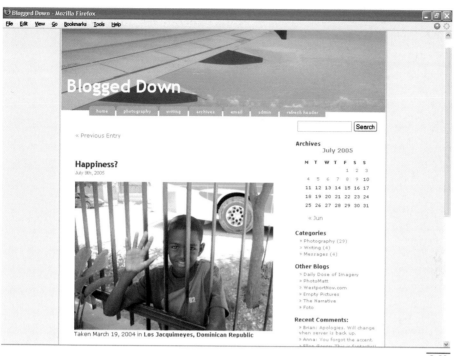

BLOG STYLE LAYOUT

This layout is the most commonly used in Web blogs and is often seen in photo blogs simply because most of the templates and services currently on the Internet are geared toward text-based blogs and not photo blogs. Many photo bloggers got their start as text-based bloggers and have stuck to the blog style because it is familiar and well supported. Additionally it serves the segment of the photo-blogging population who want to write as well as post photography such as Brian Mayer does at Blogged Down, an enchanting collection of photography and literary musings (Figure 2-23).

The Blog style is characterized by photographs that are usually accompanied by text and are displayed one on top of the other on a long page. A blog style usually has only the one main page, plus archives of older pages, and most often uses sidebars to offer links and other information about the blogger, such as Nikolai Razouvayev's Picturism (Figure 2-24).

2-25

2-26

WHICH LAYOUT IS RIGHT FOR YOU?

Before you make that actual choice, I want to stress that you are not "stuck" with a layout choice and the basic components of each layout are the same. You can start with a One A Day layout and easily change it to a Blog style, and vice versa.

This is a very good time to talk about the templates that I made for use with this book. Although they are discussed in detail in Chapter 4, it's useful for you to understand the basics of how they work so that you can start making informed decisions about your new blog. Understanding templates and how you use them to build your blog will help you review the following examples of blog layouts, themes, and designs with an eye to getting ideas for your own. It will also help you here in making your first decision, which is what layout you should select.

Making a photo blog with templates is much like building a house from a set of plans. A template is a series of independent modules like stairs and walls and ceilings that work together to create a specific result. You have a list of materials (the template) and a set of building instructions (the Web page), and if you put everything together exactly as instructed, the result is a house that looks and functions in a specific, expected way (photo blog) — which is good (see Figure 2-25).

But maybe you want a winding staircase instead of a straight one and you want more windows or fewer doors, so you alter the plans for those things. You still have a house that functions properly, just one that is suited to YOU. In photo blog design, you might want a side menu instead of a top menu and

rectangle thumbnails instead of square ones. With the templates, as with the house plan, all you really have to do is add the side menu module instead of the top menu module and the rectangle thumbnail module instead of the square one. Each time the page is loaded, a template builds the blog dynamically around your content, using the modules as bricks for the foundation of the website; all you have to do is give it a different set of plans (Figure 2-26).

In other words, in the blogging business, there is no such thing as rules that are "written in stone," and elements from one or more blog layouts and designs can be combined to make a completely unique new thing.

Deciding on your basic layout is simply your starting point. It comes down to a single two-part question. Do you want to show your photographs primarily, or do you want to show your photographs and write entries longer than a few lines with most of them?

If you select the first option, then I recommend the Photo A Day layout. If you select the second option, I recommend the Blog layout. Keep in mind that having a blog layout does not preclude you from having a single large photograph each day without any text, and having a One Photo at a Time layout does not preclude you from writing a novel on your blog. The layout you choose is merely a starting place, a way to begin with the most useful platform for you to start customizing your own photo blog design.

EXPOSING YOUR OWN STYLE

I once gave a talk at a community college about photo blogging, and I said that I believe that one of the most compelling characteristics we have as

a race of people is our need to communicate. The drawings that archaeologists find on cave walls in Africa and the etchings found in Sumeria tell us that since the time we were capable of holding tools, we used them to communicate. A photo blog that you publish to the Internet has the means to be a very powerful tool, and although all you may want to do is share your pictures, you may find that you have a message to send as well — even one you did not know you had.

For example, Brandon Hoover of the wondrous java-jive (Figure 2-27) is an American living on the island of Java, Indonesia, who says, "I initially created my site as a way to share my adventures and experiences with those I left behind. I quickly found that in such an exotic locale, the culture comes to life through photography in ways that words alone cannot express. My focus has shifted dramatically in the time since, from one of attempting to simply share my story to one where I attempt to bring the beauty and warmth of the

2-27

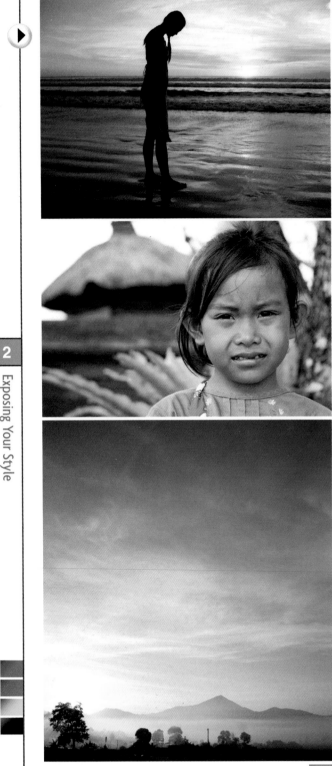

Indonesian people to the rest of the world (Figure 2-28)."

Chrys of exposur3 (Figure 2-29) sums up what a lot of bloggers tell me. "In the simplest terms," he said, "I do it to share a part of me that would otherwise be kept safely tucked away. I've always been quite shy and reserved, so the fact that I can connect to a community with similar interests is a definite plus for me." Chrys can, in fact, trace the beginnings of his photographic passion to a single photograph taken of his infant son with a borrowed camera (see Figure 2-30).

The style of your blog is what it's about, what you want to do with it. Brandon Hoover wants to share a Westerner's view of the Javanese people, and Chyrs wants to connect with a community of like-minded people by sharing what he sees in his world every day. This doesn't mean that you need to have a man-ifesto or a mission statement, merely that you have an idea of what your photo blog is going to have it in and what things you expect to accomplish with it. For years, before I turned my attention to helping other people start and begin to publish a community blog, my online publishing was all about whatever I wanted it to be about that day, and thus its style was Slice of Life. My personal site today is still aimless, and I post the photographs I want people to see and tell the stories I want them to hear. It's perfectly fine not to have a set-in-stone idea of what your blog can be or what you will do with it specifically. Your style will emerge over time, and if you think of your blog like you do your photographs, that you want to constantly improve and find new creative ways to express yourself, its own style will develop naturally.

WHAT THE COOL KIDS ARE DOING

I've divided the blogs that currently exist into seven categories of basic style, but keep in mind the

2-28

2-29

building-a-house analogy I used earlier and remem-
ber that you can pluck the menu idea from one
design and the navigation system from another. One
of the most fascinating and wonderful things about
publishing to the World Wide Web is that it encour-
ages what I call "creativity by osmosis" — you will
see things in your travels that will give you ideas for
your own site. For example, I saw a neat idea for
viewing menu buttons at a CSS site and converted it
to a way to see thumbnails on my site. It's become a
running joke among the people with whom I corre-
spond that many bloggers employ the wide white
frame that I use on images that I post to service
sites such as flickr, which is set so that the image
fits perfectly inside a standard browser setup. I
saw it referred to in a comment thread once as
"the patented Catherine Jamieson right size for the
web viewer so we lazy people don't have to scroll

2-30

(Figure 2-31)." Web design is the most open and generous artistic process that I know of. Ideas are born and shared and improved upon in just this way.

As you look through these examples, you will find elements that strike you as appealing, such as rounded corners or a style of logo while the main site as a whole is not quite to your taste. Keep these ideas in the back of your mind so that when you get to Chapter 5 and are ready to design your own blog, you will be able to get exactly the look that you want.

THE PHOTOGRAPHIC SHOWCASE

The Photographic Showcase is all about showing your stuff! You primarily want to show your pictures and maybe connect with other photographers or get feedback that you can use to become a better photographer, and you don't really want to write essays or long entries. It's all about the imagery. Jessyel Ty Gonzales of the ever-popular Daily Snap has such a blog (Figure 2-32). When I asked him what motivated him to keep a photo blog, he said, "At first, discipline. Then I discovered photo blogging. And it became the discipline to shoot every day, get comments and critiques, and just a way to get published — to get 'out there.' But now it's evolved into a passion. An art. A different way to see the world and let others peek into mine."

There are many wonderful examples of this type of blog such as one created by Carrie Musgrave, a skilled amateur currently studying photography. She publishes Delineated, a simple and elegant showcase for her appealing photography (Figure 2-33) of subjects shot in and around Toronto, Ontario, Canada. Another example is the much-lauded Shutterbug that was developed by Tracey, who takes photographs around her environment in Sydney, Australia (Figure 2-34).

The inspiration for the photography in these blogs comes not only from the mundane world but from the imagination as well. Many of these photographers regularly post images taken from scenarios

that they seek out or even create, such as the ever-creative Rannie Turingan of photojunkie, voted Best Canadian blog at the 2005 Bloggies (Figure 2-35) and an enduring personal favorite of mine.

The photographic showcase usually has a simple interface, a single large photograph, and a minimalist design. When the photograph is very large, such as in these examples, the design must be minimalist or you risk overpowering your images. The shooting style of these photographers ranges from street to studio, but their blogs all have a similar look and feel — a simple frame around a stunning photograph.

THE SLICE OF LIFE PHOTO JOURNAL

If you can imagine yourself saying something like, "I have this great digital camera, and I see people putting up their photographs. I want to put mine up, too, talk about life a little, maybe share a recipe or tell a funny story or explain a joke I heard," then your photo blog is likely to take the shape of a Slice of Life Photo Journal. Following Photographic Showcase blogs closely in popularity, this type of photo blog is aimed at those who want to do other things on their blog aside from posting photographs, such as writing a daily narrative or a poem with each image. Mathew Hollett of the wonderful non*glossy (see Figure 2-36) says of his blog, "This site is part diary, part portfolio, and part photographic notebook. I call it non*glossy because I love to photograph worn, weathered things; old friends; and found objects."

Don't let the names I choose to identify the different types of photo blogs fool you, either, because some of the most celebrated photographers keep this style of blog, such as Mathew Haughy's award-winning Ten Years of My Life (refer to Figure 2-10). This is a style preference for those who like to tell stories and communicate ideas in words as well as with photographs, and the primary difference between the two is that the inspiration for the photographs inside these Slice of Life blogs usually comes from your daily life — from your trips to the grocery store or your new

2-34

2-35

2-36

2-37

2-38

2-39

kitten or your walks along the river (see Figure 2-37), and is meant to be reflective of your personal lifestyle.

As Dave of East3rd says, "I figured that a photo blog would force me to get out there and take some photos every day, and hopefully, help me improve as a photographer." His progress is not only fascinating, but gratifying to watch (Figure 2-38). My blog started as a journal blog (which was way back before the time of digital cameras) and gradually became a photography-based site, but I never did want to let go of the stories, so I do both and my style is decidedly Slice of Life.

Slice of Life and Photography Showcase blogs draw different audiences, although there is, of course, some crossover as the primary element of each is photography. Slice of Life blogs tend to draw viewers who are interested in you, the photographer, as well as your photography, and they tend to spend more time on your blog looking around. I know people who line up 200 photo blogs in their subscription feed. They go from one to the other in a straight line and are not interested in anything but the photograph. These viewers tend to prefer the photographic showcase-style blogs.

As long as you are careful to keep one larger-size image on your front page, visible immediately in a browser window, whether your blog is a Photography Showcase or a Slice of Life is irrelevant in terms of the number of viewers you can attract.

THE SPECIAL INTEREST PHOTO BLOG

If you are interested in a specific form of photography, such as toy cameras or cross processing, or have a life circumstance that you want to share and explore or even an enthusiastic interest in music or some other hobby, then you're in good company. There are many wonderful themed photo blogs. Exposed Photography (see Figure 2-39), for example, is a photo blog "dedicated to old, abandoned factories, mines ... forgotten buildings and sites with

beautiful architecture according to traditional methods." Here you find fascinating shots of semi-ruins in Germany, France, Belgium, and Luxembourg along with a thoughtful narrative.

Bob Hyper's Food for Thought is a wonderful photo blog about making your own food complete with photographs (Figure 2-40) and recipes, and if you check the links, you see that he also keeps a gardening blog, one of the more popular themes for personal photography hobbyists. Julie Leung keeps a lovely personal garden blog called Seedlings & Sprouts, which is always full of colorful, fun, and interesting photography (see Figure 2-41).

The themes for these photo blogs are plentiful, and I have seen photo blogs made about losing weight, travel, martial arts, car collecting, motorcycle riding, cycling, and virtually every sport ever played. There are photo blogs dedicated to album cover art and classic book illustrations, and cats and dogs. Topics are plentiful, just as the interests that spark them, and anything you can represent with photography, which is just about everything, is a good subject for a photo blog.

These types of blogs are most interesting, of course, to others with a shared or similar interest, but certain themes, such as architecture, gardening, and food, draw a very broad audience from those not necessarily interested in the topic as a hobby, but who appreciate the fine photography related to it. The particular thing about these blogs is that although the base audience is smaller, those who do visit and like the blog tend to become very loyal viewers and come back every time you update.

THE GROUP OR COMMUNITY PHOTO BLOG

One of my favorite types of blogs is a community or group blog. Ranging from those that serve a particular class in a school or a department at a university, group blogs are a wonderful way to share both the effort and the rewards of photo blogging with a group of like-minded people.

The Dawdon Village Blog (Figure 2-42) is an excellent example of a group blog where efforts are centered around a shared interest, in this case a geographic location. They say on the front of the blog that it's about "A village on the coast in County Durham. . . a vibrant and welcoming place, its houses well kept and its people full of laughter and belonging." Their shared effort seems to draw them together into a close-knit group, and it's easy to see why they enjoy doing it so much — it promotes a strong sense of community.

Whether it is a blog like Dawdon Village or one like the Utata.org blog (Figure 2-43), which was inspired by a group of photographers who came together on flickr

2-40

2-41

Dawdon

A VILLAGE ON THE COAST IN COUNTY DURHAM, FORMERLY THE HOME OF ONE OF THE MOST PRODUCTIVE COAL MINES IN EUROPE. THE PIT CLOSED IN 1991 AND LATER SO DID MOST OF THE SHOPS, BUT THE SOCIAL BONDS AND SENSE OF 'COMMUNITY' HAS STRENGTHENED AND NOW THE VILLAGE IS A VIBRANT AND WELCOMING PLACE, ITS HOUSES WELL KEPT AND ITS PEOPLE FULL OF LAUGHTER AND BELONGING.

SUNDAY, FEBRUARY 13, 2005

Blast Beach shoreline

PREVIOUS POSTS

"I was worried that night"
Of Life
New Year's Party Night at Dawdon Welfare
From my Window
Seaglass
Camera creates peace and harmony.
Beach Rescue
songs from Dawdon pit
My Land

MINI COMMENTS BOX

brenda: the harbour site has some great films on it. maybe we can host them here?

trisha: i like this

sam: me too, it works. maybe dan will want one too?

POSTED BY APPRENTICE AT 9:35 PM

2 COMMENTS:

2-42

FLICKR ABOUT ARCHIVES COLUMNS ARTICLES GALLERIES PROJECTS HOME

UTATADOT ORG

previous | next

July 04, 2005

Jozef and Maria
The Structure Of Drama
By Catherine Jamieson

LATEST ARTICLE

Cinematography and Photography
An admiring look at German born cinematographer Wim Wenders. Utata's own Frans Peter Verheyen, award winning Dutch photographer, offers an illustrated homage to the gifted artist.

SITE NEWS

JULY 6, 2005: Linus Gelber (corporal tunnel) has taken charge of "The Thursday Thing" and will be coordinating that fine effort. Yay Linus! (I'm thinking "For he's a jolly good fellow" when I type this, really.)

YAHOO! PICKS

JULY 6, 2005: I forgot (can you believe it?) to put our Yahoo! Pick of The Day up here on the news bar. So, better late than never ... **TRAINS was selected by Yahoo! for a pick of the day!** How

Photo By annuka

All photography is drama in still life, of course, but there are certain photographs which have an inherent element of profound drama. You find yourself hearing the subject's sighs or imagining their thoughts as the shutter clicked. Great dramatic photography can never be achieved accidentally and never when just one element is in place. No, no - to create drama like **annuka** has done with *Jozef and Maria* not only do all of the elements have to be right (composition, lighting, exposure and timing) but we must come to understand something *about* the things we see as if we were there. The photographer must leave us with a taste in our mouth, a sound in our ears, a memory we did not know we had. This is that sort of photograph

2-43

and began to publish their "best" photography to the Web, a group or community blog serves the purpose of gathering like or related images and people together in one place. Although I was part of the community that created the Utata blog, it arose from a flickr group of the same name and was created specifically to give a broader exposure to talented photographers who did not have their own blogs and thus no means to promote themselves individually. It has proven an inspiring and welcome change from the isolation that is usually the case in solo photo blog publishing, and many of the participating photographers have achieved both professional and artistic opportunities by being showcased on its front page or in one of the projects it regularly publishes.

Many group or community blogs are kept to share or to expose the similarities and differences in common experiences, and they are a wonderful way for people to keep in touch and to let family and friends know what they are doing. A group of Persian students in the United Kingdom keeps a very compelling photo blog (see Figure 2-44) to keep their families at home apprised of their progress while they are away, and I am often impressed with the effectiveness of their endeavors.

A group or community photo blog is a wonderful project for a community club or special-interest group, and, of course, as is the case with the Utata group blog, the participants can come from all corners of the world and from all ranges of photography experience. Not only are they amongst the most interesting blogs to create, they are amongst the most interesting to view and often have the largest audience of all the types of blogs as a viewer can be assured of seeing more than one subject and style when visiting.

THE ARTISTIC OR PHOTOJOURNALISM PHOTO BLOG

These sorts of blogs are defined by their content and purpose and are usually produced by people working professionally either in the arts or in journalism. Oftentimes, such as with Kevin Sites's blog (Figure 2-45), they are personal extensions of a professional interest, and the photography is generally reflective of both their experience and their specific profession or artistic calling. Sites's blog carries the following disclaimer: "Kevin Sites is a freelance solo journalist currently on assignment for NBC News in Asia, but this site is a personal website not affiliated with or funded by NBC News."

Kevin Sites posts outtake — shots that are taken in a series or sequence for a specific purpose but are

2-44

2-45

not used in the final project — photographs from his assignments in the Middle East and Asia, and many people view this sort of site as an opportunity to see events without the editorial layer.

Jerome Ferraro's 52: A Picture a Week in 2004 (Figure 2-46) is a photo blog that I simply can't get enough of.

2-46

2-47

I first saw it through a link someone sent me in the mail, and I have been following it closely since that time. When Jerome posted this note, "Rather than a standard photoblog, this site is now more of an online gallery. There will be a brick and mortar show in the Fall of 2005 in NYC. Thanks to all who supported the project!" I wrote and said, "It's just a different kind of photo blog now!" I believe it to be one of the best examples of what can be done in this medium, with this publishing tool. Once a week Jerome found a subject and presented it to us in one unusual pose or another, and from the frank, often stark, and always generous portraiture, we found ourselves drawn into these worlds, one week at a time.

Although these are only two examples, the Web is full of interesting and unique photo blogs in which the blogger has shaped it in his or her field or profession and continues to post to a photo blog out of sheer love for the process. Many artists and professionals have begun to realize that the Internet is not only a bona fide potential market for their talents but it also increases their "name brand," the degree to which they are known by the general public.

THE PROFESSIONAL PHOTO BLOG

Many professional photographers keep other types of blogs, of course. I am a professional photographer, for example, and my blog barely acknowledges this fact. Both Sam Javanrouh of Daily Dose of Imagery and Todd Quarlo of Quarlo sell photography, although their blogs are very much in keeping with Photographic Showcase styles. What separates such blogs as the beauteous offering of Anne Hamersky (Figure 2-47)

and Carmen Sisson of Cloudy Bright (Figure 2-48) is that their blogs are identified as portfolios for their professional work and the content is usually related to the sort of photography that they do professionally.

Yuri Dojc, a professional art photographer, and one of my personal photographic inspirations, keeps several online presences (Figure 2-49), including an account at flickr, where he posts his fascinating portraiture and concept photography. These photographers are building a presence in the new media, and the result is that viewers are able to view the work of professionals and make comparisons with their own efforts. If you are a professional photographer, a blog can improve your market presence, sell your work, or even obtain new work for you such as has happened to me on several occasions. An online gallery is instantly available for viewing by prospective employers, and they are able to get a good feel for not only your body of photographic work but your skill with presentation and context.

VIEW, REVIEW, AND GET READY TO LOG ON

As you can see, the ways that you can use your photo blog are virtually endless, and although there are many styles used for blogs, there are only two basic layouts. Once you choose which layout you prefer, the One A Day layout or the Blog layout, your own personal style will develop as you design the blog itself and add images to it. Reviewing the examples in this chapter as you go through the rest of the processes in this book will help you immensely in determining not only what you want to do, but what you don't want to do.

I recommend that you take a little time now and browse through some of these sites so that you have a basic familiarity with how they work and what you like and dislike about them. All of the sites listed in the book are contained in an index in the back of the book where you can browse them in alphabetical or chapter order.

Next, we log on and start the process of finding a home for your photo blog.

2-48

2-49

The Free Account

The free account (see Table 3-2) is not suitable for photo blogging except as a trial. Photobucket.com places many restrictions on its free account that prohibits running a blog properly, such as a size limit of 250KB per photograph and a maximum bandwidth of 1GB. The premium account, which costs $25 per year, has unlimited bandwidth (with a caveat for review of excessive use) but still maintains a maximum file size of 1MB.

This service is primarily for using images on such services as eBay and text blogs where smaller images are used as illustrations, and thus it limits the photo blogger who wishes to store either high-quality archival images or high-resolution images for a photo blog.

I recommend Photobucket.com for storing photos if you

> Do not produce large images or do not want to save your originals

> Take mobile phone images only

> Take images only with a low-megapixel digital camera

Signing up for Photobucket.com

Signing up for Photobucket service is simple and direct. All you need for the free account, which is what you should start with and use for several days to make sure you like the interface and the environment, is a valid email address. Here's how to join:

1. Go to Photobucket by typing **www.photobucket. com** into your Web browser.

2. Click the Sign Up Free link as shown in Figure 3-7.

3. On the screen that appears (see Figure 3-8), you will first be asked to answer several personal questions such as name, age, and so on. Many sites that offer free accounts ask for this information

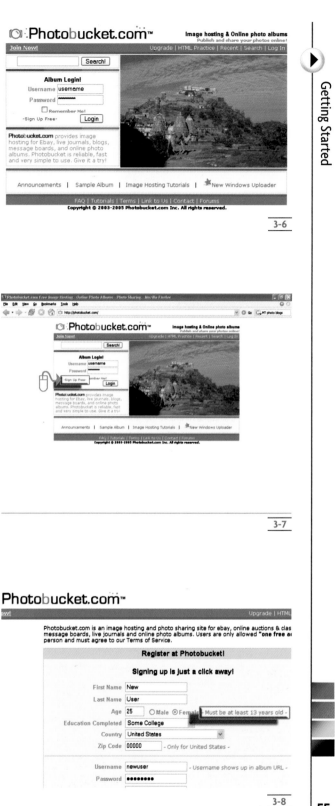

3-6

3-7

3-8

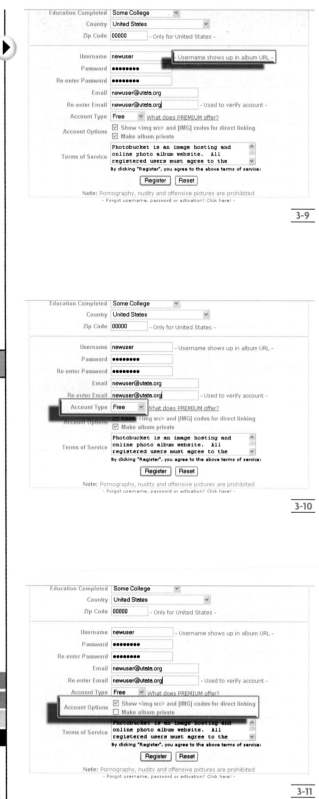

3-9

3-10

3-11

for marketing purposes. Anything that is mandatory is indicated with a green text note.

4. Below the personal information is your actual account information. First, choose a username (see Figure 3-9). Keeping in your mind my earlier advice, type the name you want to use for a username.

5. Next, type a valid email address where you can receive the confirmation email that Photobucket sends to all new registrants.

6. Choose your password and type it carefully (mistyped passwords can be problematic) into the space and press Enter.

7. In the Account Type drop-down box select Free — at least for the time being until you are certain that you like the service (see Figure 3-10).

8. As Figure 3-11 shows, there are two Account Options check boxes. The first asks whether you want to display code and tags so that your images may be linked. You should click on the box so that a green arrow appears, as you do want your images to be linkable.

9. The second check box asks whether you want to make your album private. You should ensure that the box is not checked, as you want people to be able to see your photographs.

10. Once you read the Terms of Service for the site, you can click Register (see Figure 3-12).

11. An email will appear soon in your in-box containing an activation link that you can follow to start using your Photobucket account.

flickr.com

flickr.com (see Figure 3-13) is part of the reason behind the massive surge in the popularity of photo blogs. Prior to the development of reliable photo storage sites, all of the problems I stated earlier in the chapter with bandwidth and storage space were major concerns for modern photo blog publishers and their 5-megapixel digital cameras. I am not

the only one, I am sure, who considered quitting because it was becoming more of a cost than even the most beloved of hobbies should be.

Describing flickr in full in this space is not possible, as it has become as much a community as it is a service. I describe it in more detail in Chapter 11, where I explain more of its community options. Here I discuss it primarily from a photo storage service perspective and show you how to register and start storing your photographs.

There is no way to directly compare Photobucket and flickr, as they have quite different setups and limitations on free and premium accounts, but it roughly correlates as follows:

The Free Account

> **Free Upload:** per month. This is different than storage, on which there are no restrictions per se. It limits how much you can upload each month but places no actual restriction on how much you can store on its servers. Over the course of a year it could amount to 240MB of stored photographs.

> **Maximum photograph file size:** On free accounts flickr restricts the size of uploaded photographs to 5MB, and it resizes large photographs automatically for viewing purposes and the original, if larger than 1,024 pixels wide, is not available for viewing.

> **Bandwidth restriction:** None.

> **Maximum number of photographs available for viewing on flickr:** 200. You can always use all of your photographs in your blog, but you can only access the last 200 from the user interface.

The Premium Account ($24.95 per year)

> **Upload Limit:** 2GB (about 8,000 to 250KB photographs) per month

> **Maximum photograph file size:** 10MB.

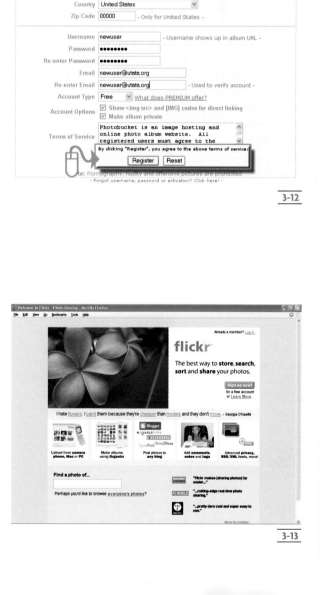

3-12

3-13

Getting Started

57

> **Bandwidth allowance:** Unlimited.

> **Maximum photos available for viewing:** None.

> **Permanent archiving of _original_ high-resolution images:** Yes.

Flickr is the photographer's choice for storing your high-resolution photographs as its generous storage and bandwidth allowance is more than enough for all but the most prolific photographers, and you do not have to make decisions about which photographs to keep and which ones to delete to make room for new ones.

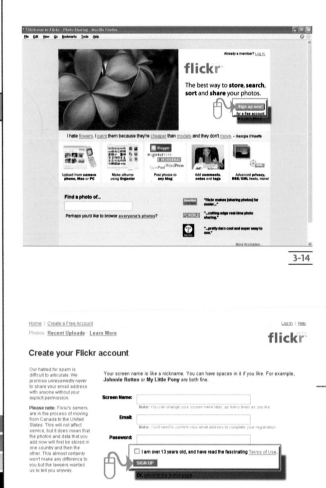

3-14

3-15

Signing up for flickr.com

Signing up for flickr service is very quick and easy. All you need for the free account, which is what you should start with and use for several days to make sure you like the interface and the environment, is a valid email address. Here's how to subscribe:

1. Go to flickr by typing **www.flickr.com** into your Web browser. Although the front-page photograph changes periodically, the design and layout should be the same as that in Figure 3-14.

2. Click Sign up now!, as shown in Figure 3-14.

3. On the screen that appears, you are asked to choose a screen name. Keeping in mind the advice I gave you earlier in this chapter, type your screen name and press Enter.

4. Type a valid email address where you can receive the confirmation email that flickr sends to all new registrants, and then press Enter.

5. Choose your password and type it carefully — mistyped passwords can be problematic — into the space and press Enter.

6. Once you verify that you are over 13 years old and have read the Terms of Use, click SIGN UP, as shown in Figure 3-15. flickr then displays a screen and asks whether you want to set up your account profile or start uploading files, which I discuss in Chapter 11. Within minutes an email will arrive in your inbox confirming your registration.

STEP THREE: YOUR OWN DOMAIN

Having your own domain on the Internet is exciting, I think. It's a sovereign state inside a public forum where you can express yourself freely, and for a lot of people, owning a domain opens up many creative doors.

Choosing a domain name can be either a very fun or a very frustrating experience. You might find that

your first several choices are already used, and you must simply forget a domain name with the word photo or foto in it unless it's very unusual; most of these have long since been taken. However, it will be worth the experience the first time you are able to type your very own domain name into your browser window and have your own site appear on your screen.

DOMAIN TYPE

The first consideration is what type of domain that you want to have. A domain name is a combination of the letters www (which stand for World Wide Web), a unique name plus a period (read as "dot"), and then two or more letters or groups of letters that signify what sort of site it might be. Although the rules and standards for domain names have been largely ignored, the general guideline is as follows:

> **.com** domain names signify that the site carries on a commercial enterprise of some sort. If you ever contemplate selling prints or other items from your site, you should register your chosen domain name with the extension .com.

> **.net** domain names usually signify that the site is part of a larger network of related sites or is part of an intranet.

> **.org** domain names signify that your blog or site is part of an organization. This extension is often used by community sites or sites that are not strictly personal in nature.

DESIGNER TIP

Many people like to "box in" their domain name and register all the possible extensions of it to ensure that someone does not register a .org that is the same as their .com. This prevents mistyped URLs and allows people who can only remember the other part of your domain name to find you. Although it is a fairly common practice, I do not always do so myself, and you will make the decision whether you do so based on whether you want to spend the extra effort and money. A domain registration is approximately $15 for each name and will cost approximately the same each year to keep registered.

Recently, several new domain extensions were added, the only relevant one being .name, which I have yet to see in actual use but which does exist as a possibility for a personal photo blog.

Additionally, some domain extensions indicate your country of origin such as .ca for Canada, .us for United States, or .uk for United Kingdom. They are stringently controlled by a regulatory body that generally verifies all information separately from your application. They usually require you to be a member of the regulatory body to register a domain with the country extension, and there is an additional cost associated with this type of registration.

On my personal domain, `www.catherinejamieson.com`, I use the .com extension because I anticipate the possibility of selling prints and other artwork from my site and do not want to have to change later, once I am established. It's very important that you choose your domain name well because it is very unwise to alter it after you have established an audience with it.

I usually recommend a .com address for people starting photo blogs as the potential always exists that people will want to purchase prints from a photo blog site. There are no restrictions on a .com address, and you may use it even if you do not operate a commercial business on your site, so there is no harm in being prepared for the best-case scenario. Additionally, the "dotcom" address is the most easily remembered. It is the most easily expressed verbally because it is the most familiar to people and carries with it an instant recognition as a Web site.

DOMAIN NAME

The name itself is where you can have as much fun or be as practical as you desire, but keep in mind these things:

> Your domain name should be easy to remember and type, so avoid any unusual letter combinations that are not usually typed together; use real words and real word combinations.

> Avoid the use of dashes as they get lost in links.

> Your domain name should not contain any profanity whatsoever, even that which is clearly meant to be ironic.

> Your domain name should reflect either your name (such as www.joesmith.com) or your photography theme (such as www.travelpics.com) or even your small business name (such as www.smith photography.com).

> Your domain name should be a word or words that you can tell someone that he or she can remember and understand without a lot of difficulty. Once your blog is up and running, you will tell people where to find it, and it should be something they can easily remember.

My recommendation for a domain name is your own name or some other family or personally important name that you don't mind being associated with in 10 years' time. You might also want to think of your domain as a small business. If you opened a small photography-based business, what would you call it? I'd likely call it Catherine Jamieson Photography, and thus I named my site eponymously. I do not recommend that you use the name of your blog as you might wish to change that from time to time. I have had several differently named blogs over the years, all on the same domain, and it is my experience that many bloggers change the name of their blog every now again as their interests or sensibilities change.

Choosing what to call your domain is both very exciting and somewhat daunting as you realize that millions of people can access your work through whatever name you choose.

REGISTERING A DOMAIN NAME

The registration process for a domain name actually helps you select a name. Many of the registration services available have an excellent system for both searching to see whether a name is available and suggesting alternate names.

Virtually every Web-hosting company offers a domain name registration service with all hosting packages. It won't cost you any more to register as part of your hosting service, and it is much wiser to use the same company for registering and hosting your domain. When you choose your Web host, I suggest that you register your domain with it.

WEB HOSTS

Your choice of Web host is one of your most important as they are the people who actually have your data on their machines. They need to be reliable and trustworthy, and their equipment and software has to be compatible with your publishing plan. This is the company that will serve up your photo blog to your viewers, and you must be able to rely on it to keep everything in proper working order.

This is where all the decisions that you made in the preceding sections come together and enable you to make this last step toward creating your own photo blog on your own domain.

Domain Names

Selecting a domain name can make you a little crazy. There are so many sites on the Internet that it can be difficult to get exactly the name you want. Surf around, and find examples of clever name variations that people have used. The first step in registering a domain is verifying that the domain is not in use and, every domain name registrar will have a facility to tell you whether a domain name is available. As you are deciding on your domain name, you can use one of these free services to check out your ideas. This way, when you get to the part where you actually register a domain name, you are well prepared.

CONTENT MANAGEMENT SUPPORT

If you decide to use a content-management system (which is my strong recommendation) and follow along with the instructions in this book for using one of the supplied templates with it, then you need to select your Web host according to this decision.

The content-management system for which the templates have been built is called Movable Type, and it is the designer and developer choice for building Web sites of all types. It is both well supported and well used. Thousands of forums and support groups, templates, and plug-ins are available to augment its use. You may choose other content-management systems such as Wordpress and My Expressions, but Movable Type is both the best supported and the most often used, which makes it the safest choice.

The Web host I recommend in the following section supports the Movable Type content-management system, and, in fact, the hosting package it puts together for you as a reader of this book offers the environment as a preinstalled option (see Figure 3-16). In other words, it does all the "geek stuff" at no extra cost, and you can simply log on, register your domain name, and start blogging.

CONTRACTING WITH A WEB HOST

You can choose from many, many Web-hosting companies on the Internet. The company you choose should be able to not only meet your storage and service needs but also have all the correct options available for your individual publishing plan needs. There are a lot of factors to consider when choosing a host, from the sort of hardware it uses to the manner in which it manages its databases and the things that it allows users to do, such as running scripts or using forms. If you use a content-management system, such as those recommended and discussed earlier in this chapter, you will need to be able to run scripts and use forms.

Nexcess (see Figure 3-17) provides excellent support and service to me, and is, in fact, already prepared

for your arrival. It's offering to you a great hosting deal with a Movable Type content-management system and a pre-install of all of the custom templates supplied with this book. Using this system, you'll be just a few clicks away from a fully functional, ready to go photo blog!

REGISTERING AND CONTRACTING WITH NEXCESS

By typing **www.nexcess.net** into your browser's address bar, you will be taken to the Nexcess home page, where you can select the Create Your Own Photo Blog link, as shown in Figure 3-18. You will be taken to a page, as shown in Figure 3-19, which will outline the details of the package that has been prepared for your use.

3-16

3-17

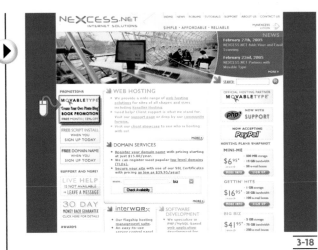

3-18

3-19

3-20

THE RIGHT PACKAGE

If you follow each of my recommendations from this chapter, you will have chosen to

> Use a content-management system

> Store most of your photographs on flickr

> Store the rest of your blog on your own domain

In this case, the best package for your needs will be the one which Nexcess has developed especially for buyers of this book. This is based on their Smart Start package and has 750MB of server space, 25GB of monthly transfer (bandwidth) and 75 email boxes, as well as offering each person who registers 1 month of free service and a discount of $15 for the first year of service.

To register for this package, arrange for your domain, and set yourself up with Nexcess, from their main page click the Sign Me Up button as indicated in Figure 3-20. You will be taken to a new screen, as shown in Figure 3-21, that gives you all the details of what you are purchasing, allows you to select a payment option and gives you the option to register a domain. If you are using the discounted package, you will need this book with you when you register as you will be required to verify that you are a purchaser by entering the last word from a specific page. That page number will be indicated on the screen shown in Figure 3-21.

DOMAIN NAME AND ACCOUNT REGISTRATION

You are ready to register your domain name. Here's how:

1. Click the radio button labeled I need a domain name and would like to register it now, as indicated in Figure 3-22.

2. Without using the letters www, type the name you have selected to call your site in the input box. Use all lowercase letters, and avoid using dashes in the name.

3. Select the domain type (.com, .net, .org, and so on) from the list box, as shown in Figure 3-23. In the example, I am signing up for a new Nexcess account and registering the new domain `catherinejamieson.net`.

4. Click Next at the bottom of the page, and the Nexcess servers verify that the name you selected is available. If it is not available, you are redirected back to the previous page to try again. Keep trying. Use all your ideas and reasonable variations until you get a domain name that you like.

5. When you select a domain name that is available, you are taken to a new page that enables you to "box in" your main domain name by registering it with as many extensions as are available. Select the name(s) you want to register by clicking the appropriate radio buttons, and then click the Next button link to proceed.

6. A new page appears that outlines Nexcess's Acceptable Use Policy (AUP) and its Terms of Service (TOS). Read this whole section carefully before you select the I agree to the AUP and TOS check box and click Next (see Figure 3-24).

7. Another page appears. After selecting the "I'm a new client" option as shown in Figure 3-25,

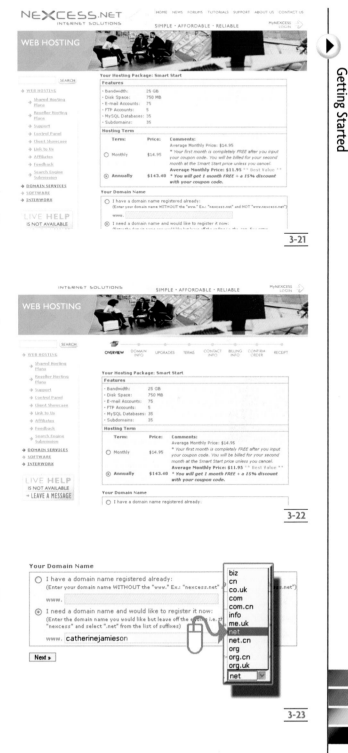

3-21

3-22

3-23

3-24

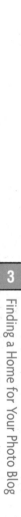

Nexcess asks for personal information like your name and billing address. When you complete all this information, which is all required, you are taken to a payment screen.

3-25

8. The payment screen will allow you to enter the password requested (see Figure 3-26) and will apply the discount available to you as a book purchaser. You will now need to select how you wish to pay. After you designate either a credit card or PayPal, you are asked to submit the details of either your credit card or to click on the PayPal link and complete the transaction at the PayPal site.

Once your transaction clears, your domain is registered and you are a registered user of Nexcess, which is now your new Web host and registrar. Very shortly you receive several emails indicating that your payment was approved, that your domain registration was successful, and that your account is ready to be used. Complete, detailed instructions are contained in these emails regarding how you log on and begin to use your account, but I walk you through that process in Chapter 4.

3-26

Congratulations! You have a home for your photo blog and are ready to start learning about how to personalize the design and add photographs.

SETTING UP

Part III

BUILD YOUR BLOG: THE TOOLKIT

There will be between a 12- and a 24-hour period before your new domain is fully propagated, and during this time you cannot access it by using the name you selected. Propagation as it relates to the Internet is, in the simplest terms, the process by which all the computers on the Internet become aware of where your domain is located. By communicating among themselves constantly, domain name system (DNS) servers keep registries of what a domain's resolved address is and on what physical server it is located (in this case it is on a server called NS1.nexcess.net). Thus, whether you are logging on from Tokyo or Madison, your Internet service provider's DNS server will know where your site is located within 24 hours or, in the worst case, 48 hours. As an example, my .com address took 18 hours to resolve, whereas my .net address was resolved in 9 hours. There is no way to accurately predict how long it will take, and the only way you will know is to type your domain name into your browser's navigation bar and see whether it comes up.

4-1

When your domain is propagated, you will see a page that looks exactly like the one in Figure 4-1, and you will be ready to start making your own photo blog.

YOUR WEB HOST

If you signed up with Nexcess, you will have in your email inbox a total of four emails:

1. **Invoice:** Establishes an account for you and verifies that your order has been processed

2. **Billing:** Verifies that payment was received and will provide you with the information to log on to your billing account

3. **Account Details:** Provides you with all the information required for logging on to your site account, setting up your environment, and getting your email up and running

4. **Movable Type:** Provides you with the Movable Type interface logon and password

If you already had a domain or used another Web host, you will still need to set up your account and customize your site space. Although the exact instructions will be different, the steps will be the same and you will have received one or more emails from your new host verifying that your account is active and providing you with instructions for logging on to your administration account and setting up your site environment.

SETTING UP HOUSE

As with any Web hosting company, Nexcess sets you up with a temporary domain space until yours is propagated, and you will be able to log on

to the server and get things ready for when your new domain is ready to be used.

The first task on the agenda is setting up your site environment and becoming comfortable with your site's features. The Nexcess email labeled "Your Account Details" explains the SiteWorx Control Panel, which is the site-management software that you will use to personalize the settings on your account and set up your environment to best suit your needs. This software is already installed on the Web host and on your account, and there is nothing you need to do except to configure it to your liking.

All the emails that you receive from your new Web host, as well as those received from PayPal (if you paid using that service), should be printed and stored in a safe place in case your computer fails, your laptop is stolen, and so on. Additionally, make a folder in your email program called "Info" or "Docs" in which you can store all your password and logon

DESIGNER TIP

Most Web hosts purchase a single security certificate (a digital license) so that a user's browser can authenticate the server it is connecting to, thus allowing the exchange of secure information. As the company grows and physical servers are added, the certificate may show as invalid as it will not match the exact identification number of the server to which your data has been assigned. Consequently, when you log on to your Web host before your domain is propagated, you may encounter an "invalid security certificate" warning in your browser. It is perfectly safe to proceed; when you are logged on, you are in fact in a secure environment. Once your domain is propagated, you should not see this warning again.

information. It's very easy to collect dozens of passwords and logons and very easy to forget which one belongs to which site.

LOGGING ON

There are two links you can use to go to the SiteWorx panel from your email client — make sure that you use the one that does not include your new domain address, however. It looks like this:

```
https://lv2race.nexcess.net:2443/siteworx
```

When you arrive at the SiteWorx panel page, as shown in Figure 4-2, you will be prompted for your email address, a password, and a domain name. Be sure and type the information exactly as specified in the email you are working from, which contains this specific data in the right order you will need it. Click the login button when you are sure all the information is accurate, and you will be taken to the control panel shown in Figure 4-3, where you can manage virtually every aspect of your site's operation.

4-2

4-3

4-4

4-5

4-6

SETTING A NEW PASSWORD FOR SITEWORX

You are given a randomly generated password to log on to your account, but it will have no meaning to you and will be hard to remember; so I recommend changing the password before you do anything else on your site. The original password needs to be kept and used in order to change to a new password, so make sure you have it available.

From the main page of the SiteWorx panel, click the User Accounts link, as shown in Figure 4-4.

You are taken to a new screen (shown in Figure 4-5) that shows that the information you provided when you signed up has been placed into your user account file. You will be listed as the only "Existing User," and you will be able to see both your own name and whatever email address you used to sign up for your account.

To change your password, click Edit, as shown in Figure 4-6, and a new screen appears where you can type your new password. You will have to type it a second time to confirm that you had no typographic mistakes, and when you click Save, as shown in Figure 4-7, the system resets your password. The next time you log on to SiteWorx, you will need to use the new password that you just set, not the one in the original email from Nexcess. Take the time now to record your new password so that you will not forget it and have to email the support desk to get a new logon before you can access your own site.

SITE EMAIL

One of the best things about having your own domain is the fact that you can have your email address be your domain name and send and receive email from your own unique address. It helps people to remember your domain if you use site email, and

it's a good way to get your domain name seen by as many people as possible. The most important thing is to establish an email address for yourself and set it up so that any mail sent to your domain actually gets to you.

In keeping with my advice in Chapter 3 about choosing screen names, it is important that you choose a good email address. There are a few general conventions that will help you choose a good name for your own personal email that people will remember.

The length should be no greater than 10 characters unless you are using your first and last name, but if your domain name is long and your name is long, you increase the chance of people making mistakes when they type your address.

The first and all other characters should be lowercase letters or numbers. Although some systems may translate names to uppercase, this should always be typed in lowercase.

Punctuation marks, spaces, and other special characters and symbols should not be used.

If your domain is named eponymously, I recommend that you not use your full name in the front part of your email address as this repetition is unnecessary and can be confusing.

The best name to use is your real first name or a combination of initials in your name.

ACCESS AND SET UP YOUR PRIMARY EMAIL

Click the Site Services link on the left side menu and then click the E-mail link under it as shown in Figure 4-8. A menu appears under the E-mail link that shows all the options for managing your mailbox. Click on Mailboxes option.

On the right side of the panel, your existing mailbox information will appear as well as a form to create a new mailbox, as shown in Figure 4-9.

Type the name of the email address you want to use, type a password, and confirm the password by typing it again.

You will have a regular email address from your Internet service provider (ISP) that you will likely use with an email client program such as Outlook Express or Mozilla Thunderbird.

OTHER EMAIL ADDRESSES

There are several standard conventions that are followed in domain management, and one of them is the inclusion of a standard webmaster@yourdomainname. com email address so that people who want to contact the manager of the site or the proprietor of the domain can do so without knowing the specific person to contact. I recommend that you set up a webmaster email

4-7

4-8

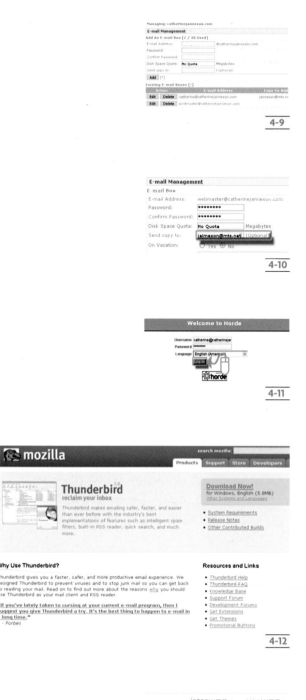

4-9

4-10

4-11

4-12

4-13

using the same process as explained earlier for setting up your personal email.

Additionally, many people like to establish specific emails for specific purposes such as feedback, information requests, dealing with a particular mailing list or recipient, or just to keep things managed. I use a system for my mail where feedback from the site goes to one address, business and professional mail to another, personal mail to a third address, and general mail to a fourth address so that, at a glance, I can tell what is in my mailbox.

Using web mail

Your Nexcess account comes with free access to a Web mail program where, by default, your domain email is sent. If you do not want to use Webmail, you should perform the preceding steps for your email to be forwarded to you so that you can manage it inside of whatever email client you currently use.

However, if you want to use Webmail, you can access the program via the same interface as above and selecting the Webmail menu option. You will be taken to the Webmail page, which uses the same logon and password that you have set for your domain, as shown in Figure 4-11.

I recommend that you use a client for your site email, such as Outlook or Outlook Express, Eudora or Eudora Light, or one of the free programs such as Mozilla's Thunderbird (www.mozilla.org/products/thunderbird/), as shown in Figure 4-12. It is easier and wiser to manage all your email from one place so that you will not lose track of your correspondence.

After you reset your password and set up your email, you are done for the moment with your site management, and it is ready to go as soon as your domain name is propagated. It is always wise to actually log out of the SiteWorx control panel (see Figure 4-13) or any other password-protected page (as opposed to just clicking on another link or opening a new site in your browser) before moving onto

the next phase, which is exploring the Movable Type interface, the place where you build your photo blog.

IF YOU ARE NOT USING NEXCESS

If you have chosen to use another MT-enabled Web host, you will either need to install all of the templates and template modules manually or inquire with your Web host as to whether it will perform a reinitialization of your Movable Type installation and install the templates for you. Along with all the necessary files, complete instructions for either installing the templates manually or having your Web host perform a reinitialization process are available on the companion site.

IF YOU ARE USING ANOTHER CONTENT-MANAGEMENT SYSTEM, A WYSIWYG, OR A TEXT EDITOR

A complete download package of all the CSS support files and basic HTML templates, without any Movable Type markup, is available on the companion site, www.createyourownphotoblog.com. These files can be used in any editor or modified to be used in any other content-management system and do not depend upon the Movable Type interface. It should be noted that items like comments, automatically generated archive and category (sets) files will no longer be automatic; each entry must be manually coded, and all of the archive and set files will need to be created manually. This option should not be used unless you are very experienced with HTML and CSS and have a good command of whatever editor you plan to use.

THE MOVABLE TYPE INTERFACE

The templates and all the instructions for using them and publishing your blog are based upon using the Movable Type interface. The base templates and all the skins can be used with any other

content-management system or from a WYSIWYG or text editor, but in this book I assume that you have signed up with Nexcess or some other Movable Type-enabled Web host. If you are using Wordpress, for example, follow the guidelines on its site for installing and using templates. If you are using a WYSIWYG or text editor, I assume that you have a sufficient level of skill and expertise to use the templates and will know how to install and modify them inside of your preferred software.

LOGGING ON TO MOVABLE TYPE

When you signed up with Nexcess, one of the things that happened is that a directory called **blog** was created on your new account. Inside of this directory are all the templates and system files you will need to get your blog up and running. You can do so within hours or even minutes, if you do not make many changes.

You log on to your MT account by going to `http://(www.yourdomain)/blog/mt.cgi`. A screen, shown in Figure 4-14, appears asking for a username and a password. One of the emails that was sent to you from Nexcess, or your other MT-enabled Web host, will have contained the default username and password required to log on to the MT interface. Keeping in mind that they are case sensitive, type them now and click Log In as shown in Figure 4-15.

MOVABLETYPE™
Publishing **Platform**

Username

Password

Remember me? ☐

Log In

Forgot your password?

4-14

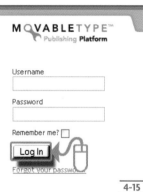

4-15

CONFIGURING YOUR NEW BLOG

You are now inside the Movable Type system. Before you do anything else inside the system, you need to configure the system settings as shown in Figures 4-16 and 4-17 so that Movable Type knows where you store your blog and will rebuild it to the correct location — this is vitally important and must be done before any changes are made to the templates.

WEBLOG AUTHORS

Under the System Shortcuts menu on the right side of the main screen, click Authors, as shown in Figure 4-16. A listing of the recognized authors of your blog appears that looks like the screen shown in Figure 4-17. Notice that the username is Melody, which is the default login (all new Movable Type users use the same login and password) and should be changed immediately to prevent anyone from logging on to your blog and making changes without your permission.

To make changes to the default user (Melody), click the Melody link under Username and you are taken to the Author Profile screen, where you can change your logon and password settings (see Figure 4-18).

USERNAME

This is the name you will use to log on to Movable Type, and you should make sure that you use a simple and easy-to-remember name. If you forget your username, you will be unable to log on to your site and no one will be able to retrieve it for you.

DISPLAY NAME

This is the name that appears in your subscription feeds; it should be your real name or the name that you choose to be identified with on the Web.

4-16

4-17

Email Address

Type the email address you selected earlier when you set up your domain email or any other valid address that you use for email.

Web Site URL

This is an optional field and is usually not necessary unless you have more than one site or URL and wish to direct people to it. By default, it is the site you are now setting up.

Language

The default and only option is US English, and at this time you cannot change it.

Passwords

You will need to type the current password (Nelson) in order to change it to something else. Select a new password and type it in the input area. Make sure that it is one you will remember and not too difficult to type. Confirm this password by typing it a second time.

Password Hint

Create a password hint and type it in the space. Hints should be cryptic so that you will get the reference but others might not. For example, if you have two children and use one's name as a password, your hint could be "not (other child's name)". A hint is used in case you forget your password and need to retrieve it from Movable Type's database.

API Password

API stands for application program interface and is the password used by other independent services such as flickr when blogging to your blog from the flickr interface. There is nothing to prevent you from using the same password for your API as you did for your own logon password, but to ensure a higher level of security (potentially people could discover

your password and login through an API interface and be able to log on to your blog), select a separate password for this field. As a general rule, you should not use default passwords for anything, as they are assigned to everyone who uses the software or service.

Click Save Changes. Your settings will be updated, and a screen like the one shown in Figure 4-19 lets you know that your settings have been changed.

It's a good idea to type your new username and password data into an email and send it to yourself so that you can always refer back to it if you forget.

Main Menu > System Overview > Authors > **Melody**

Author Profile: Melody

Edit your author profile here. If you change your username or your password updated. In other words, you will not need to re-login.

Profile

Username: Melody
The name used by this author to login.

Display Name:
The author's published name.

Email Address:
The author's email address.

4-18

Main Menu > System Overview > Authors > **Melody**

Author Profile: Melody

Edit your author profile here. If you change your username or your passw updated. In other words, you will not need to re-login.

Your profile has been updated.

Profile

Username: Melody
The name used by this author to login.

Display Name:

4-19

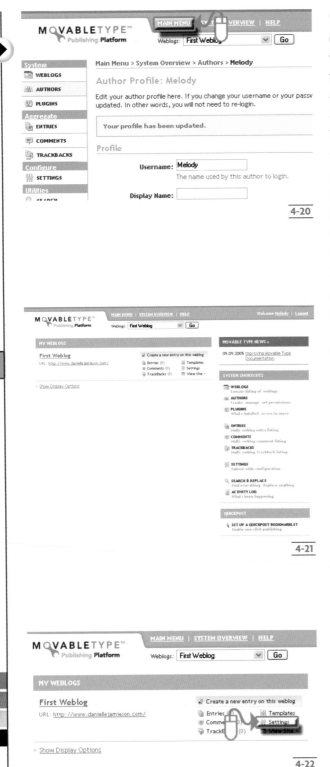

4-20

4-21

4-22

CHANGE SYSTEM SETTINGS

Click the Main Menu link on the top of the interface window as shown in Figure 4-20 and you will be taken to the Main Menu page as shown in Figure 4-21. This is the default screen for Movable Type, and whenever you log on in the future, you will see this screen layout.

This page lists all your blogs and allows you to navigate easily between them. For now, you have only the one default blog for which you will need to perform a settings configuration. To start (see Figure 4-22), click the Settings link for the default blog, which is called First Weblog. You are then taken to a page entitled General Settings - First Weblog.

At the top of this configuration page are a series of tabs labeled General Settings, New Entry Defaults, Feedback, Publishing, and Plugins. The default screen, General Settings, is the best place to start.

NAMING YOUR BLOG

The first thing to do is to change the name of your blog. In the Weblog Settings category you will see the name First Weblog, which is the name that will be displayed on the front page of your blog as well as in the browser header. To change the name, simply type the name you wish to call your blog.

You can name your blog anything you want; the name can be very long name or contain hyphens or colons. If, for example, you decide to name your blog Adventures with a Camera: Photographic Essays, the words simply wrap. However, I recommend that you limit your name to a single word or a short phrase that is easy to remember and displays neatly on your blog page.

ADDING YOUR DESCRIPTION

Chapter 10 offers advice on creating a description for your blog and instructions for adding it to the configuration. At this stage, simply leave this field blank while you continue with the rest of your setup.

TIMEZONE

Using the drop-down menu shown in Figure 4-23, select the correct time zone for the area where you live. This is important because this setting determines the time and date of your entries based on your local time. The time stamps from both your entries and comments use this data. If you are unsure of your time zone, you can visit `www.timeanddate.com/worldclock/` and find the appropriate category for your location.

All of the Default Weblog Display Settings except the excerpt length are already set properly and do not need to be changed.

EXCERPT LENGTH

This is the default number of characters that Movable Type will cull from your Entry Body field to create an excerpt. Because all of the templates use the Entry Body field for photographs and use the Excerpt field for another purpose, change this setting to **0** (see Figure 4-24).

THIRD-PARTY SERVICES

The only third party that is relevant at this stage is a Creative Commons license. Creative Commons licenses allow you to share your work on the Internet while keeping your copyright intact. Other people can copy and distribute your work provided they give you proper credit — and only under the conditions you specify in your license. Choosing the conditions you apply to your license is very important and should be considered carefully. If you want to offer your work with no conditions, you can choose a public domain license. It should be noted that a public domain license is permanent and irreversible — in other words, if you dedicate your work to the public domain (anyone can use it for any purpose whatsoever), then you cannot change your mind and take it back later.

To choose a Creative Commons license, click Create a license now in the Creative Commons License box of the Third-Party Services page, as shown in Figure 4-25 . A pop-up window appears (see Figure 4-26).

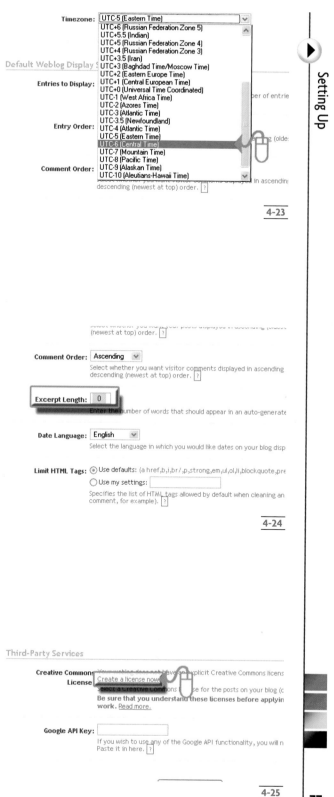

4-23

4-24

4-25

To start, I recommend that you select a noncommercial, no-derivative works license, which means that no one can use your work for any purpose without your explicit permission.

Under the "Allow commercial uses of your work" section, select the No option. Under the "Allow modifications of your work" section, select the No option.

Under the Jurisdiction of your license section, leave it set for Generic as this is the most appropriate for the Internet; however, if you want your copyright to be protected by the laws of a specific jurisdiction, select one from the drop-down menu.

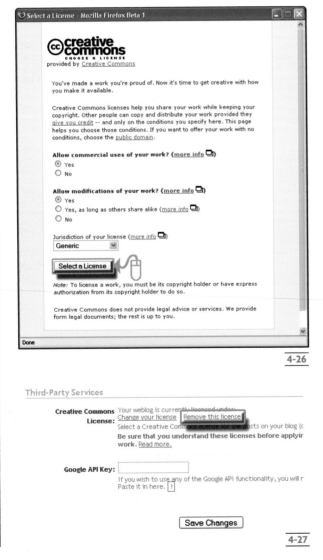

4-26

4-27

Click Select a License and you will be taken to a new screen to verify your choices. Click the You may now proceed link. The window closes and your blog settings are automatically updated. As shown in Figure 4-27, your settings now include a link to remove the license you just applied in case you change your position on licensing your work. A piece of code is inserted into the head of all your HTML documents that outlines the terms of your selected license.

You are now done with the general settings. Click the New Entry Defaults tab.

POST STATUS

I recommend that you leave this field as it has been set in the unpublished mode, which allows you to make your entry and review it in preview mode before publishing it live to your site. Once you are comfortable with your blog and want to make entries directly without a preview, you can change this setting to published.

TEXT FORMATTING

This field is set to convert line breaks so that pressing Enter at the end of a line forms a new paragraph. This option makes the typing of text in your entry much easier because you can simply type as you would in any word processor. I recommend that you leave this setting in the default position.

ACCEPT COMMENTS

The default setting for this field is yes. However, if you do not want to accept comments on your blog, deselect this radio button.

ACCEPT TRACKBACKS

Trackbacks are alerts that someone else has referenced or linked to your entry. These are meant primarily for text blogs to keep readers alerted to similar topics and further discussion on the same topic. To start, the Accept Trackbacks option should not be selected. By default, this option is selected, but the base template does not provide a way to display trackbacks because photo blogs don't generally use them. However, if you want to alter this setting

and alert your readers on trackback information, instructions for adding it to the template are included on the companion site.

BASENAME LENGTH

The basename length is the number of characters in an automatically generated basename (the name that Movable Type gives to your entries when it stores them in the database). The length can range from 15 to 250 characters. It is set at 30 characters, and unless you envision titles that are longer than 30 characters, the default should be fine.

PUBLICITY/REMOTE INTERFACES

Information about pinging, which is what this section covers, is contained in Chapter 10 along with instructions for setting up the Movable Type interface to ping automatically when you update. At this time, when you are setting up your new blog and have not yet made any entries or set up the auxiliary pages, I recommend strongly that you do not activate any of the automatic pinging and notification options in Movable Type. The reason for this is simply that the first impression you make to your potential audience should not be the initial test entries you make to your blog. Additionally, most pinging services have a limit to the number of pings they will accept within a given time frame from a site, and if you are setting up your blog, you will exceed this limitation and your pings will be denied.

You are now done with the New Entry Defaults. Click the Feedback tab.

FEEDBACK

This section allows you to set the parameters of comments to your blog. Comments can be a tricky business on blogs. Spam, an electronic form of junk mail, is often sent through comment input areas and can seriously cripple your ability to administer feedback from serious commenters. Movable Type has many built-in systems that help guard against spam, but it is still a concern, and I strongly suggest that you adhere to the setting suggestions that follow.

ACCEPT COMMENTS FROM

I highly recommend that you select the Anyone option because this allows you to accept comments from any viewer and still allows you a great deal of control and protection from spam and other comment abusers if you follow the steps in the next section.

AUTHENTICATION STATUS

Authentication is a service offered by a third party (or in this case TypeKey, which is another division of Movable Type) that allows you to make sure that the comments you receive are from real people with real email addresses before they can post comments to your blog.

By default, Authentication is not enabled on new installations; so if you want to use an authentication service (recommended), click Setup Authentication, as shown in Figure 4-28, and you will be taken to another screen that looks like the one shown in Figure 4-29.

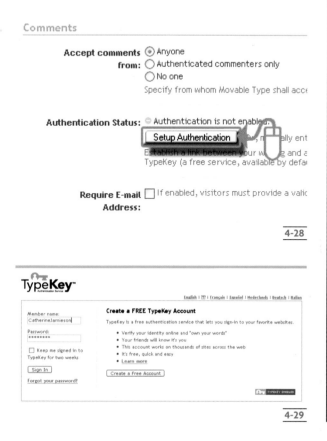

4-28

4-29

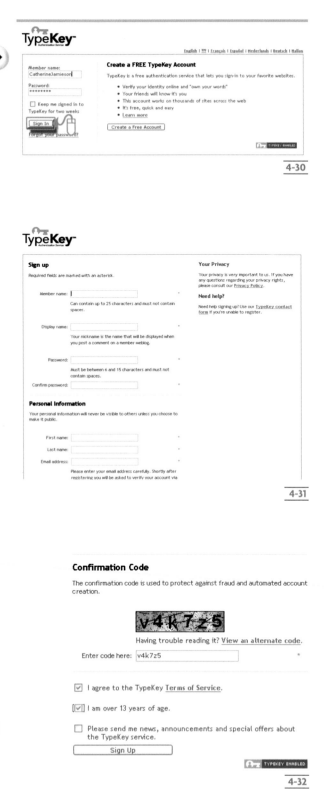

4-30

4-31

Confirmation Code

The confirmation code is used to protect against fraud and automated account creation.

Having trouble reading it? <u>View an alternate code.</u>

Enter code here: v4k7z5 *

☑ I agree to the TypeKey <u>Terms of Service</u>.

[☑] I am over 13 years of age.

☐ Please send me news, announcements and special offers about the TypeKey service.

Sign Up

4-32

USING TYPEKEY

Using TypeKey on your blog actually requires you to initiate two separate TypeKey actions. You must create an account for yourself and then you must connect that account with your blog.

If you already have a TypeKey account, then you can type the required information on the left half of the screen as shown in Figure 4-30. Type your Member name and Password in the appropriate places, click Sign In, and you are logged on to TypeKey.

If you do not have a TypeKey account, you need to create one.

CREATING A NEW TYPEKEY ACCOUNT

Click Create a Free Account. A screen like the one shown in Figure 4-31 appears. Type the required information in the input boxes; take special care with the email address as you will need to respond to an email that TypeKey sends to that address to activate your account.

At the bottom of the page there is the Confirmation Code section, which contains a graphic similar to the one shown in Figure 4-32. TypeKey uses a program to produce a unique graphic image as a confirmation code to reduce the ability of spam robots to sign up for accounts. This code cannot be read by a program, and you will need to study it carefully and type the letters and numbers that the graphic represents. In the case of the example, the code is **v4k7z5**. You do not have to worry about case sensitivity (all lowercase is fine). If the code is unclear to you, simply click the View an alternate code link and a new graphic appears that you might be able to more easily decipher.

Select the options below the confirmation code to verify that you have read the Terms of Service and that you are over the age of 13. Click Sign Up, and you will be taken to a screen that looks like the one shown in Figure 4-33. Do not close this browser window.

Before you can continue, you need to check your email box for the verification email that TypeKey sent as soon as you clicked Sign Up. It will look like the one shown in Figure 4-34 and will have the title Activate Your TypeKey Account.

There are several ways to activate your account, but because you left the browser window open, highlight the activation code and copy it to the clipboard by right-clicking and choosing Copy. Go back to the browser window with the TypeKey screen shown in Figure 4-33 and paste the activation code into the input box as indicated. Click Continue.

EDITING YOUR TYPEKEY PROFILE

You will be at a screen now that looks like the one shown in Figure 4-35. Click Edit Your Profile. You will be taken to a screen with two tabs as shown in Figure 4-36. The active tab will be called Your TypeKey Profile Page. Fill out as much or as little of the profile as you wish to be seen by the public and click on the Save Changes link button.

Next, click the Account Preferences tab. In the top section — Your Account Information — type all of the information requested, including the Password Recovery field. If you forget your password, the easiest way to recover it is with your own hint.

In the next section — Your Commenter Preferences — you can select a screen or nickname that appears when you leave comments on other TypePad-enabled blogs, or you can use the name you entered in your TypeKey Profile. If you want to use a nickname, be sure that the radio button on the left is selected and type the nickname you want to use. Otherwise, select the radio button on the right and your profile name will be used.

The next option, whether to send your email address to the blog on which you are commenting, should be selected because many blogs (including your own if you follow my instructions) will not accept comments unless you do.

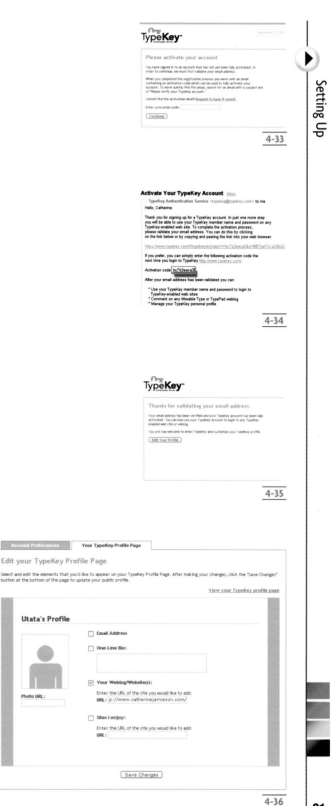

4-33

4-34

4-35

4-36

YOUR WEBLOG PREFERENCES

Your TypeKey token: f4lgi5ZLdKVr3U6xnlhg

http://www.catherinejamieson.com/

4-37

TypeKey™
Authentication Service

September 15, 20

| Account Preferences | Your TypeKey Profile Page |

You have set up TypeKey comment registration for the following Movable Type installation:

http://www.catherinejamieson.com/newblog/mt.cgi

using the following TypeKey account:

Utata

You must now <u>return to Movable Type</u> to complete the handshake.

4-38

Comments

Accept comments ○ Anyone
from: ⊙ Authenticated commenters only
○ No one
Specify from whom Movable Type shall accept comments on this we

Authentication Status: ☑ Authentication is enabled. [Clear Authentication Token]
Authentication Token: f4lgi5ZLdKVr3U6xnlhg
Establish a link between your weblog and an authentication servic
TypeKey (a free service, available by default) or another compatit

Require E-mail ☐ If enabled, visitors must provide a valid e-mail address when cc
Address:

Immediately publish ○ No one
comments from: ⊙ Trusted commenters only
○ Any authenticated commenters
○ Anyone

4-39

In the next section — Your Weblog Preferences — you will need to do two things:

1. Type the URL of your blog into the first input box, as shown in Figure 4-37. It must be the full URL and look like this: `http://www.YOURBLOG/.com/`. For example, my blog would be `http://www.catherinejamieson.com/`. You do not need to specify the index.html extension.

2. As shown on Figure 4-37, highlight the token code beside the words Your TypeKey token, right-click your mouse, and choose Copy.

Click Save Changes and a page will appear similar to that shown in Figure 4-38, which indicates that your blog has been set up and that you must return to Movable Type to complete the process. When you click the link indicated, you are returned to your blog and the setup page should appear, as shown in Figure 4-39, with your new token automatically placed in the field.

However, sometimes network problems cause a timeout with the handshake, and you will need to type your token manually. If your page does not appear as shown in Figure 4-39, simply paste the token into the space indicated and go to the bottom of the page and click Save Changes. This saves your work and ensures that the token is properly in place before continuing with your blog setup.

Although the top of the setup page indicates that you should rebuild your indexes now, ignore that until the rest of the setup is completed. Continue from the Authentication Status field.

REQUIRE EMAIL ADDRESS

Another way to protect yourself against mail and comment spam is to require an email address from commenters. I recommend that you select the Require E-mail Address option.

IMMEDIATELY PUBLISH COMMENTS FROM

If you have decided to use the TypeKey authentication service and have required an email, it still pays to ensure that you have eliminated all potential problems with comments. In this area you can choose which comments will be published as soon as the viewer leaves them and which comments you must approve.

Your options are:

> No one

> Trusted commenters only

> Any authenticated commenters

> Anyone

The Trusted commenters only option means any commenters that you have designated as trusted (which you can do from the comment screen, once someone has left a comment) as well as any that are authenticated (an authenticated commenter automatically becomes a trusted one). I recommend that you select the Trusted commenters only option.

EMAIL

You can have Movable Type send you an email when comments are made to your site in one of two ways. You can select On, which means that Movable Type will email you whenever a comment is made, or you can select Only When Attention Is Required, which means that Movable Type notifies you of a comment only if you have to approve that comment (if it is not from either a trusted or an authenticated commenter).

ALLOW HTML

By allowing HTML, your commenters can add links or other HTML formatting to their comments (bold, italic, and block quote). Movable Type performs a process called "sanitize" on all posted comments that strips them of any inappropriate HTML. I recommend that you select the option to allow HTML.

AUTO LINK URLS

When a URL is typed into a comment window, it is simply a piece of text containing a Web address. In order for Movable Type to convert this text to a hyperlink that people can click, select the check box.

TEXT FORMATTING

The default for this option is Convert Line Breaks and should not be changed. This option allows commenters to type paragraph text by just typing and pressing Enter to separate paragraphs, much like you would do when typing text in a word processor. Movable Type places all text between these breaks inside <p> (begin paragraph) and </p> (end paragraph) tags.

TRACKBACKS

Trackbacks are set by default to be accepted. Because trackbacks are fairly complex and are not generally used in photo blogs, I recommend that you deselect the Trackbacks option.

JUNK

Movable Type uses a system of rating incoming feedback (comments and trackbacks) on a scale of -10 to +10. The default settings for all items in this category should be left as they are unless you find that you are receiving spam or junk in your comments, in which case you can increase the filter to be more aggressive by increasing the Junk Score Threshold.

You are now done with the Feedback tab. Click the Publishing tab.

Site URL

This is the resolved location that simply means whatever address is typed into a browser to view your page. The templates work on the basis that your blog will be in your root directory. If your site URL is, for example, http://www.mysite.com, then this field should be typed as follows: **http://www.mysite.com**. Movable Type works so that the default location to publish your blog is the same directory as the location of the configuration files, so there will be a "/blog" that you should remove.

Site Root

The site root is the URL that your Web host has used to store your files on its servers and is typically either home or html or even public_html. This field will be filled in automatically by the system and will look something like this:

/home/catheril/catherinejamieson.com/
html/blog

You will be publishing to the root directory, so you need to remove the "/blog" from the Site Root address. This ensures that your default index.html file will exist in the main root and will be automatically loaded anytime anyone comes to your domain.

4-40

Advanced Archive Publishing

To begin with, you should not need to fill in anything in this field as your archives will be published to the directory indicated by your templates, which is called /archives. At some future point, when you have a lot of archived entries, you may want to publish them to a separate directory, perhaps one for each year, but you do not need to deal with this issue now.

Preferred Archive Type

The default for this field is individual archive, which is both the standard and the one that is required for your templates to work properly. This means that when your Next and Previous links are clicked, the viewer sees the next or the previous entry and not the next or previous month. Individual archives are stored in chronological (date) order. Do not change the default of this field.

File Extension For Archive Files

The default for this field is .html, which is also the Web standard. It is not recommended that you alter this field.

Dynamic Publishing

Dynamic publishing is a system offered by Movable Type for the advanced user who is keeping a complex site that uses several design templates and contains a lot of data. At this time you do not need to alter the default settings for this option.

Archive Mapping

For the short term it is best to leave the default settings in these fields as all of the templates assume these default settings, and you will have to make changes to them if you change the archive mapping settings.

Click Save Changes at the bottom of the page, and a notice appears at the top, as shown in Figure 4-40, that you should rebuild your site.

REBUILDING YOUR SITE

When you click the rebuild button or link from any of the Movable Type screens, a small pop-up window appears as shown in Figure 4-41. Click Rebuild and your site will be rebuilt. Rebuilding, in Movable Type terms, means to process all data on your site against your new settings and/or your new entries. This ensures that all your data will appear properly, all of your links will work correctly, and your design changes will be implemented. It is usually very important to rebuild when prompted to do so. When the site is rebuilt, close the pop-up window.

Your blog will now function the way it should and will store and archive entries according to your instructions.

CHOOSING A BLOG MODEL

When default templates are installed on a Movable Type system, they work on every new blog you create. The templates are set up so that all the necessary files and modules for all four models and styles are included in your template installation, and you can choose to make one blog in each style, if you wish, as all the files you will need are included. Every model performs the following functions:

> Automatically archives images by date and category

> Creates a customizable 404 (error) page, a links and about page

> Allows you to enter images and/or text

> Allows you to provide data to link back to a source file such as to your flickr stream

> Allows you to accept or not accept comments

There are four (4) models from which you can choose. Your primary choices are whether to have a one-at-a-time style or a blog style, and within those two options, whether you want to use a banner or not. Bear in mind when reading the following descriptions and choosing which style you use, that each of these templates can be easily customized in both function and appearance, that skins can be applied, and that even which side the menu is on can be changed. Choose the functional style that is closest to your needs.

DEFAULT STYLE

The default style shown in Figure 4-42 is a one-at-a-time style (one large image is shown on each entry) with a left-side menu and a top navigation menu. If you do nothing else and simply sign up with Nexcess and prepare your Movable Type environment as indicated thus far, your blog will be set up and ready to use in the following style:

> The content area adjusts in height to accommodate the image but does not adjust in width. Images larger than the content area (700 pixels wide) are made smaller to fit the content area.

> If you add text, it is formatted and displayed below the image. If you add no image, the text is formatted and displayed where the image would normally be.

4-41

PHOTO BLOG

First Weblog

Test Entry
Sep 26 2005

ABOUT
LINKS
SETS
ARCHIVE

COMMENTS(0) PERMA# ALIKE

4-42

WEB RESOURCE

To see an example of the styles available with the included templates, please visit the companion site at http://www.createyourownphotoblog.com/.

BLOG STYLE

The blog style in Figure 4-43 shows the last five entries, stacked vertically, with any text entered available through a link under the image. It is recommended for anyone who posts primarily photographs and wants a viewer to see several images on one page or for anyone who wants to keep a lot of side-bar content on the front page of his or her blog.

> The content area adjusts in height to accommodate all the images but does not adjust in width. Images wider than 700 pixels are made smaller in size to fit in the content area.

> If entries have text, it is stored on the individual entry archive (perma#) with a link to that page on the main page.

> The sidebar is as long as the content area, and once you have five or more entries, you can fit a lot of material such as links and feeds in your sidebar.

BANNER STYLES

The banner style and the banner blog style as shown in Figure 4-44 are the same as the previous two styles except that each contains an 80-pixel-high banner on top where you can add your own customized graphic banner. Other than the addition of a banner and a few design changes to accommodate this, they operate in the same way as the styles previously described. To see an example of these styles in use, go to `http://www.createyourownphotoblog.com/examples/styles/banner` and `http://www.createyourownphotoblog/examples/styles/bannerblog`.

CONFIGURING YOUR BLOG STYLE

The templates are set up so that you can easily change not only the appearance and design of your blog but its style as well. The default template can be easily changed from the default state to

> Operate as a blog style, which simply means that more than one photograph/entry is shown on the front page

4-43

First Weblog

Test Entry
Sep 26 2005

ABOUT
LINKS
SETS
ARCHIVE

COMMENTS(0) PERMA• ALIKE

4-44

> Accept a banner, an 80-pixel-high area where you can store a graphic image to decorate or define your blog

> Operate with a right-side menu instead of the default left-side menu.

To make your default, one-at-a-time style into a blog style so that more than one entry is shown on the index page, perform the following steps:

1. Select the templates link on the left menu inside the MT Interface.

2. Select the index template titled default main index, which outputs to the file called index.html, and open this file by clicking it.

3. Towards the bottom of the document is a line of code that reads
 `<$MTInclude module="singlestyle"$>`.

4. Replace that line of code with `<$MTInclude module="blogstyle"$>`.

5. Click on the Save and Rebuild button link, and your blog is now a blog-style and will show five (5) entries on one page.

6. Make the same change to the archive template by clicking the Archives tab of the Templates page as shown in Figure 4-45 and opening the file called Individual Entry Archive.

To add a top banner to your default, one-at-a-time, or blog-style blog, perform the following steps:

1. Select the TEMPLATES link on the left menu inside the MT Interface.

2. From the top tabs of the templates interface select Modules.

3. Open the module file called banner.

4. Select all of the code (press Ctrl+A) in the file and copy it (press Ctrl+C) to the clipboard.

5. Click on the Indexes tab on top of the templates page.

6. Open the file called Skin, which outputs to css/skin.css.

7. Paste the copied code (press Ctrl+V) at the top of the skin.css file between the comment lines:

```
/ * --Add Banner Styling Code Here-- * /

/ * --End Banner Styling Code ------- * /
```

(See Figure 4-46.)

8. Click on the Save and Rebuild button link, and your blog now has a banner (see Figure 4-47).

There is one other major change that will affect the appearance but not the function of your blog, and this is whether you want a left- or a right-side menu. The default is to have a left-side menu because this is the print publishing standard and the one that is generally the most comfortable for people to use, but many people prefer a right-side menu. To make your blog into a right-side menu, perform the following steps:

1. Click the TEMPLATES link on the left menu inside the MT Interface.

2. From the top tabs of the templates interface, select Modules.

3. Open the module file called rightmenu.

4. Select all of the code (press Ctrl+A) in the file and copy (press Ctrl+C) it to the clipboard.

5. Click on the Indexes tab on top of the templates page.

6. Open the file called skin, which outputs to css /skin.css.

7. Paste the copied code (press Ctrl+V) at the bottom of the skin.css file, as indicated by the following comment lines:

```
/ * --Add Right Side Menu Code Here-- * /
/ * --End Right Side Styling Code ------ * /
```

8. Save and rebuild the file.

Your blog now has a right-side instead of a left-side menu (see Figure 4-48).

4-45

4-46

4-47

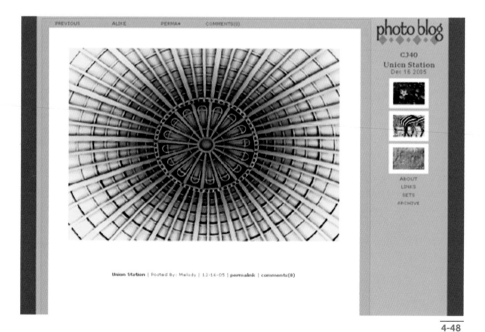

4-48

ADDING CONTENT

Chapter 5 explains the templates and how the files work together, along with ways to customize and personalize your design. However, to familiarize you with the workings of your new site, the first thing to do is to add a test entry. This entry can be deleted later, but in order for all of the parts of your blog to appear, an entry must be present.

ADDING A TEST ENTRY

In the Movable Type interface, there are small question mark (?) links beside the titles of most fields where you enter data, as shown in Figure 4-49. If you click this link, you will be shown context-sensitive help, as shown in Figure 4-50, which will help you when you have a question.

To make a new entry, click the New Entry link from the left side of your Movable Type window, as shown in Figure 4-51. The standard entry screen, shown in Figure 4-52, appears, and you are ready to start your test entry.

ENTRY TITLE

The entry title is important for several reasons, most notably because this is the title that appears in your rss/subscription feeds and is also used, in part, to name the entry in the database. In other words, whatever you type here is seen by the general public and so should be descriptive, be spelled properly, and employ the use of standard publishing conventions (capital letters, primarily). You will find that a descriptive title yields the best results from search engines and blog searches, and your traffic will increase if your titles spark interest in potential viewers.

Type the title in the Title area and click in the Entry Body area.

PRIMARY CATEGORY

For the test entry, we are not going use a category, so you do not need to select a category to enter in this field; move directly to the Entry Body area.

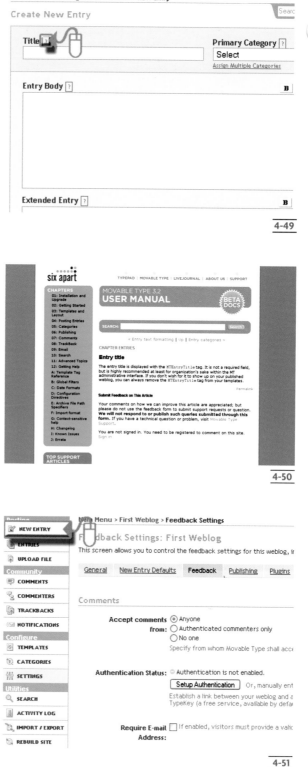

4-49

4-50

4-51

Setting Up

4-52

4-53

4-54

ENTRY BODY

The templates are designed specifically for a photo blog, so they presume that there will always be a photograph with each entry. Although you can make entries with no photographs, if there is no photograph in your entry, you must leave the Entry Body field blank.

In this case, you are using a photograph that can now be entered in the Entry Body field.

USING A PHOTOGRAPH FROM YOUR COMPUTER

If you are using a photograph that you have stored on your hard drive, you need to upload it to your host server account before it can be used in the entry.

To do this, perform the following steps:

1. Click Upload File on the left menu, and a window appears as shown in Figure 4-53.

2. Click Browse to find the file on your computer. A pop-up window showing your computer's file system appears. When you locate the directory where your photograph is stored, click the file you want to use and press Enter or click Open.

3. In the Choose a Destination section, you are prompted to select a location to store this file. It is a good idea to create a separate directory for your uploaded images. If you do not specify a directory, all files are uploaded to the root/main directory, and this can create a very disorganized and hard-to-maintain site. Therefore, in this input box, I recommend that you specify a directory now where you will always store your image files. To do this, type the name of the new directory followed by a forward slash (/). For example, as shown in Figure 4-54, if I want to create a directory called images and store my photograph in it, I type **images/** in the input box. Once

you specify where you want to store your photograph, click Upload.

4. Another pop-up window appears, as shown in Figure 4-55, which tells you the size of the file and provides two options for what happens next. You have already started a new entry, so select the Show me the HTML radio button. For this test entry you do not need to create a thumbnail, so leave this option deselected and click Embedded Image.

5. A new screen, shown in Figure 4-56, appears that contains the HTML code that identifies the URL of the image. Click and drag with your mouse to highlight the entire block of code inside the window, and right-click and select Copy from the options menu shown in Figure 4-57. Click Close, and the window disappears.

6. In the Create New Entry screen, click in the Entry Body field, right click, and select Paste from the options menu.

7. The code you paste will look something like this:

```
<img alt="0509-09.jpg"
src="http://www.yoururl.com/images/
uploadedimage.jpg" width="700"
height="521" />.
```

Using this code as an example, you would delete the highlighted portions:

**

and be left with a URL that looks like this:
http://www.yoururl.com/images/uploadedimage.jpg

Please note that the quotation marks are also removed.

4-55

4-56

4-57

USING A PHOTOGRAPH FROM FLICKR

To use a photograph from flickr, follow these steps:

1. Open a new browser window and find the image in your photo stream that you want to blog; click the All Sizes link as shown in Figure 4-58.

2. Select the size you want to blog (remembering that any image wider than 700 pixels is adjusted in size to be 700 pixels wide in your blog) by clicking one of the size links along the top of the image. If your image is larger than 700 pixels wide, I recommend using the "large" or "d" size as this is 500 pixels wide, which is a good sized blog image.

3. Scroll down to the code boxes under the image and highlight the URL in the Grab The Photo's URL code box; using your mouse and right-clicking, select Copy from the options menu.

4. Go back to the MT Entry screen and paste the code into the Entry Body field by right-clicking your mouse and selecting Paste from the options menu.

 You do not need to add anything to the Extended Entry for this test entry and should now scroll to the bottom of the page to the Post Status. Select Published from the drop-down menu as shown in Figure 4-59.

 Click Save, and your entry is saved and published to your photo blog.

VIEWING YOUR TEST ENTRY

As shown in Figure 4-60, click View Site at the top of the MT entry screen to see your test entry and how your photographs will look when published to your new blog.

DESIGNER TIP

Your photograph will not appear on your photo blog unless you take away all of the extra coding that MT adds to uploaded images. Because your blog is especially designed to accommodate photographs and display them to best advantage, it only wants to know the base URL of the image and adds all of the styling instructions itself. You must delete from the entry code everything except the actual URL.

The only reason that your photograph would not appear would be if you typed the wrong URL or typed a URL with any HTML code in it. If your entry does not appear, check that the proper URL has been used and that it does not contain any HTML code.

The only reason that your photograph thumbnails would not appear is if you did not specify a default excerpt length of "0" in the set up process described in "Configuring Your Blog./Excerpt Length," earlier in this chapter. If your thumbnails do not appear, verify that you have a 0 (zero) default excerpt length in your Movable Type blog settings.

4-60

THE WORKBENCH: INSIDE YOUR BLOG

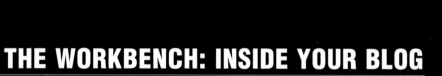

The image shows a browser window with a photo blog. Menu bar: Edit View Go Bookmarks Tools Help. Header text within the image includes "photo blog", "COMMENTS(0)", "PERMA*", "ALIKE", "PREVIOUS", "NEXT", "Samples", "Mother's Day Flowers", "Jun 02 2005", "ABOUT", "LINKS", "SETS", "ARCHIVE".

5-1

The tools available to today's blogger are both powerful and easy to use. Among the most versatile and powerful creations of those tools are templates.

As part of this book's purchase, you are entitled to the free and unlimited use of a set of templates that I designed especially for blogs. If you signed up with Nexcess, the templates are pre-installed on your server, ready to use. If you are using another system or Web host, they are available from the companion site as a downloadable self-extracting archive file.

Even if you are designing from scratch in Notepad or using a WYSIWYG editor, you will use some form of template that uses repeated code to ensure uniformity across your Web pages.

For ease of explanation and consistency in illustration, most of the examples and figures show the default style and default skin (see Figure 5-1), but many of the other skins present an entirely different look and feel. I urge you to review all of the skins at the companion site, www.createyourownphotoblog.com.

USING TEMPLATES

A template is simply a pattern that a browser follows when displaying a Web page. This pattern is created with three types of elements:

> **Style or design information.** This information is delivered by way of cascading style sheet or CSS files.

> **Data placeholder information.** In the case of the included templates, it comes in the form of Movable Type tags, but could be used for data you enter manually or via any other content-management system's tags.

> **Presentation information.** These are HTML pages that combine the styling and data information.

The CSS tells the HTML code how each element should look — what color and size it should be, whether it has a border or padding or a margin, and so on — and the MT tags tell the HTML code what data to put into each element. The HTML then displays the data provided in the style and format indicated, and your viewers see what you want them to see in exactly the style that you want them to see it.

The number of files installed with the included default template set is fairly extensive, and you can find a complete breakdown of them on the companion Web site. Files installed include the CSS files, the HTML template files, the MT module files, and the graphics for each of the installed skins. This chapter discusses primarily the CSS files as they contain the "design" in terms of how things look.

THE TEMPLATE CSS FILES

The included templates work with the two CSS files called photoblog.css and skin.css. Two files are used so that the basic "engine" of your blog remains

DESIGNER TIP

When creating a site design using CSS, I strongly recommend that the use of two CSS files be employed: one to create all the base functionality of your design, the dimensions of the blog area, and how photographs are managed, for example; and another to indicate colors, link behavior, and other "decorating" items. Without risking the integrity of your main file and ensuring that your blog will still *work* properly, you can be daring and experimental with design ideas. You can create, in this way, as many of your own skins as you like.

X-REF

Skins are covered more fully in Chapter 6, and all of the 10 installed skin.css files are covered in great detail on the companion site.

constant and functional while you are able to change the appearance by applying design changes through the skin file.

PHOTOBLOG.CSS

Photoblog.css is the most important file in the template package. It defines all the major elements so that the HTML recognizes them and establishes how they generally look and work. Every skin and individual template works with the photoblog.css master file. It is stored with the skin file in a directory called CSS that is directly off the main directory. For example, on my site, the photoblog.css is contained in the folder `www.catherinejamieson.com/css/photoblog.css`. It will be in the same path (`http://YOURURL/css/photoblog.css`) on your site.

The photoblog.css file establishes the default size, position, and action of the elements that make up your page. These elements include the entry title, the photograph, and the links.

SKIN.CSS

The skin.css file provides the colors and actions of the already defined elements so that you can change the face or appearance of your blog without upsetting any of the data or the basic way it functions and is organized. You may be familiar with skins if you use the Firefox browser; you can apply any number of design skins to Firefox without changing the way the browser operates.

GETTING YOUR DESIGN TO THE BROWSER

The `<head>` section of an HTML document contains a series of commands and other information that the page uses to communicate with the browser.

Among the information in the head of the HTML template pages is the location of the CSS or styling file(s).

```
<head>
...
<link rel="stylesheet "
href="<$MTBlogURL$>css/photoblog.css"
type="text/css" / >
< link rel =" stylesheet " href = " <
$ MTBlogURL $ > css / skin.css "
type=" text/css " / >
...
</head>
```

The HTML document loads up the file photoblog.css first, reads all of the definition information, and then loads up the skin.css file and reads all of that information. The HTML page uses the last instruction it reads as the valid one. If the default background color, for example, is defined as #FFFFFF (white) in the first CSS file but is redefined as #000000 (black) in the second, the page loads as black.

CREATING BLOG ELEMENTS IN CSS

Templates work by defining page elements in the CSS and then using them in the HTML. For example, in the primary CSS file called photoblog.css, there is an element that defines the area of the screen that is set aside to display your blog design, like a chalk pattern outline. It is called blogstylearea and is defined as follows:

```
#blogstylearea{
position: absolute;
top: 0px;
width:930px;
left: 30px;
margin-bottom: 30px;
overflow: hidden;
}
```

The HTML document (Web page) will translate this code as follows: Position this element exactly as indicated, regardless of whatever else might be there (position: absolute). With no top margin (top: 0px;) and 30 pixels from the left edge of the screen (left: 30px;) create an element that is 930 pixels wide (width: 930px;). If anything put into this area is bigger than it, don't show the excess (overflow: hidden;). As no height is given, the element reverts to its default behavior, which is "as long as it needs to be," so the element increases or decreases in height, depending upon what you put into it. Finally, leave a 30-pixel margin on the bottom so that the element does not butt up against the viewer's status bar (margin-bottom: 30px;).

In the skin file skin.css, that same element (blogstylearea) is then given its style:

```
#blogstylearea{
background-image:
url(../skins/default/blogskin.jpg);
background-position: top right;
background-repeat: repeat;
border: 1px solid #686C7E;
border-bottom: 20px solid #686C7E;
border-top:0px;
}
```

5-2

Translation: Load the background image as indicated (`background-image: url(../skins/ blogskin.jpg);`) in the top right (`background-position: top right;`) and repeat as many times as necessary to fill the element (`background-repeat: repeat;`). Give it a solid border of color #686C7E (`border: 1px solid #686C7E;`) but make the bottom border 20 pixels thick (`border-bottom: 20px solid #686C7E;`) and leave off the top border (`border-top:0px;`).

Inside the HTML page, this element is represented as follows:

```
<div id="blogstylearea">
 (additional HTML code)
</div>
```

If you load a page with only that code, the code generates a blank `blogstylearea` that looks like the image shown in Figure 5-2.

CONTAINER ELEMENTS

The element in the previous example is what is known as a container, as it is intended to be used to store all the elements that will make up your basic page. All the templates work with the same

5-3

5-4

┃DESIGNER TIP┃

The best way to allow a CSS element to stretch according to the items it contains is to give it no height and no width instructions at all or to give it the instruction "auto" for each of these items. It will become as wide and as long as it needs to become to fill whatever container or area it is within. As a rule, it makes a more pleasing design to have adjustable heights and fixed widths with centered data.

primary container element (`blogstylearea`) into which other page elements such as the menu and the content area are loaded.

A container such as this, with a fixed width and positioning, will hold everything you put between the `<div id="blogstylearea">` and `</div>` tags. What does not fit in width is usually truncated, which means that the overflow is not displayed but will be hidden from view. In the included templates, all of the elements, including the image, are always adjusted to fit inside the width of this main container. Content that does not fit in height causes the container to grow vertically to accommodate the content. In Figure 5-3, the top container has stretched vertically to accommodate a taller, portrait-oriented image, whereas the bottom one contains a photo that fits into the container without causing it to stretch. The blog page basically wraps around your image so that it is always the right size.

DEFINING THE THREE MAJOR DATA ELEMENTS

A data element is one into which you put data such as a photograph, a link, or text. Virtually every blog, whether you are using the supplied templates or not, will employ the same basic structure and will need:

> A place to put photographs and text

> A place to put a basic navigational menu

> A place to store all the other links, buttons, affiliations, archive listings, and information that make up a personal blog

These are the three primary data elements that make up your photoblog's design and are represented, respectively, by the CSS elements called —`#content`, `#navmenu`, and `#sidebar`. Figure 5-4 shows the placement of each one.

If designing your own blog, I recommend that you stick closely to this standard format as most content-management systems offer some variation of this

layout as their default setup. If you ever want to port your site to a system, it will be easier if they have the same general types of data elements.

DISPLAYING A CONTENT AREA WITH #CONTENT

The #content area is another container element and, as the name implies, holds your content. Generally this will be a photograph, but it could also be text. The content area drives your blog in the sense that the other elements' size and position are relative to the #content element.

The CSS code that generates the #content area is as follows:

```
#content{
position: relative;
width:702px;
top: 14px;
left: 194px;
margin: 0px 0px 12px 0px;
padding: 1px;
text-align: center;
overflow: hidden;
min-height: 500px;
height:expression(
    this.scrollHeight < 500? "500px" :
"auto" );
}
```

This code lets the system know that the content area does not go into any specific place but depends upon the element that comes before it for where it is positioned (position: relative;). It is always 702 pixels wide (width:702px;). To accommodate the #sidebar and a margin, it places itself 194 pixels from the left side (left: 194px;) and pads itself with 1 pixel of empty space (padding: 1px;). By default, text and images are center aligned (text-align: center).

The min-height and height:expression definitions require a special note as they seem to be redundant pieces of code. The two most-used Windows browsers are Microsoft's Internet Explorer and Mozilla's Firefox. Although they handle 99 percent of coded instructions in exactly the same way, they handle certain things like height and width instructions (as well as padding and some display properties) quite differently. In brief, Internet Explorer does not recognize or act upon the min-height command, and Mozilla browsers do not respond to the height: expression command. To have the blog look and act the same way in both browsers you must sometimes perform a little redundant coding.

The first command (min-height) is straightforward enough: Make this element a minimum height of 500 pixels. The second (height:expressionscroll Height < 500? "500px" : "auto");) is a little more complex in structure but performs the exact same function. Basically it means: Is this element at least 500 pixels in height? If it is not, make it 500 pixels. If it is longer already, make it "auto" height, which means "as long as it needs to be." This same type of code is also used inside the content area for images to force them to a width equal to 700 pixels if they are wider than that. See the Entry Body section that follows for this code.

DISPLAYING A MENU WITH #NAVMENU

The #navmenu element holds the top menu items. It is a container element, meaning that other elements, in this case, menu links, fit inside it.

The code for the #navmenu is as follows:

```
#navmenu{
position: relative;
top:12px;
left: 196px;
width: 702px;
overflow:hidden;
display: block;
text-align: center;
}
```

The #navmenu positions itself 12 pixels from the bottom of the previous element (top: 12px;), 196 pixels from the left (left: 196px;), and is 702 pixels wide (width: 702px;); anything that does not fit in width is hidden from view (overflow: hidden;), and the entire element is displayed on a new line, regardless of whether it is full or empty (display: block;). By default, text is center aligned (text-align: center:;).

CREATING MENUS AND LINKS

One of the most critical aspects of a good Web site is the way in which you set up your navigational links. The supplied templates allow you to use one or both of two distinctive menu systems.

As discussed previously, the #sidebar and #navmenu are both container elements that can hold other things. Notably, they can both hold navigational links.

All main/navigational links in the templates are created with a CSS class called .menuitem. CSS allows you to define a base element and then provide an alternate styling for it by redefining it in case it is used inside of another element. This allows you to use your basic elements many times in many situations with small changes so that they are most appealing in the context of the place they are being used.

As an example, the .menuitem definition is first seen this way in the photoblog.css file:

```
a.menuitem:link, a.menuitem:visited,
a.menuitem:active{
```

```
height: 6px;

text-align:center;

display:block;

padding: 2px 20px 10px 20px;

margin: 0px;

font:9px Trebuchet, Verdana,
Helvetica, sans-serif;

text-transform: uppercase;

letter-spacing: 0px;

overflow: hidden;

}
```

This code defines a link that is 6 pixels high (height: 6px;), is as wide as its container (no width specified but a display: block; command given). The element will pad itself with blank space (padding: 2px 20px 10px 20px;), measured in pixels and starting at the top and continuing on in a clockwise pattern (top, right, bottom, left).

Among other things, this element turns itself into capital letters (text-transform: uppercase;) and displays the actual text in the center of the block or container. Links in the #sidebar are displayed in this style. Because the #sidebar is 176 pixels wide, so will the menuitems be that you put into it.

A little further down the photoblog.css file, you find two compound definitions for these same elements. In order to control even very minute aspects of design, one or more CSS definitions can be added to another to create a compound that alters the way the first acts in specific circumstances. In the following example, the CSS is telling the HTML that any .menuitem links that are inside of the #navmenu element should act in a way that is different from the way a .menuitem acts when not inside a #navmenu. It is a method that designers use to maintain control and consistency with basic functions while allowing for multiple usage of common elements.

```
#navmenu a.menuitem:link, #navmenu
a.menuitem:visited, #navmenu a.menu-
item:active, #navmenu a.activelink {

width:116px;

float: right;

margin-right: 1px;

overflow: hidden;

padding: 3px 0px 8px 0px;

}

#navmenu a.menuitem:hover{

letter-spacing: 1px;

background-position: top;

background-repeat: no-repeat;

display:block;

}
```

This code works with the first definition for the class .menuitem and overrides any instructions for the same declaration (such as the new margin instruction) and adds new instructions for the element when used inside of the #navmenu element. In this case, the new instructions are: add a float instruction (float: right;) and a specific width (width:116px;).

In other words, if you put links styled with the class .menuitem inside of the #navmenu, they act according to these instructions. If you put the same links inside the #sidebar, they act according to the first set of CSS instructions.

All of the navigation and primary links ("home," "about," "links," "sets," "alike," and so on) used in the templates are styled with the .menuitem class so that you can move or duplicate any of the links inside of the #navmenu (the top or bottom menu) and put them in the #sidebar simply by moving them. You can use any link item styled with the class=".menuitem" in either the #sidebar or the #navmenu and they will act according to the styling instructions for the container they are in.

The #navmenu item links have a specified width of 116 pixels with a 1-pixel margin, and they fit into an element that is specified as 760 pixels (the #navmenu). Therefore, you cannot fit more than six menu items in the #navmenu. Anything you put inside this element that does not fit inside of the defined pixel width is truncated, which means that anything that falls outside the defined height and width will not be shown.

You can change the #navmenu element to a bottom menu quite easily with the addition of a single line of code in either skin.css or photoblog.css and shuffling the template HTML code. Instructions for this design change are located on the companion site.

DISPLAYING A SIDEBAR AREA WITH #SIDEBAR

#sidebar defines the side menu where the logo, thumbnails, and links to the "about " and "links" pages are kept. This container is as long/high as the content area, and anything in it that exceeds this space is truncated or hidden.

The CSS code that generates the sidebar is as follows:

```
#sidebar{

position: absolute;

top:0px;

left: 0px;

width: 176px;

text-align: center;

overflow: hidden;

}
```

X-REF

See Chapter 6 for a fuller explanation of how the sidebar works and what interesting things you can put into it.

This code tells the system to create an element that is in a fixed (position: absolute;) position, which is 0 pixels from the top, and left of the browser page, which is 176 pixels wide and in which all content is centered (text-align: center;). The overflow:hidden; command tells the system to not display any content in the sidebar that exceeds the natural height. The sidebar, because it is inside of the #content area, follows the height of that area and is never less than 500 pixels high and never taller than the content area.

The #sidebar is the only major element, aside from the master container (#blogstylearea) that is positioned absolutely — meaning that it puts itself at the coordinates given (top and left, in this case) regardless of where you put it in the HTML code. The reason for this is that the #sidebar is not dependent upon any other element and should not be permitted to float around the page. It goes where it goes, in short; whereas the #blogstylebottom, for example, goes after the content area, and its position on the page is relative to the end of the content area.

GETTING THE DATA TO THE PAGE

Of course, your HTML page needs more than just a design. It needs data of two types: dynamic and static. Dynamic data is that which you add yourself with each entry such as photographs and entry text. Static data is that which you add once to your blog configuration and which the MT system then reuses as often as it needs. Examples of static data include the name of your blog, your blog's URL, the author name you use, and where you store your files.

DESIGNER TIP

To learn about the different ways elements in the supplied templates can be used, explore the various skins that are installed with the templates. New styling instructions have been applied to many elements to make them look or act in different ways in each skin. Once you become familiar with all of the elements in the templates, you can start to make changes to your own design with confidence.

Movable Type stores all this data in databases and allows you to access it via the use of tags. Using the same sort of system as HTML, which also uses tags, MT slots the database information into your page wherever it finds a tag that calls for it. This is the information you will add manually if you are not using a content-management system.

As an example, when an MT-generated HTML page reads `<p><$MTEntryBody$></p>`, it knows to start a new paragraph (`<p>`) and then load the information contained in the `EntryBody` data field into the paragraph (`<$MTEntryBody$>`) and then close the paragraph (`</p>`).

Following are the primary Movable Type fields into which you place information when you make an entry in your blog.

ENTRY TITLE

If you do not specify an entry title, the Movable Type system assigns one automatically — which will generally be the URL and a word or two from the text in the entry body. This can make for some very ugly titles, and more importantly, titles that won't be found in searches or won't be very appealing to people browsing through feeds. As outlined in Chapter 4, it is important to choose your title well, spell it properly, and adhere to general grammatical conventions. Avoid the improper or excessive use of punctuation marks.

Table 5-1 outlines the details for creating an entry title.

Table 5-1: About Creating an Entry Title

How Entered	Movable Type Entry Screen (Figure 5-5)
Movable Type Data Tag	`<$MTEntryTitle$>`
Contains	User Defined Title
Default Display	In sidebar, under the blog title (Figure 5-6)
Default Template HTML	`<div id=" sidebar ">` `<$ MTInclude module = "logo"$ >` `<$ MTInclude module = "blogname"$ >` `<h3>` `<$MTEntryTitle$> </h3>` `</div>`
Default Template CSS Styling	`h3{` `font-family:Georgia, "Times New Roman", Times, serif;` `margin: 20px 0px 20px 0px;` `font-weight:normal;` `}` `#sidebar h3{` `font-size: 16px;` `text-align: center;` `font-weight:bold;` `margin: 0px 10px 0px 10px;` `}`

DESIGNER TIP

Whether you are designing from scratch or using a template set other than the one provided with the book, you will be dealing with both static and dynamic data. Static data like the information on your About and Links pages can become outdated and forgotten as you do not have to deal with it except when creating it. Make sure that you check your static data frequently to keep your information fresh and accurate.

PRIMARY CATEGORY

The primary category is the main category by which your entries are sorted and determines to which set your entry is assigned. Though you can add secondary category designations and the entry appears on the set page of each category you assign, it is the primary category that is used to sort and organize your entries. When you first make your blog, there are no categories, so you assign categories for each entry that you make for which you have not already made a category.

Categories use a series of MT tags and MT commands and are contained in a variety of places in your blog templates. In the section "SETS(Categories)" a more comprehensive explanation of using categories on your blog can be found.

How to add a primary category is outlined in Table 5-2.

SUBCATEGORIES

By clicking on the link "Assign Multiple Categories" under the Categories drop-down menu on the Movable Type entry screen, you can either select additional categories to which you want to assign your entry or add new categories to use.

ENTRY BODY

The entry body is especially designed in the templates to hold a photograph and assumes there will be one. Due to the tight control that the templates exercise over the way the photograph is displayed, the only information that should be contained in the entry body is the URL of the image. There should be no formatting whatsoever in this field. No quotation marks, no width or height instructions, and no < or / characters. Just the URL.

Table 5-2: About Adding a Primary Category

How Entered	Drop-down menu in Movable Type Entry Screen (Figure 5-7)
Movable Type Data Tag	`<$MTEntryCategory$>`
Contains	User Defined Category
Default Display	The category is not displayed on the page in the default template, but a link named "alike" is placed into the #navmenu as shown in Figure 5-8, which leads the viewer to a set page that shows thumbnails of all the other images in the category, as shown in Figure 5-9.
It is possible, of course, to display the category name on the page and to do other interesting things such as showing another entry thumbnail from the same category as the current item, adding a link to a random page from the same category, or showing your flickr set of the same name, or your flickr photos tagged with the category name. For ideas on things to do with categories and sets, see the companion site. |

5-7

5-8

Changing Files

All of the original skin files, including the code to render a style into a banner style or a right-side menu, are stored as modules with the rest of your templates, so if you make changes that you decide you do not like, you can always restore the original code from the module template. Additionally, each time you build a new blog, the original template files are used, regardless of what changes you have made to the ones you are using on any existing blog(s).

5-9

Incorrect

> `<img src = " http://www.theimageurl/`
> `theimage.jpg " />`

> `<img src = " http://www.theimageurl/`
> `theimage.jpg " width = 350 height = 250 />`

> `"http://www.theimageurl/theimage.jpg "`

Correct

> `http://www.theimageurl/theimage.jpg`

Table 5-3 outlines how to use Entry Body.

Table 5-3: About Using Entry Body

How Entered	Movable Type Entry Screen (Figure 5-10)
Movable Type Data Tag	`<$MTEntryBody$>`
Contains	Photograph
Default Display	Right side, under `#blogstyletop`, on top of `#blogstyle bottom` (Figure 5-11)

DEFAULT MAIN INDEX TEMPLATE HTML

```
<div id="blogstylearea">
<div id="blogstyletop"> </div>
<MTEntries lastn="1">
<div id="content">
<MTIfNonEmpty tag="EntryBody">
<div class="imageholder" ><img
src="<$MTEntryBody$>"/ > </div >
</div>
</MTEntries>
</div>
```

DEFAULT TEMPLATE CSS STYLING

The code that follows resizes any image larger than 700 pixels in width to 700 pixels so that it fits inside the content area. It leaves smaller images at their original size.

```
#content .imageholder{
width: 700px;
text-align: center;
margin: 0px;
}

#content .imageholder img{
display: block;
border: 0px;
float: none;
padding: 0px;
margin-top: auto;
margin: auto;
max-width: 700px;
width: auto;
width:expression(
    this.scrollWidth >700? "700px" :
"width:auto");
}
```

5-10

5-11

The way that a browser performs a resize can best be described as "quick and dirty," and I do not recommend that you use it to resize very large images or very many images. Really, I do not recommend that you let the system resize your photographs at all, as the results can often be unappealing. It is much better either to resize your images yourself and upload them in the correct size or to allow a service such as flickr perform and store the resize.

EXTENDED ENTRY

In the templates, the Extended Entry field has a very specific use. Because the Entry Body is dedicated exclusively for photographs, the Extended Entry is devoted to whatever text you want to add to your entry. If you want to make just a text entry, with no photograph, you can do so by putting it in the Extended Entry field, and the templates determine that the entry is a text entry and treat it accordingly (they will not attempt to find/or create a thumbnail for the entry and will present it as a text link on the sidebar menu).

It is important to note that any text that you enter into the Entry Body instead of the Extended Entry field will not appear on your blog. Your system treats everything in this field as a photograph and will try to display it as one.

Inside of the Extended Entry, any number of inline styling commands can be given such as <h3> or <h4>, (bold), or <i> (italic).

Table 5-4 describes Extended Entry.

5-12

Table 5-4: About Using Extended Entry

How Entered	Movable Type Entry Screen (Figure 5-12)
Movable Type Data Tag	<$MTEntryMore$>
Contains	User Entered Text
Default Display	In the content area, either under the photograph, if there is a photograph, as shown in Figure 5-13, or instead of the photograph, if there is no photograph, as shown in Figure 5-14.

DEFAULT MAIN INDEX TEMPLATE HTML

The code that follows tells the system to check whether there is a photograph entry (<MTIfNon Empty tag="EntryBody">) and, if so, to display it as indicated. If there is no data in the Entry Body field, the system looks to the showtextentry module, which checks the Extended Entry field. If an

5-13

DESIGNER TIP

Image editing software such as Picassa or Photoshop resizes photographs using a bilinear or bicubic filtering process. This means that the area of a pixel in the original photograph is reproduced to a smaller size by using the average color of that area. This results in a smooth image. Browsers, on the other hand, use a 'nearest neighbor' system for resizing or scaling. This method takes the color of the nearest pixel in the original photograph and ignores everything else. This normally results in quite jaggy images.

5-14

extended entry exists, it displays the text in it, formatted inside of the #entrytext container element. It is an either/or piece of code in that if there is a photograph, it will not display the text entry.

```
<div id="content">
<MTIfNonEmpty tag="EntryBody">
<div class="imageholder"><img
src="<$MTEntryBody remove_html =
"1"$>" / > </div >
<MTElse>
<$MTInclude module="showtextentry"$>
</MTElse>
</MTIfNonEmpty>
</div>
```

The showtextentry module code:

```
<MTEntryIfExtended><div id="
entrytext"><h3><$MTEntryTitle$></h3>
<$MTEntryMore$></div></MTEntryIfExtended>
```

The default behavior for the index page with all styles is to not show any text entry on the front page. The individual entry archive always shows the text as was shown in Figure 5-13. However, when this is the front-page item (the latest entry), the text is not shown as in Figure 5-15.

In Figure 5-16, there is a line of code that is placed inside the sidebar that alerts readers and provides a link to the individual entry archive if you do, in fact,

5-15

5-16

make a text entry with your photograph. This code appears in the Main Index template as the bolded lines that follow indicate:

```
<div id="sidebar">
<$MTInclude module="logo"$>
<$MTInclude module="blogname"$>
<h3><$MTEntryTitle$></h3>
<h5><$MTEntryDate format="%b %d
%Y"$></h5>
<$MTInclude module="lastthree"$>
<$MTInclude module="sidelinks"$>
<MTEntryIfExtended><a
href="<$MTEntryPermalink$>" class=
"menuitem">note</a></MTEntryIfExtended>
</div>
```

This code tells the viewer that there is a text entry associated with the photograph by adding the menu item "note" to the sidebar. If you choose to show your text entry automatically on the front page as described in the next section, then you should remove this code as there is no need to alert your viewers to the fact that there is a note. They can see it themselves when they load the page.

DISPLAYING YOUR TEXT ENTRY

The template design and included CSS files allow you to either display any text entry on the front page with the image or to always keep the front page in a

"photograph only" gallery style and to show the text on the individual entry archive (the "permalink"). The default, as indicated, is to not show any text entry on the front page. To change the default and show your text with your photographs on the index page, you need to alter the code in the module file called singlestyle, which is located in the templates section under the modules tab. The existing code will look like this:

```
<div id="content">
<MTIfNonEmpty tag="EntryBody">
<div class="imageholder"><img
src="<$MTEntryBody remove_html =
"1"$>" / > </div >
<MTElse>
<$MTInclude module="showtextentry"$>
</MTElse>
</MTIfNonEmpty>
</div>
```

You must remove the bolded parts so that the code looks like this:

```
<div id="content">
<MTIfNonEmpty tag="EntryBody">
<div class="imageholder"><img
src="<$MTEntryBody remove_html =
"1"$>" / > </div >
</MTIfNonEmpty>
<$MTInclude module="showtextentry"$>
</div>
```

This essentially tells the system to show whatever is there; if there is a photograph, show it; if there is an extended entry, show it as well.

PHOTOGRAPHS IN THE EXTENDED ENTRY FIELD

You can place photographs inside the Extended Entry field because you may want to use smaller images to illustrate your writing. By default, all images in the Extended Entry are floated, which means that they will float to one side (the right side, in this case) and the text wraps around them, as shown in Figure 5-17.

5-17

The photograph in the text entry portion of the example (see Figure 5-17) was placed there with the following code:

```
<img src="http://photos3.flickr.com/
4759377_9f8cf4b064_m.jpg"/>
```

If you want the default float on smaller images inside of your text to be to the left instead of the right, simply change the following lines in your photoblog.css file:

```
#entrytext img{
padding: 4px;
float: right;
margin: 0px 0px 10px 10px;
}
```

The new lines should read:

```
float: left;
margin: 0px 10px 10px 0px;
```

These lines of code can be found under the /*------ images -------*/ heading in the photoblog.css file.

EXCERPT ENTRY

You can use the Entry Excerpt field to either provide a flickr URL to send your viewers to your flickr stream to see comments on your photograph, or you can use it to provide a thumbnail URL so that your archives and sets pages load more quickly than they will using the default method of creating a thumbnail, which is simply the resized on-the-fly original photograph.

Table 5-5 outlines the Excerpt Entry field.

Table 5-5: About Using Excerpt Entry

How Entered	Movable Type Entry Screen (Figure 5-18)
Movable Type Data Tag	`<$MTEntryExcerpt$>`
Contains	User Entered Text
Default Display	The Excerpt can be used in several interesting ways. One of them, directing your viewer to your flickr stream or other storage service location, is described in the next section, and the other, using it for a thumbnail reference, is described in the section "Thumbnails" later in this chapter.

The Order of Things

CSS and HTML depend very much upon order — the sequence in which instructions are located. In the index templates, for example, the #blogstyletop is placed and then the #content and then the #blogstylebottom. If you reverse the order of these instructions, your blog would look funny. The bottom would load on the page before the top. In the CSS, the order is very important because the effect of CSS is cumulative. In other words, the system reads all the CSS and uses the last instructions it finds for each element — not necessarily the correct ones, but always the last ones. It is your job to make sure the correct ones are the last ones. Additionally, inside of CSS, certain conventions of order exist. Primarily this is in the use of margins, borders, and padding — those elements that accept four distinct instructions for top, right, left, and bottom. Think of using them like using a clock. Top is always first and it's at 12 o'clock, right is next at 3 o'clock, and so on; the order of instructions always starts at the top and progresses clockwise.

DIRECTING VIEWERS TO YOUR FLICKR STREAM

Put the module named `flickr` in either the `sidebar` or the `navmenu` inside any of the HTML templates, and the system will run the following piece of code:

```
<MTIfNonEmpty tag="EntryExcerpt"><a
href="<$MTEntryExcerpt
html_encode="1"$>"
class="menuitem">on flickr</a></
MTIfNonEmpty>
```

This code verifies that data has been entered in the Entry Excerpt field (`<MTIfNonEmpty tag="`

5-18

NOTE

If you want to place an image inside the Extended Entry, you need to format it so that the HTML knows it is an image URL. The Entry Body is set up in the templates to assume that a photograph will be placed there, and it acts accordingly, but the templates assume that the Extended Entry will contain text, so you need to put your image URL inside of an `` HTML tag.

`EntryExcerpt">`) and then creates a link from it. This is why it is important to have the automatic excerpt width set to 0 as the system uses whatever it finds in this field to create thumbnails or links such as this one to fllickr.

It is very important that when you type the URL of the flickr page that you do not include any formatting or HTML code within the URL. Do not encase it in quotation marks or add the < a href = "...> code. Just type the base URL beginning with **http:**. A correct excerpt URL looks like this:

```
http://www.flickr.com/photos/
catherinejamieson/49436963/
```

To include the flickr module in the HTML code, do the following

Module Name: flickr
Module Include code: `<$ MtInclude module = "flickr" $>`

Excerpt Length

In Chapter 4, the instructions for setting up your blog include the advice to set your excerpt length to "0". This is a very important step; failure to do so causes Movable Type to enter a set number of characters from the Entry Body into the Excerpt field, and your thumbnails will not appear on your page. This is particularly important if you are using the default mode of creating a thumbnail from the Entry Body.

5-19

Insert the preceding line of code into either the `#sidebar` or the `#navmenu` in the place you would like it to appear. Following is an example of the flickr module added to the `#sidebar` in the Main Index template:

```
<div id="sidebar">
<$MTInclude module="logo"$>
<$MTInclude module="blogname"$>
<h3><$MTEntryTitle$></h3>
<h5><$MTEntryDate format="%b %d
%Y"$></h5>
<$MTInclude module="flickr"$>
<$MTInclude module="lastthree"$>
<$MTInclude module="sidelinks"$>
<MTEntryIfExtended><a
href="<$MTEntryPermalink$>" class=
"menuitem">note</a></MTEntryIfExtended>
</div>
```

This causes the flickr link to be presented underneath the entry date (`<h5><$MTEntryDate format="%b %d %Y"$></h5>`) and before the three thumbnails (`<$MTInclude module="lastthree"$>`) modules that appear on the side, as shown in Figure 5-19. The flickr module can also be used in the `#navmenu`. If you're going to use this module, you'll need to adjust the thumbsource module so that the only line of code it contains is `<$MTEntryBodyremove_html="1"$>`

NOTE

At the end of this chapter is a sidebar called "Quick Reference Files" that outlines which files are grouped together. Make sure to change files as necessary if you make a change in another template.

ARCHIVING YOUR ENTRIES

When you make an entry, the Movable Type system does several things so that your data is both stored and indexed. This means that the system keeps track of your entries, the order in which they were entered, and how they are related to other entries.

The template system allows for the storage and display of entries in two primary archival methods:

> **Chronologically.** Entries are, by default, viewed one after the other in date format and can be viewed in monthly archives, as shown in Figure 5-20. The Archives link on all of the main template HTML pages leads to the latest month's archive page and places a navigation menu in the sidebar to see other months. The archive pages are created by the Master Archive Index template and the Date Based Archive template.

> **By category.** Entries can be viewed by category from a sets page, as shown in Figure 5-21. The SETS link on all of the main template HTML pages leads to the master sets page and places a navigation menu in the #sidebar to see other sets pages. The sets pages are created by the Main Category Index template and the Category Archive template.

The system automatically sets up previous and next archival links and keeps track of where everything is stored.

CREATING AND MANAGING CATEGORIES

Movable Type uses a category system by which you can assign your entries to one or more categories that provide your viewers with sets of similar images to view.

Sets, or categories, work very simply and are very easy to manage. Essentially, if you create a category and assign an entry to it, that category automatically appears on your #sidebar the next time a sets page is loaded. If you create a set but do not have any entries assigned to it, the system will not show the category name on the list.

You can create as many categories as you like and assign as many or as few entries to each category as you wish. Keep in mind, however, that you will have a hard time managing too many categories. Viewers presented with too many choices often choose none or become frustrated with all the navigation.

5-20

5-21

Fifteen to 20 well-chosen categories can cover most needs. On my own site, the sets that are viewed the most often are "portrait," "abstract," "color," and "urban." I recommend that you spend some time looking around at other blogs to determine which naming and grouping conventions make the most sense to you as a viewer. Avoid using cute or unclear category names that may only have meaning to you, and use those names that seem to be most often used in general practice. Remember that many of your viewers may speak English as a second language or not at all. As much as possible, adhere to naming conventions that are in general Internet use.

ASSIGNING THUMBNAILS TO CATEGORIES

The sets.html page uses the image or thumbnail from the last entry added to the category as the icon for each category, but you can assign specific thumbnails to each category. If you do this, whenever the sets.html page is loaded, the thumbnail you assigned to the category is used instead of whichever one was last entered. Follow these steps:

1. Click CATEGORIES on the side of the MT interface as shown in Figure 5-22. A list of all your categories appears (see Figure 5-23).

2. Click the category you want to assign a thumbnail to and place the URL of the thumbnail you want to use into the category description field, as shown in

5-22

5-23

Figure 5-24. There is additional information on creating and using thumbnails later in this chapter. Make sure that you do not have any quotation marks or other HTML — that it is just the URL, which looks something like http://www.url.com/g/thumb1.jpg.

5-24

3. Click Save. When you're done adding thumbnails to the category descriptions, you must rebuild your site to see the results.

LOCATING YOUR THUMBNAIL IMAGES

The module called categorythumbs tells your Master Category Archive index (sets.html) where to look for your sets thumbnails and is an important piece of code to understand because you may need to alter or troubleshoot it one day.

```
<div id="content">
<MTCategories>
```

```
<MTEntries lastn="1">
<MTIfNonEmpty
tag="CategoryDescription">
<div id="thumbwrapper">
<a href="<$MTBlogURL$><$MTArchiveTitle
dirify="1"$>/">
<img src="<$MTCategoryDescription
remove_html="1"$>"></a><br/><$MTArchive
Title lower_case="1"$>
(<$MTCategoryCount$>)</div>
<MTElse>
<MTIfNonEmpty tag="EntryBody">
<div id="thumbwrapper">
<a href="<$MTBlogURL$><$MTArchiveTitle
dirify="1"$>/">
<img src="<$MTInclude module=
"thumbsource"$>"></a><br/>
<$MTArchiveTitle lower_case="1"$>(
<$MTCategoryCount$>)</div>
</MTIfNonEmpty>
</MTElse>
</MTIfNonEmpty>
</MTEntries>
</MTCategories>
</div>
```

This tells the system to first check in the Category Description field, and if this field does not contain a thumbnail URL, to create a thumbnail from the photograph in the last entry assigned to that category. If you type text descriptions in your category description fields, you need to alter this code to reflect this change by removing the bolded lines.

Name Your Categories Wisely

Although you can assign any sort of name to categories — including those with spaces — simple, single-word category names enable viewers to more easily navigate your photo blog. Do not use any capital letters or improper punctuation and avoid names that have no meaning to the casual reader, are used very often, or relate to only a few images. Generally people like to view images by basic type such as urban, color, abstract, mono, still life, portrait, scenery, people, and so on.

STORING PHOTOS

As discussed earlier, there are a variety of ways to store your photographs. If you store them on your own server and upload them with either the Movable Type file uploader (see Chapter 3) or through an FTP client, you should store them in a directory off of the root such as a folder called "g" or "images" or "photos." Additionally, you should employ a method of using subdirectories such as by month or year and topic to store photos so that they are easier to manage.

DISPLAYING THUMBNAILS

Thumbnails are used in several places on your blog and are created, by default, through a simple resizing of the image contained in the Entry Body, which is represented by the MT tag <$MtEntryBody$>. When you add a photograph, the system simply shows it at a smaller size — it does not make it a smaller size and store it anywhere. This is an important distinction as it means that the system is downloading a full-size image and squeezing it into a smaller space. If the original image is 300KB, for example, the thumbnail will also be 300KB — it will just be very small and condensed.

The CSS in place creates a representative thumbnail forced to a square of 75 pixels by 75 pixels from each main entry image, unless you have a thumbnail URL stored in your entry excerpt.

TELLING THE SYSTEM WHERE TO FIND THUMBNAILS

There is a single module called Thumbsource that feeds all of the other code in modules and templates that use a thumbnail (such as lastthree, lastnextarchive, categorythumbs, master archive, master category archive, and so on); so if you want to use another way of displaying thumbnails, you only have

to change one small piece of code and all of your templates automatically update.

Table 5-6 outlines how to use Thumbsource.

Table 5-6: Using Thumbsource

Module name	Thumbsource
Including it in HTML template	`<$MTInclude Module="thumbsource"$>`
Module code	`<MTIfNonEmpty tag="EntryExcerpt">` `<$MTEntryExcerpt remove_html="1"$>` `<MTElse>` `<$MTEntryBody remove_html="1"$>` `</MTElse>` `</MTIfNonEmpty>` This code tells the system to check first in the Entry Excerpt field for a thumbnail URL. If it finds nothing, then it uses the URL in the Entry Body field.

As your blog becomes more full, you may find that your thumbnail pages begin to load slowly as the system has to load each large image and create a smaller version of it to display. I recommend that you use the following method for displaying thumbnails.

CREATING YOUR OWN THUMBNAILS WHEN UPLOADING

When uploading a file with the Movable Type file uploader, you are given the option of creating a thumbnail from the uploaded images. In Chapter 4, instructions were given for uploading a file through Movable Type. Using these same instructions, begin the upload

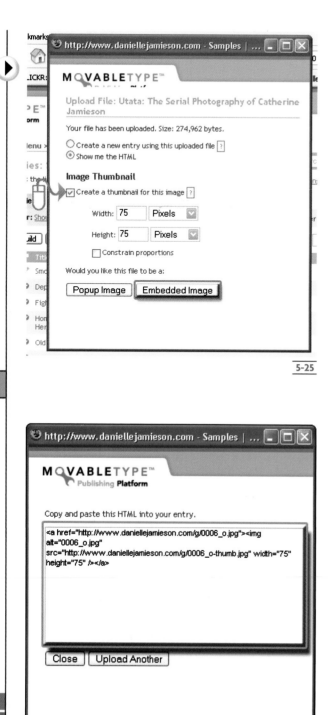

5-25

5-26

process, and when you get to the screen shown in Figure 5-25, which asks you whether you want to make a thumbnail, select the check box as indicated and follow these steps:

1. Type **75** in both the Width and Height fields

2. Make sure the Constrain proportions option is not selected.

3. Select the "Show me the HTML" option

4. Click Embedded Image. The box that appears shows you the code for both your original image and a new thumbnail image, as shown in Figure 5-26. It has the same name as the original image except that the word "thumb" is inserted as shown.

5. Cut and paste this thumbnail code, as shown in Figure 5-27, into the entry excerpt field and save your entry.

Remember that you should not have any HTML coding such as <img src=... or even quotation marks in the URL. Copy only the URL portion from the code that Movable Type provides.

CUSTOMIZING YOUR THUMBNAIL SIZES

Thumbnails are sized according to the instructions contained in the photoblog.css file.

Except for #sidebar thumbnails that are simply displayed in the sidebar without any other container, thumbnails are displayed inside a CSS container called #thumbwrapper, which is defined in photoblog.css. It provides the following styling instructions, first for all images contained inside the #sidebar and then for all images contained inside the #thumbwrapper element:

```
#sidebar img{

margin: 3px 10px 3px 10px;

padding: 5px;

width: 75px;
```

```
height: auto;
}

#thumbwrapper img{

float: none;

width: 75px;

height: 75px;

padding: 4px;

margin: 8px 16px 4px 16px;

}
```

All of the thumbnails used in the templates are set to be 75 pixels wide. You can, of course, make thumbnails any size you want by adjusting the width and height instructions in either or both of the above definitions. Keep in mind that you may have to make adjustments to the margins of the containers if you make your thumbnails too large or small.

The code for thumbnails is contained under the /*----------images------*/ heading in the photoblog.css file.

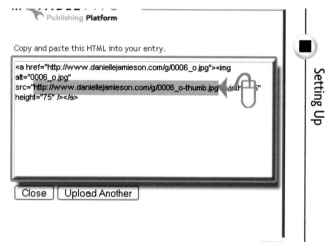

Quick Reference: Files

Often, changing something on your site requires that you change more than one file. Following is a quick reference chart for making design changes:

If you change...	And You Want to Also Change...	Then You Should Also Change...
Main Index	Individual Archive pages	Individual Archive template
Master Archive Index	Monthly Archive pages	Date Based Archive Template
Main Category Index	Category/sets pages	Category Archive template

THE DESIGN STUDIO:
SKINS AND CUSTOMIZING

If you've read Chapters 4 and 5, you should have a good feel for the nuts and bolts that hold your blog together, but the best way to learn about how your blog works is to use it. By applying your chosen skin to your blog and setting up your menus and blog elements, you become more familiar and comfortable with the code and the Movable Type system.

You may be tempted to skip this chapter if you are not using the supplied templates or the Movable Type system, but I urge you not to. It contains critical information about such things as building About and Links pages and what works well or not in sidebars.

Although you can use the supplied templates out of the box or simply apply a new skin on top and use them the way they are, you can also use them as a jumping-off point for your own design ideas. As you learned in Chapters 1 and 2, you can do many things with a little bit of CSS and a sprinkling of HTML. Don't be afraid of them. If you make a change you don't like, you simply change it back.

MAKING INTERESTING PAGES

A blog contains not only entries, which have already been discussed, but also other pages that you create to share information with users. There are many types of pages that you can add to your blog that will make it more appealing to readers. People love to poke around on websites and see what nuggets the blogger has tucked away. My about page is one of the most-viewed pages on my site, and almost everyone visits the links page sooner or later.

By using the supplied templates or some other method such as creating pages yourself in a WYSI-WYG editor, you can create any number of cool pages to do any number of interesting things. I highly encourage using the real estate you have – creating pages about as many things that interest you. You can create indexes and direct readers to these pages without disrupting the flow of your regular photo blog.

On my site, for example, I use one index template to generate a mailform (see Figure 6-1) and another to tell the viewer that his or her mail has been sent.

6-1

Two of the index templates installed with the supplied package are not designed to hold entry data but rather hold "hard-wired" information — text information you put directly into the HTML code. The two pages are called About (see Figure 6-2) and Links (see Figure 6-3).

If you are creating your Links and About pages yourself, I recommend that you follow the same conventions I used and name them links.html and about.html, and that you store them in the root directory of your site as they are part of your primary content.

My statistic logs tell me that my About and Links pages are referred to very often by other sites and search engines, and I like to make the URLs to frequently referred pages as short as possible to ensure they do not break in email and bulletin board postings.

CREATING LINKS

A typical link will look like this: `link text to show on page`. The `<a>` tag alerts the HTML that it should begin linking here, and the href means (H)TML (REF)erence and tells the browser that this will be a link to another HTML page. The `="URL"` tells the browser that the link is equal to the URL in the quote.

The URL or address of the linked-to page goes between the quotes and the text to describe the link goes between the > </a tag brackets. ` g o o g l e ` will create a linked piece of text that shows up on the page as g o o g l e and takes the viewer to `http://www.google.com` if clicked.

CREATING A FABULOUS LINKS PAGE

O h my, but people love it when you provide good links for them to follow after they're done visiting your site. If they like your blog, your recommendations

6-2

6-3

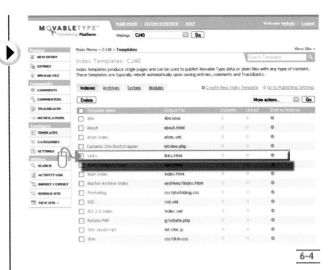

6-4

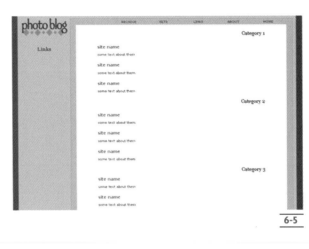

6-5

DESIGNER TIP

A blogroll is your list of personal links, usually kept on a news aggregator or a portal site such as Yahoo! These are the places you visit frequently, truly enjoy, and would have no problem recommending to others. You can have several blogrolls, from lists of similar blogs to geographical sorting to lists arranged by content. Some news aggregators even allow their users to export that list directly to a web log.

will be valuable to them and they will check this page often to see what you have to offer. Guidelines for choosing links and using them to publicize your blog are covered in Chapter 10, while this section is all about creating the page to present to them.

The blank Links page that is provided with the included templates is very straightforward, and you should be able to fill in your links information quickly and add new items easily as you come across sites on the web that you want to link from your site. For this exercise, I assume that you have a list of links or favorite sites already established, perhaps as part of a blogroll or from the favorites folder on your computer.

If you're designing your own, I recommend that you use a similar system of categories to differentiate between the types of links you are providing.

To make changes to the Links page provided with the included templates, click the TEMPLATES menu link from the Movable Type interface and then click the Links template as shown in Figure 6-4. Then, follow these steps:

1. When links.html opens you will see the HTML template code in the text window. Were you to load this page into your browser window without making any changes, it would appear as shown in Figure 6-5. To make changes to the content, scroll down in the window until you see the section of code that starts with <div id= "entrytext">.

2. Category headers are contained in between a <h3> tag and a </h3> and are named Category 1 through 3. Rename the headers to whatever categories you have decided for grouping your links. Adding more categories is simply a matter of placing the category name inside a <h3> tag and a </h3> tag. As an example, if you want your first link category to be Photoblogs, change <h3>Category 1</h3> to read <h3>Photoblogs</h3> . See Figure 6-6 to

see how this would appear on the Links page. As you can see, the `<h3>` tag has been styled in the CSS file to be right aligned and of a larger and bolder font than the rest of the text.

3. Each link in the category is encased in a `<h4>` tag that tells the system how it should be styled (as a bolded title) and that holds the hyperlink to the URL of the linked site. For example, if you want to add a link to my site in the Photoblogs category, change `<h4>site name</h4>` to `<h4>Catherine Jamieson</h4>`. This change would display on the Links page as shown in Figure 6-7. If you clicked on my name, you would be taken to my site.

4. Below the title of the link is a line of code that looks like this: `<p>some text about them</p>`. You can either add a description or review about each of your links now (recommended), or simply delete these `<p>` containers and present a links-only page. As an example, if you want the description "A nice photo blog," under the link you just added, replace `<p>some text about them</p>` with `<p>A nice photo blog</p>`. See Figure 6-8 to see how this would appear on the page.

5. Repeat these steps for as many categories and links as you have and then Save and Rebuild your file. Your links pages are rebuilt and ready to go.

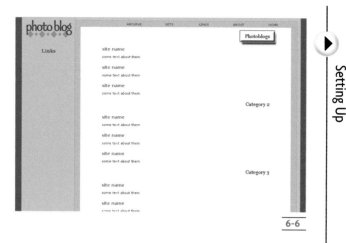

6-6

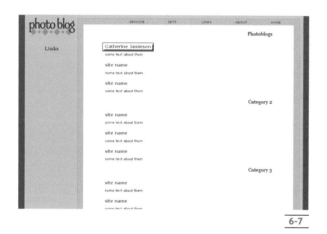

6-7

DESIGNER TIP

When linking from your site, be sure not to add any code to your links that will cause pop-up windows to open unless you are linking to content on your own site. It is generally considered good net etiquette to create your links so that they open in the default manner, which is in the same browser window. You should not avoid "target" commands in your links.

6-8

MAKING A MEMORABLE ABOUT PAGE

The About page is an important one. After the home or index.html page of my site, the about.html page is the most visited, and almost all new viewers click on the About link during their initial visit. I cannot stress enough the importance of a good About page. Even though it does not need to contain your life's story or a lot of personal information, it should say enough about you, your site, or your art so that people can feel, for the lack of a better word, "connected" to you enough to have more than a passing interest in your photographs.

The blank About page that is provided with the template package contains default section headings that you can either use as they are or change to suit your own needs or sensibilities. If you use the default headings, the following section contains instructions and hints for their most effective use.

DESIGNER TIP

By either providing a written review or a short blurb about the linked-to site or person, or an image such as screen shots (see Figure 6-9), your links are much more likely to be clicked on. If your links are clicked on, you will come to the attention of other bloggers who may add you to their list of links if they like your work. I talk more about this in Chapter 10, but because links are, in many ways, the currency of the Web, you should always take care in what links you provide and how you provide them.

6-9

If you are making your own About page I recommend that you start with an outline similar to the one that follows.

BIO

Your bio can be simple but punchy, such as Emily Smith's About page shown in Figure 6-10 (`http://www.emsmithphotography.com/info.php`), elegant and informative like Graham Jeffery's in Figure 6-11 (`http://sensitivelight.com/about/`), a list of your interests, or a short essay on your life's philosophy. In any case, it should follow some of the time-honored rules that ad copywriters use. Notably, it should be short and snappy in nature with no really long sentences (or, if they are going to be really long and funky, at least make them very, very interesting), and it should offer something of the personal, some hint as to the sort of human being you are. I've always admired the About page of Lorissa of Apparently Nothing. As shown in Figure 6-12 (`http://www.apparentlynothing.com/about.shtml`), it is a wonderful collection of the useful and the whimsical and is lovely to behold.

There is a dummy photograph called self.jpg in the bio section contained with the included template installation files that you can replace with one of yourself. Viewers love to have an idea of what you look like and even a fuzzy, dark, or abstract image provides some clue as to what you're like. Although I recommend that you include an image of yourself, if you do not want to use a photograph on your bio, just delete the following section of code from the About page template:

```
<p><img alt="me.jpg" src="css/self.jpg"
class="leftimg">Some text about this
category.</p>
```

which can be found just under the `<h4>Bio</h4>` heading in the `#entrytext` container.

DESIGNER TIP

It's always wise to limit the amount of personal information you give to strangers, and especially so on the Internet, where you are not always aware of who is reading what you write. Although they are relatively rare, there are cases from time to time of such crimes as identity theft or stalking taking place after someone was not careful with personal information on the Internet. Generally speaking, I recommend that you offer no more information than you would to a stranger you met at a bus stop and do not put your home address, telephone number, or any financial information whatsoever on your About page.

PHOTOGRAPHY BY EMILY SMITH

Exhibition: i am 8-bit April 19-May 20, 2005 at Nineteen Eighty Eight.

I also take photos for Minor League Baseball.

Photos in: 28MM Printed final issue.

Group show: Lucky Dip Studio, Los Angeles, CA 7/1/05-7/3/05

Exhibition: Killer Dreamer June 22-July 16, 2004 at Nineteen Eighty Eight.

Coolstop - 12.01.2002

Personal favorites:
brownglasses.com
fiftymillimeter
The Snowsuit Effort
No traces
Express Train
joe's nyc
zonezero

contact

6-10

Sensitive Light About Recent Images Galleries Favourites Wallpaper About E

About Sensitive Light
The Sensitive Light site was launched at the beginning of
March 2003 and is nothing more than a place to present the
results of my photographic interest. I had other sites in the
past but to be honest nobody ever visited them.

Different to my previous sites, this site includes a photoblog.
A photoblog is a regularly updated chronological web log
(blog) of recent work. There is a community of photobloggers
and the combination of regular updates, and interaction with
others, help to keep the site fresh and my interest sustained.

The frequency of my photoblog updates varies over time,
sometimes it's every day, sometimes every few days, and
sometimes I have breaks while I look for fresh inspiration.

For an excellent list of other photoblogs I strongly recommend
a visit to photoblogs.org While you are there you could check
out the Sensitive Light photoblogs profile if you wanted.

About Me
My name is Graham Jeffery, I live in Hinckley a small market
town in the middle of England. When I originally built the site I
went by the alias of Sensiti, I can't remember quite why, but I
thought it was the right thing to do at the time. So, if you see
a reference on the site to Sensiti, it means me.

I have had a lifelong interest in photography and have
practiced on and off for the last 30 years. It wasn't until I
retired from computing in 2003 that my interest really took off.
On accepting the offer of early retirement I invested in a
whizzy digital camera and some lenses, and haven't looked
back since.

I have no aspiration to become a full time professional

Random picture

Frequently Asked Questions

6-11

APPARENTLYNOTHING ABOUT | FAQ | ELSEWHERE | ARCHIVES | CONTACT

obligatory about info

lorissa (also referred to as lor or lols) is a south african (and a very proud one at that), living in london with her
husband and cat, pelei. she is a freelance web and graphic designer, and photographer. she co-created
expressions which is the photoblogging system that powers this site. she spends her days in front of a
computer or behind a camera - not a bad way to pass the hours. she has various interests and is inclined to:
illustrate a children's book, establish an animal sanctuary, design a greeting card line, create a photography book,
travel the world and learn other languages (japanese is first on the list). she's an agnostic, vegetarian,
rugby-loving, coffee-addicted geek. she tends to worry too much, stress too much and laugh a lot

her greatest passion though is photography and she never leaves home without a camera. she fell in love with
photography at a young age but was always rather nervous handling the family camera due to her knack for
dropping things. it wasn't until 2001, when she got her hands on her own little camera (her canon powershot
s30), that she began to truly explore her love for photography. she now owns a variety of cameras from a
snazzy canon 300D to her somewhat broken holga (she dropped it - surprise surprise).

» atom feed
» photoblogs profile
» del.icio.us goodies
» flickr fun

PARTICIPATE:
» all things girl
» london photobloggers
» europephotobloggers
» small spiral notebook

CONTRIBUTE:
» 28mm.org - issue 004
» lalaland
» mirror project - 1 . 2 . 3
» photojunkie.org - "Everything Old
is New Again"
» the way we see it

CHEERS!
» guardian unlimited - best of
bristish blogging
» digital camera shopper magazine
- issue12

© 2001-2005 lorissa shepstone
powered by expressions | atom feed | photoblogs.org listed

6-12

6

The Design Studio: Skins and Customizing

CAMERAS

You can make a list here of all of the cameras and equipment that you use. This is a very often looked at piece of data of vast interest to most other photographers. Some people who are interested in the technical aspects of photography or traditional analog photography often include an exhaustive list of camera bodies, lenses, and filters used; others simply make a "Photographs on this site are taken with a ..." statement.

SUBSCRIBE

This heading already contains text explaining how to subscribe and a standard list of your rss feeds, correctly linked if you are publishing your about.html file to the root directory (which is the default template behavior). The following files are generated automatically when you post an entry and the templates for them are contained in your Index template listings.

```
<li><a href="index.rdf">RSS
1.0</a></li>
<li><a href="index.xml">RSS
2.0</a></li>
<li><a href="rsd.xml">RSD</a></li>
<li><a href="atom.xml">Atom</a></li>
```

The other link under the "Subscribe" heading is the one to flickr. If you have a flickr stream, you can

place the URL to the RSS of your stream where # is located in the code below.

```
<li><a href="#" >flickr</a></li>
```

ELSEWHERE

Elsewhere is the place to put links to your other sites or storage locations, and to any sites on which you have been published or linked or featured. It can contain lists of your other publishing accomplishments or anything that you wish to direct to the reader's attention about your other endeavors.

CREDITS

It is considered polite on the web, in general, to provide credit links or mentions to those services or individuals who have helped you publish your site. You can provide a link to your web host, your ISP, mention any software you use (such as Movable Type) or anyone who has inspired you particularly. The default template Credits section, as an example, contains a sentence of credit to me for designing the templates along with a link to my site. You may, of course, remove this information at your discretion.

MAIL

I do not recommend that you place a regular `mailto:` link to your email address on your website but rather that you type your address inside a set of `<p>` `</p>` tags as a regular piece of text as shown:

```
<p>catherine (a) catherinejamieson.
com</p>
```

where (a) replaces the normal @. Doing this prevents
most email spam, but the only really effective way to
eliminate email spam is to use a mailform or graphic
that indicates your email without any text.

USING SKINS TO GIVE YOUR BLOG STYLE

A skin is a set of instructions that alters the way ele-
ments look and act so that the same basic data can
be displayed in any number of ways. Although they are
called skins in this book, that is really just a short way
of saying "design instructions," and whether you are
using the included skins or creating your own blog
design, the information in this section is valuable.

The included skins will help you make changes to an
existing blog or build a new one based on their basic
design principals. Even if you're not using the templates,
they make excellent teaching tools as you can use
the code from the supplied files to achieve certain
effects. You can cherry-pick which aspects of which
designs or skins you like and use that code to create
your own design. In some ways you can think of this
as a catalog of design ideas.

HOW SKIN FILES WORK

Most skin files, like the ones included with the pro-
vided templates, are simply new styling instructions
for the same master elements as defined in the main
CSS file.

All of the ten basic skin files and their graphics are
installed as part of your book package, so everything
you need when using any of the skins, such as
"Simple 1" (see Figure 6-13), "Mauve" (see Figure
6-14), or "Organic" (banner style) (see Figure 6-15),
are already on your server space or available for
download. I urge you to explore the many ways that
CSS can be used to alter design and presentation,
but for the purpose of learning the basic function of
your site, all examples and instructions are provided

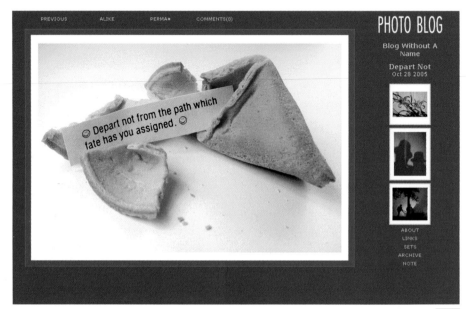

6-13

for the default skin and style as shown in Figure 6-16.

No matter what style you choose, because the templates all work with the same basic CSS master file and the same basic HTML templates, making the changes explained in this chapter work no matter what skin set you use.

Skins are composed of two types of files:

> **CSS:** cascading style sheets

> **Graphics files:** JPEG and GIF

In the case of the provided templates, skins are all stored in a directory called skins. Inside of this directory are subdirectories that are the names of the skins such as mauve, teal, or mono. Inside of these subdirectories are the graphic files needed to make the skin work on your blog.

SKIN GRAPHIC FILES

All of the primary graphics have the same name for each skin. This is to allow easy switching of skins as well as to allow easy change to either a left or right side menu. The graphic file, for example, that fills the #blogstylearea, is always called blogskin.jpg in all of the skin files.

HOW THE SKINS ARE USED

The skin.css file tells the browser where to find the graphic files needed to make each skin work. It assumes that you are using the default directory structure and that all your skins are in the same place as the default skin files. In other words, the templates assume that you are building your blog in the root directory of your domain. Chapter 4 explains how to configure your blog to publish to the root directory.

If you want to publish your site to another subdirectory of your domain you need to move the entire directory called skins and all of the subdirectories contained in it (blue, default, embossed, mauve ...) to the folder in which you put your blog.

6-14

6-15

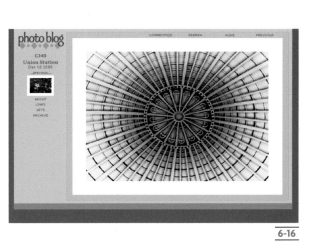

6-16

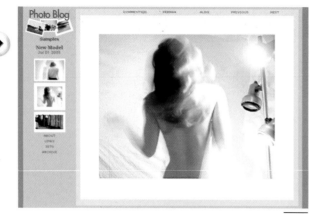

6-17

6-18

6-19

DESIGNER TIP

Do not delete any of the modules, even if you are not using them with your currently selected blog style and skin. Unused modules do not cost you any overhead and they take up a very small amount of space. Leaving them intact makes design changes easier, and you will have all of the modules available should you need them.

The skin.css (cascading style sheet) file tells the browser where to find the graphics it needs. Each skin.css file uses the graphics from the corresponding skin folder in the skins directory. If you choose the blue skin, for example, it finds its graphics files in the http://YOURURL/skins/blue folder.

CHANGING TO AN INCLUDED SKIN

The exercise that follows illustrates how quickly and easily you can change your blog from the one shown in Figure 6-17, which uses the blue skin, to the one shown in Figure 6-18, which uses the mono skin — or even the one in Figure 6-19, which uses the teal skin with just a single change in a single file.

Once you have selected a skin to use it is a very simple matter to install it. In the default style, which is a non-banner, one-at-a-time style, any of the included skins may be used. Every style can be made into a right-side menu and except for the skins sky and mauve, all may be used in a banner-style blog.

To change skins:

1. In the Movable Type interface, open your default or main blog and click the TEMPLATES link. A page appears listing all the templates on your site.

2. Select the Modules tab at the top of the templates screen. A page appears with an alphabetical list of all of the template modules. All of the skin files are stored as modules and are named with skin_ preceding the name of the skin. skin_mauve, for example, is the code for the skin called Mauve.

3. Open the skin module file you have chosen to use by clicking it, and then select all of the text.

4. Copy this selected text onto the clipboard.

5. Click the TEMPLATES link on the left side of the screen and then click the file skin.css.

6. After the file opens, select all of the text. and paste the new skin text into the skin.css master file.

7. Click Save and rebuild, and your new skin css will be installed on your blog.

MODIFYING SKINS

Customizing the skins is where you can impose your own personality and style on your blog. There is always a backup copy of the original skin on your Templates ⇨ modules page. With the skin file, you can alter the background colors and the font styles or even the way your photograph is bordered. And with changes to the CSS, you can modify how the menus look and work and how your text and photographs work together.

MAKING THE BEST USE OF A SIDEBAR

If you want to keep a lot of information in your sidebar, I strongly recommend that you use one of the blog styles where more than one entry is shown on the index page. It will still pay to watch carefully to ensure that your sidebar content does not stray too long past your content.

DESIGNER TIP

The *sidebar* is a tricky part of a blog in terms of design. One of the ongoing problems with the presentation of information on blogs is with keeping the sidebar and main text balanced. Often you see blogs with a long sidebar that is full of things and which is longer than the actual content. For a variety of reasons — aesthetic to practical — this is not a good practice and should be avoided.

DESIGNER TIP

Avoid cluttering your sidebar with too many items. Things like membership buttons and affiliation links should be placed on the Links page.

It is the standard among very well-designed and popular blogs to ensure that the information available is easy to access and organized in such a way that visitors can easily make sense of where they might find things. The sidebar is intended to provide navigation information to the viewer but should never intrude on the content.

If you are using the supplied templates, the sidebar has these general properties:

> Images placed in the sidebar will be resized to a maximum width of 75 pixels.

> Elements in the sidebar are displayed in whatever order they are stacked. Generally, the design templates provided work best if `<$MTInclude module="logo"$>` is the first item in the sidebar.

WHAT TO PUT IN THE SIDEBAR

People design effective photo blogs in a manner that allows the photograph to take precedence. They devote the bulk of the design space to displaying the image. The sidebar is the logical place, therefore, to add any design or functional elements that you want to display on your blog.

The provided templates are installed with a default sidebar configuration but, of course, you can alter this sidebar to suit your own tastes and purposes. Pretty soon, I'd wager, you'll be building your own modules to put into the sidebar or customizing those that are already there.

On all non-blog styles (styles where the images are delivered one at a time to the browser), the sidebar is particularly important, and you must keep firmly in

your mind that anything you put into it that exceeds the height of the content area will not be seen.

The following modules are part of the included template package and can be used in the `#sidebar`. To include any of them in your sidebar, simply create the `include` module code `<$MTInclude module="modulename"$>` and place it into the `<div id="sidebar"> </div>` container in the HTML template.

If you are not using the provided templates, this list provides excellent examples of items you can create to put into any sidebar menu.

> **calendar**: Shows a calendar of the current month with links for the days where entries have been made.

> **search**: Allows users to use the search template that has been installed with your MT system so that entries can be located by keyword or entry title.

> **flickr:** Allows you to add a link back to the flickr page of the photo you are blogging.

> **lastone:** Allows you to simply show the last photo, in context.

> **sidenews**: A module into which you can put your latest news or links or anything that strikes your fancy.

> **rotatethumb**: Selects a random thumbnail from a specified directory.

> **navigationlinks:** Normally used in the `#navmenu`, this module shows the navigational links (previous, next, alike, and comments) for each entry and can be used in the sidebar.

WEB RESOURCE

The companion site (`www.createyouownphoto blog.com`) includes a PSD template that can be used in either Photoshop or Elements and instructions for creating your own logo and simple navigational graphic icons.

A FEW QUICK TROUBLESHOOTING TIPS

Although I cannot provide a comprehensive troubleshooting guide, here are a few of the issues that might commonly arise.

My index page looks blank even though I have added an entry.

Check that the URL is entered properly and that it does not contain any HTML code or errant punctuation marks.

Make sure that the status of your entry is "published."

Did you rebuild your site when prompted? If you are not sure, it will not hurt to rebuild it again,

My thumbnails aren't showing up.

You may have entered an incorrect URL in the entry excerpt field. Ensure that it does not contain any HTML code or errant punctuation marks.

It may be that the URL that you entered in the category description is incorrect or contains extra coding.

Check to make sure that the default excerpt length in your blog settings (settings ⇨ general) is set to 0.

Stuff keeps disappearing from my sidebar.

The sidebar is only as long as the content area and will not display any items that exceed this height. The solutions for this are to add a piece of code to your skin.css file to force the sidebar to a certain height, but this should be approached with caution. Instructions for dealing with this are located on the companion site.

I changed the sidebar but the changes are not showing up on all my pages.

Ensure you make the change to the archive templates as well as the index template and any other template where you want the change to appear.

Did you rebuild your site when prompted? If you are not sure, it will not hurt to rebuild it again.

WORKING WITH PHOTOGRAPHS

THE PHOTOGRAPHS THAT WORK

7-1

Someone once asked me why a person would keep a photo blog. He suggested it might be a little self-indulgent. I said that we photographers are like the kids who come home from school with a hundred paintings who want them all hung on the fridge and cry if they don't all fit. I told him, "We're those kids grown up. With cameras."

I still run into my house and insist everyone within ear- or eyeshot come and "look at this picture" if I capture something particularly wonderful on one of my "picture-taking walks" or have cooked up something I like a lot in my office studio. The photos in Figure 7-1 and Figure 7-2 were each like this; I couldn't wait to get them out of the camera, and each of them was very well viewed after I posted them to my blog. Your own instincts become honed with experience, and soon you just know when you take a shot whether it will have mass appeal or not, or whether it will be remarkable to only a portion of your audience.

7-2

I've been doing this a very long time so I have an advantage, of course, and loads of data that tell me that things with skies work better than things with a lot of dark areas, and that upbeat and colorful images are viewed more often, on whole, than dark, moody ones. Over the years I have collected quite a bit of information and can usually guess how well a photograph will be viewed. However, I want to stress here that I would never, nor do I suggest that you, alter your own instinctive style and artistic sensibility just to get high views. One of the most important and compelling aspects of being self-published is that you are able to display your art, to bring an audience to your work.

Of course you want to build traffic, but you build the most enduring and loyal traffic by finding your own innate style and creating the sort of photographs that you love to make. What this chapter does is help you make the best and most compelling shots within your own style. Using the concepts and practices that have proven successful in attracting viewers, you will be able to produce the most compelling images possible, whether your chosen subject is pretty flowers or urban decay.

7-3

Only a few examples in this chapter, such as Figure 7-3, came from a studio setting. Most of these photographs — for example, Figure 7-4 — were taken "on the fly" in the course of a regular day. Both images, which are of completely different styles and appeal to entirely different audiences, have been viewed frequently and commented upon often.

My father, for example, thought the photograph of the girl in the grass was quite lovely but wondered why I would pile three pieces of marble fruit on a Kleenex box and take a picture. Many other examples used come from "what if" ideas that occurred spontaneously and organically or from situations that suddenly presented themselves.

Perusing the photographs in this chapter should give you a good idea of not only what viewers like to see but also how they like to see it, and should solidify in your mind the truth that there really isn't a bad or wrong subject for a photograph. Virtually anything can be photographed well and interestingly if attention is paid to composition and technique.

7-4

7-5

DEFINING THE WOW FACTOR

There really is a formula for getting your photographs and your photo blog noticed by the viewing public, but it's not magic. All of the photographs in Figure 7-5 are among my most viewed, and they hold several characteristics in common with all those other well-viewed photographs that I found while researching in that they all fit into one of these four archetypical categories:

> **Dramatic** — The subject itself is beautiful, compelling, or fascinating.

> **Invented** — The arrangement of the subject(s) is creative or inventive.

> **Artistic** — There is use of light or perspective to create an unusual visual effect. It's representative or abstract.

> **Narrative** — The photograph implies a story.

Each of these categories favors certain subjects that will be more popular than others as well as photographic and composition methods that are best suited to their style.

DRAMATIC: THE NATURAL BEAUTIES

Certain photographic subjects have universal appeal and they are, in terms of attracting viewers, the slam dunks — photographs that even the jaded and cynical find themselves looking at over and over again. Although they can attract attention in any number of ways — with glowing colors or deep contrast, for example — they're always about the

portrayal of scenes or subjects that resonate with us as human beings. With Figure 7-6, for example, it is hard not to be affected by the sweeping panoramic view and the immenseness of the subject, but even naturally compelling subjects need to be handled properly to get the most impact.

BE BALANCED

Balance is the arrangement of shapes, colors and light/absence of light into negative (empty/light) and positive (filled/dark) spaces that create a pleasing whole. This does not necessarily mean that there is an equal amount of light and dark or filled and empty space, but that offsetting elements come to a balance which is pleasing to the eye. Figure 7-6 is a good example of a well balanced photograph.

INCLUDE CONTEXT

Attention-grabbing, high-impact shots all include an important element — the sense of space and context that they provide, even in small view.

The photograph in Figure 7-7 is appealing because it contains a small subject within a large background and the effect is both visual and intellectual. The lone bird in a close-up (see Figure 7-8), taken from the immensity of its environment, loses the overall impact that the lone bird flying through the clouds, clearly a long way in the distance, possesses. There is usually contrast inside of context and much like a story, an element of conflict or contrast makes for a more dramatic photograph. The more dramatic it is, the more it will be viewed.

7-6

7-7

7-8

7-9

7-10

7-11

SHOOT THE EXOTIC

There are always subjects that get views. Certain animals such as polar bears, lions, and tigers are inherently interesting to most Europeans and North Americans, simply because we do not see them often. The two polar bear shots shown in Figure 7-9 and Figure 7-10, taken two years apart, are among my most-viewed shots.

GET TONED

Not all of the Dramatic photographs are deeply colored. In fact, monochrome, tinted, black-and-white, and sepia can offer as much impact as even the most vividly colored shot. Certain subjects lend themselves very well to this style of color-restrained or singular color tone photography and have a high initial impact, such as the image shown in Figure 7-11. Even the most sharply focused single-tone photograph has a naturally soft appearance, a subtle gradient instead of the sharper lines of a color photograph where one color meets another abruptly. Certain subjects, like skies and water, make extremely catchy photographs and often make very good prints and diptychs.

There are many people, photographers, and viewers who prefer black-and-white or tinted photography, and of all my images, I actually get the most requests for prints, generally speaking, from the monotone images. A good, attention-grabbing, mono image has plenty of contrast, is crisp and clearly focused, and uses a subject for which color is not important to record accurately. A black-and-white photo of a rainbow or a bowl of bright candies, for example, would not be very interesting and would not grab a viewer's attention.

One of the most compelling uses of black and white in this category is with portraiture. While certain types of portraiture could fall into any of the other

categories, a good black-and-white portrait will have the same effect as a stunning color photograph of a beautiful sunset in terms of attracting viewers. A portrait done in black and white, such as the one shown in Figure 7-12, is very attractive to viewers; whenever I post one, it is viewed quickly. People are interested in people and, in fact, close facial portraits are a very large draw whether they are done in black and white or in full, brilliant color.

Black-and-white or monotone provides an excellent tonal range for texture and contrast and is well suited to urban shooting (see Figure 7-13), and landscapes and seascapes, although there are people who shoot only in black and white and do very well with all types of work. In terms of very high impact, a well-executed black-and-white photograph has the added benefit of requiring a closer look to see it; people tend to look at it just to make sure they're not missing something. For making can't-look-away, high-impact single-color-tone photographs, you must have high contrast, clarity of subject, and evenness of tone. A black-and-white photograph is simply one where the colors in the spectrum are converted to a range of grays so you must actually pay very careful attention to color when making a black-and-white photograph. See Figure 7-14 for an illustration of a color strip that has been converted to grayscale.

7-12

7-13

7-14

FINDING A DRAMATIC PHOTOGRAPH

Photographs with this instant wow factor are not as easy to create as some of the ones in the Invented, Artistic, and Narrative categories because it is primarily the subject matter that makes them so commanding. They are not impossible, and can be found almost anywhere if you look for them. For example, John Watson, a California photographer, took the portrait shown in Figure 7-15 on a windy day. He noticed a dramatic photograph in waiting and was fortunate to have a camera with him.

Which brings me to Rule Number One of this and all the other categories: Carry your camera with you all the time. If you have it near, you will not miss these opportunities and, with the exception of some of the landscape and portrait shots, it's a good bet that most dramatic photos are, in fact, impromptu "glad I had my camera with me" shots, such as the one shown in Figure 7-16.

Mystery writer Greg Fallis, frequent poster to flickr, found the birds caught in a rain shower shown in Figure 7-17 while walking near his home. This photo has become one of the most-viewed on his stream — a beautiful image we would not be able to see except for the fact that Greg usually has his camera with him.

Whether it's psychology or simply mathematics, if your camera is close by, not only will you be more likely to notice the photo opportunities but you will also be more likely to look for them. Photography is as much about documentation and storytelling as it is visual art, and you can't very often go back and recreate a moment or a circumstance, so it's best to be prepared for them when they happen.

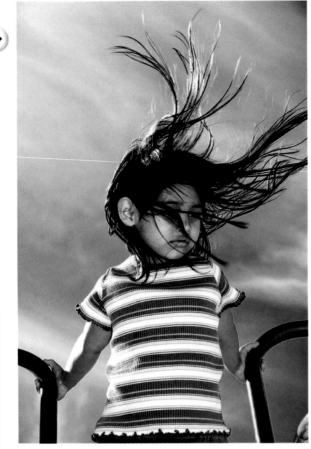

7-15

DESIGNER TIP

Whether working with film or digital images, what you do in the darkroom is as important as what you do while holding the camera. There are very few photographs that can't be improved with a little sharpening, and many benefit from minor color adjustment or cropping. From Ansel Adams to Cindy Sherman, every photographer of note has told us repeatedly that the darkroom is part of the process, not an extra process.

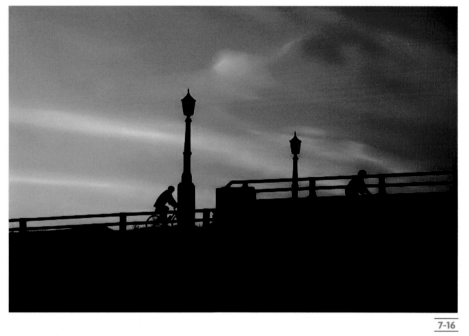

7-16

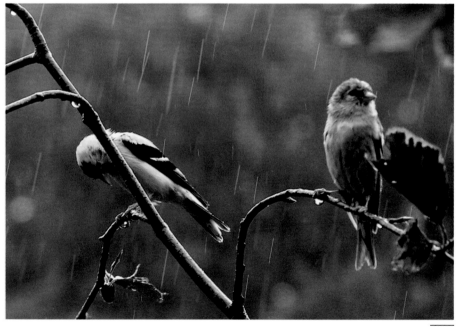

7-17

7-18

INVENTED: CREATE AND DIRECT

Full of clever crops, unusual settings and scenarios, still lifes, arranged and studio shots (see Figure 7-19) and unusual portraits (see Figure 7-20), the photographs in this category have the potential to be the most fun to create and to view. A true win-win.

It is my experience that viewers, many of them photographers as well, are most keen to see those images that combine some element of creative direction. Creative ideas are contagious; not only can they give other people inspiration but they can also grow organically inside the person who had them and inspire even bigger and better ideas. I can think of many times that I sat down to make picture A and ended up enhancing my idea as I worked and ended up with a much better picture B.

7-19

Figure 7-19 has the wow factor for a number of reasons, but the most prominent thing about it is that it is presented unusually with an anonymous model and is cropped tightly to the model's hair. It is a photograph of a moment or an experience more than of a subject. The subject is the wind through the hair and not the hair or the fan or the model herself. It intends to display itself dramatically as an active scene, and thus I chose subtle surrounding colors to set off the distinctive hair color and emphasize the motion that has been captured with the still photograph.

7-20

Although many of the photographs in this section are staged or presented in such a way that it is clear that the photographer spent some time and effort in deciding on the angle or perspective, some photographers, such as Eddy Joaquim, have a keen natural eye for design and balance and are able to spot these unusual photographs as they create themselves (see Figure 7-21). Edward Jackman, who

7-21

7-22

prefers to use Lomo and Holga cameras, is often able to spot these naturally compelling and occurring compositions and his stream is full of such captures like the one in Figure 7-22.

Photographs in this category aren't always invented in whole by the photographer, but some part of them is staged or manipulated — even if just in the framing or awaiting the right moment — so that it provides a particular sort of visual impact. When one makes a Dramatic photo, for example, one tries to do justice to a beautiful or compelling thing and is being a photographer. When one makes a photograph of a floor full of people from above or a threesome of old chairs against a wall, one composes a piece of art with a camera. When one gets under the flower AND the cat, such as Texas painter Lorrie McClanahan did when shooting Figure 7-23, we see a vision of the photographer as much as an actual photograph. People loved all three of these photographs, each one being the most viewed on the photographer's flickr stream of photographs.

The stark white daisy against the neon pink with the small burst of yellow shown in Figure 7-24 is brilliant naturally, but to draw it off into the corner of the frame, down and pointed away from the viewer, is downright genius. Nancy Ward shows an imposing natural talent for composition and graphic design, and her photographs are always appealing in this same way. We cannot help but be drawn to it, not just on color and subject, but because of the good use of negative space (space with nothing in it) and the unusual composition.

7-23

7-24

BE A DIRECTOR

People love the unusual and the unexpected. They also love the iconic (things like the Converse sneaker shown in Figure 7-25) and the familiar, so shots that address both themes together are always well received. A good formula to remember is show the familiar in unusual ways. In part due to this formula, the photographs in Figure 7-24 and Figure 7-25 were both frequently viewed, employ precisely the same composition technique, and are effective for precisely the same reasons:

7-25

> They each employ the use of only three "chunks" of principal color, thus they have high graphic impact.

> They each have a single iconic object as their main subject, so they appeal to the attraction to the familiar.

> Each subject is not only iconic but poetic as well: we all know the "he loves me, he loves me not" daisy rhyme and a Converse sneaker is alike to a rite of passage in North America.

> Each of them employs a focusing technique where the whole image is not in tight focus but a specific focal point has been selected, as indicated by the color cutouts in Figure 7-26.

CAPTURE THE MOTION

Sometimes, being the inventive photographer and creating shots that appeal to people is about letting things happen instead of controlling them — or by exercising only certain sorts of control but actually counting on the mutability of the subject to help create an interesting photograph. In the photograph in Figure 7-27, I relied on two things to provide the interest in this shot:

7-26

7-27

> The motion of the water (which I made bright blue with food coloring) when the olives fell into it.

> My own ability to control the lighting in such a way that I could bring attention to the splash with both the actual motion capture and the brightness of that quadrant of the photograph. In other words, I intentionally created an overexposed area in the top left and an underexposed area in the bottom right as part of balancing this photograph's overall appearance.

Any photograph that captures movement or illustrates the dynamics of motion (see Figure 7-28) is usually successful with viewers. Examples like the racing neon car and the cyclist are always popular with viewers.

There is excitement and change in motion, and these images resonate in a special way with people who see them — particularly in portrait work or photographs of people where there is a sense that they have been captured in a moment of animation.

A shot that depicts motion provides not only an idea of what people look like, but what they are like when they are alive and engaged with the world (see Figure 7-29).

7-28

7-29

155

7-30

Great animated subjects include kites and balloons, anything with wheels, and anything that splashes or crashes or flies through the air. Consider carnival rides, go-kart races, or a ballet recital as animated subjects to photograph. Don't forget, however, that you can also create motion to add interest to a shot, as I did in Figure 7-30, a photograph that I made for an illustration about modern, fast-paced life.

Photographs that I call "still life with motion" (see Figure 7-31) are often viewed and commented upon as a general rule. The beach scene in Figure 7-32 — all constructed in my office with winter safety sand and a bucket and ball from the discount store — is attention grabbing both in its use of iconic subjects and the way that motion has been introduced to what is essentially a very classic still-life setup. The butterfly and partial face in Figure 7-33 was made as an illustration for another purpose but it was an instant hit when I posted it to my blog. It is not only whimsical and light in nature, but it has an interesting color palette.

7-31

7-32

7-33

STILL LIFE MAKES A COMEBACK

These staged and invented shots are no different than what Ruth Bernhard or Man Ray used to cook up in the early days, before photography came to be seen as a primarily journalistic or recording device. In fact, in its infancy photography was very much an artistic medium. Today, as digital photography makes experimenting and having fun possible for a large number of people, people are showing more

and more inventive and creative photographs on photo blogs, where they are enthusiastically embraced by the viewing public.

One of the most inventive and time-honored styles of photography is still life, and many of today's photographer's are creating fascinating still-life photography, as shown in Figure 7-34. This image was created by Lorrie McClanahan, who said that she'd been "experimenting with photos within a photo," and in that process created the outstanding still life shown.

7-34

MINE YOUR SURROUNDINGS

For the longest time, well before anyone ever hired me to take a photograph professionally, I was left to my own devices, and with a limited budget for props and costumes, I learned to "make do." To this day, I scour thrift stores, flea markets, and my own house for most

of the things that appear in my photographs. For example, I made the paper props in Figure 7-35 from an old calendar of art that I cut into pieces. Then I used two cheap desk lamps, a piece of tinfoil (to reflect the ambient light), and a cone made from construction paper (to focus the directed light) and created a series of photographs that I eventually sold at a gallery show and were often viewed and well received on my blog.

The photograph in Figure 7-36 was taken when I noticed that the bright sun through my office window was cutting a line across a vase of roses that my daughter had given me for my birthday, and it struck me how different they looked in both bright light and shade. When the cat walked across the table I thought, "Oh, I hope she doesn't knock them over." Which gave me the idea to . . . well . . . knock them over and take a picture of that against the spot where the sun dissected the shade.

7-36

ARTISTIC: CONTROLLING THE CANVAS

I refer to "Artistic" as the photographs that are all about making a particular impact, that are not just created but designed as well. The Dramatic beg you to take them and usually reward you with a good photograph; the invented ones in the second category are the manifestation of your own subject and composition ideas, and intrigue people with their uniqueness and unusual perspectives. Those in the Artistic category strike up conversations, get people asking how you did it, are widely linked and blogged, and are always viewed frequently, as was the photograph in Figure 7-37.

Artistic photos can be of any subject or composition, including any from the aforementioned categories, but they're presented as artistic pieces. Sometimes they come out of the camera as they are presented (see Figure 7-38) or are worked on later in a

7-37

7-38

photo-editing program. Figures 7-39 and 7-40 were both post-processed to provide a more vibrant color space. For further reference, photographic techniques and post-processing are discussed in Chapter 8.

Some of the photographs in this category, such as those shown in Figure 7-41 and Figure 7-42 rely on the use of generous white space and striking composition to give them impact. Each of these uses a reflection, providing a split canvas and a specific kind of visual cue that forces the viewer to consider the picture from two perspectives and thus consider it longer.

7-40

Artistry is very personal, and there are no rules so much as there are guidelines. For example, Figure 7-43 is one of those that is viewed a few new times each day as people look through my archives, even though it does not conform to very many accepted photographic principles. One of the reasons it is viewed a lot, in fact, is because it defies the rules so blatantly and one wonders what the subject is doing all the way over at the end, almost out of the frame. Of course, the symbolism inherent in the shot is an important aspect of its appeal. To anyone familiar with the Judeo-Christian thesis, the subject could well be Eve, offering up the very apple of temptation.

7-41

DESIGNER TIP

Take risks, be daring, make the images YOU think are cool, beautiful, or meaningful, and the chances are very high that you will find your own individual style AND an audience for it.

2005 Catherine Jamieson

7-42

7-43

7-44

7-45

7-46

Go ABSTRACT

The photographer and his perception of his visual world is very apparent in the successful artistic photograph. Abstractions and other treatments, such as the motion blur shown in Figure 7-44, are usually very well viewed.

The artistic or abstract photograph doesn't rely on crisp focus or perfect color tone — it relies on graphic or visual impact apart from the subject. For example, even though the three cars shown in Figure 7-45 are compelling enough as a subject, the thing that makes this photograph interesting is the sense of motion that its abstraction implies; there is an environment in the photograph that the viewer can "feel" when looking at it.

Many photographs that have high appeal do not even contain a subject that is readily identifiable, such as the very popular abstract of a shower head I took while shopping for a new kitchen floor one day (see Figure 7-46). This photo is both abstract and macro in nature.

In all of these Artistic shots, the appeal is in the symmetry and the use of light more than the accurate recording of an object. Repeating patterns and themes are very popular, and images with stark lines or which are cut into symmetrical sections (see Figure 7-47) make excellent prints for hanging. When shown in a series, these photos can be very compelling to a wide range of viewers.

Many or most abstract and macro shots do not contain a complete scene but rather some portion of it; generally the object(s) being photographed are not shown in full and tend to run off the edge of the photograph without any negative or framing space. It is therefore especially important with these photographs to present them with some matting or blank space around the image so that the image does not get lost in the environment.

GET CLOSE

Macro shots are perennial favorites. People love to see things close up or removed from even their natural context. Macros also offer one of the most effective methods of attracting the viewer in search of eye candy.

Flowers, such as the coneflower macro shown in Figure 7-48, provide some of the best opportunities for macros. Many online groups and clubs specifically collect these photographs. Flower macros serve as good examples of shallow depth of field (DOF), which is explained in more detail in Chapter 8. A shallow depth of field means that only a shallow or small portion of the object is in focus; many macro photographers employ DOF variations to create interest in the image.

The photograph in Figure 7-49 has a very shallow DOF with only the very tip of the flower in focus. You can achieve this effect by placing the camera lens very close to the subject and using a very low aperture setting.

When you can draw out either a whole subject or a piece of it from its surroundings and provide good color or texture contrast between the focused parts and the blurred parts, you create a natural conflict in the image itself that is generally intriguing to people. Contrast like this works to create interest with many photographic elements — color, texture, and light — where you can distinguish one from the other with clever framing, perspective, and choice of focal points.

Contrast is a vital component to all art, and amongst the easiest ways to achieve good visual contrast with photography is with color. Ironically, the colors that appear opposite each other on a color wheel are called complementary (red/green, yellow/violet, orange/blue) and often provide the most compelling and pleasing combinations. I highly recommend that you spend a little time reviewing basic color theory when you determine that you want to start making artistic shots as the information will help you understand why things look good (or not) together.

7-47

7-48

7-49

7-50

LIGHTING

With just a few lights and a blank wall, you can do a great deal with photography. The shot in Figure 7-50 was achieved with some directed light, a plastic bowler hat, and a cigarette. I always say that photography is all about lighting and timing; even though it is about more than that, to some extent the success of a photographer depends upon how well he or she understands light. Photography is, after all, the recording of light, and learning to master it will improve your photography 100 fold.

The use of direct soft light on the portrait shown in Figure 7-51, combined with the use of an obscuring piece of cloth and the very tight crop, creates an exotic-looking portrait from a very ordinary looking model in conditions that could be repeated in your own office, living room, or wherever you work.

In Figures 7-52 and 7-53, lighting was the primary creative tool; the key to getting the shots was, quite literally, practice. In Figure 7-52, I shone a bright halogen lamp at my face while pulling away a reflective safety blanket in order to achieve the "melting" look, and it took many tries to capture the right light at exactly the right time. In Figure 7-53, it was the use of colored light on the model's back and a small hidden spotlight in front that creates the unusual effect of over bright and over dark on opposite areas, as well as the mysterious ambience on the left side of the photograph.

When you are starting out, there is no reason whatsoever to have to invest in expensive lighting as there are many readily available options. Full-spectrum light bulbs, such as those used by doctors and lab technicians or used as plant lights, offer an excellent natural-light effect and are available at most hardware stores. Avoid incandescent lighting (regular household light bulbs), as they leave a yellow cast; if you can't find any full-spectrum bulbs, look for bulbs with a blue cast to the glass, which are usually called "daylight" or "natural light." With two goose-neck lamps, two full-spectrum light bulbs, and a little experimentation, you can achieve virtually any effect or result that you want.

7-51

7-52

7-53

GALLERY STYLE

I help administer a group called "Pick a Portfolio" that helps amateur photographers pick out a selection of their photographs suitable for printing, matting, and presenting with a professional portfolio to a prospective client. The most frequent comment I hear by those having their portfolios picked is, "It doesn't look as good in print." This is not a commentary on the quality of the image or the resolution, but on the composition of the image and its impact when taken away from the light-emitting screen and placed on light absorbing paper and given no context but itself.

One of the reasons it is better to have a blog and show your photographs inside of your own environment instead of using only a photo storage site to display your work is that you can control it. You can provide, for example, wide mattes and an appropriately uncluttered environment for your photographs to appear much the way they would in print. Anything that is specifically framed to be a good print will automatically be a good blog shot but, conversely, not all good blog shots make good prints. Those rare shots that would make good general use art prints (which is a quality that bears much more discussion but boils down to a stunning composition, a good tonal range, and an interesting subject) are always big hits on a blog.

If I am participating in a show and need to make specific photographs for it, I take them with a special attention to the composition, knowing it will be seen from ten feet away at eye level, much farther away and higher than it is on a computer screen. The photographic artwork in Figure 7-54 was all created with framing in mind. I find them interestingly similar in several ways. They all have a strong, off-center focus, they all have an extreme tonal range (deep color saturation and/or high contrast), and each of them has a color hotspot (an area where a color "pops" much more than in other areas creating a natural focal point. Additionally, each of them is very in-line with the standard photographic Rule of Thirds, which basically states that a photograph's center of interest should exist on one of the intersections created were you to divide the photograph into three equal vertical and horizontal areas.

To make photographs that will make good prints, the best way is the old-fashioned way — print them, matte them, and hang them on your wall for a few days. You will soon develop your own instinct about which of your photographs will gracefully make the transition to paper.

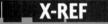

X-REF

Chapter 8 provides a detailed discussion of the Rule of Thirds.

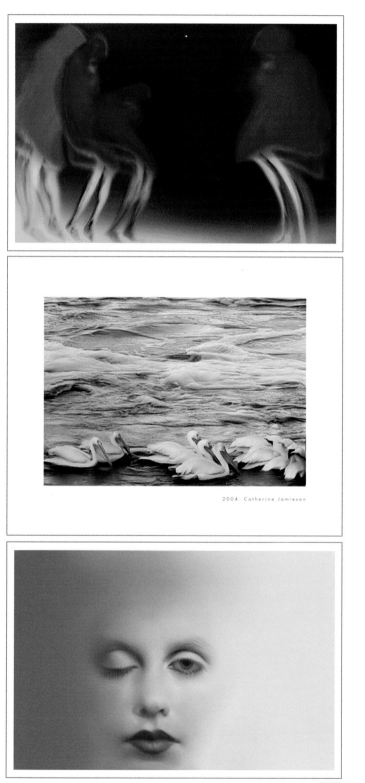

2004: Catherine Jamieson

7-54

ART IS EVERYWHERE

Some art you make and some art you are just lucky enough to be able to record. Call it what you will — made by something divine, made by mother nature, made by renegade quarks — some art photography is a matter of recording it and framing it to best advantage such as the wonderful photo from London photographer Taro Taylor, who got help from the overhead sun and a friendly pigeon (see Figure 7-55).

What makes these photographs special is the choices the photographer makes for angle and perspective, the places they choose to begin and end their photographs, the lines and curves they choose to exist, and where they choose to put them. The pigeon would not work so well if he were outside the reflected circle and a step or two in either direction would have changed the balance of the image significantly as the perspective indicates the photographer was very close to the subjects or at close focal range. The light standard in the middle of the round area creates a clock effect, and this requires careful planning while you are behind the camera.

7-55

NARRATIVE: THE STORYTELLERS

Photography is a recording medium. It captures light and presses it to a surface, and a moment in time is captured (see Figure 7-56). It can be used to tell visual stories. Even without actual words, some of the most compelling photographs on blogs today are those that make narrative statements, whether they are literary, social, political, or philosophical in nature.

7-56

The photograph in Figure 7-57 was not only viewed very often but it was viewed very quickly. It has generated more email than any other photograph I have ever taken because it is representative of an idea and is intended to provoke, at least, an internal dialogue in the viewer.

Sometimes we take photographs merely to create something pretty, and sometimes we take photographs to record something such as a social condition.

These photographs appeal to not only the traditional photograph viewing audience, those who seek out photography especially, but to the reading and general Internet audience, as these are the photographs for which the expression "worth a thousand words" was invented. We might call them journalistic, poetic, or narrative, and they all have different stories to tell. Have a voice. Mean something beyond the visual.

7-57

If you have a camera, you don't need to be able to write stories or create poetry to tell your story or express your thoughts and opinions. A camera can be used to express virtually every idea or emotion. When created for the task of saying something you feel is important, a photograph extends beyond being merely a craft or hobby and becomes a bona fide artistic expression.

THE NARRATIVE PORTRAIT

The portrait is most often a narrative by design, meant to express a unique quality or a valued characteristic. Many of the most compelling photographs online are personal portraits. Whether it is of yourself, which are extraordinarily well viewed on most community sites and blogs, or of someone you met who intrigued you in some way, the human moments and conditions displayed in personal portraits are compelling to people searching for some synchronicity or merely because they are curious about other people.

Carrie Musgrave's endearing portrait of the bored angel (see Figure 7-58) is not only technically excellent with a terrific crop and color tone, but it reminds us of the little angels in our own lives and it is, quite simply, very cute, very human, and very grounding.

7-58

The narrative photograph is almost always what I call subject-centric in that it puts the subject right there as not only the unmistakable focus of attention, but the unavoidable one. The ethereal and beautiful portrait of Sakura Handa shown in Figure 7-59 is intended as a loving memorial tribute to a beloved friend. In her smile we see a narrative of affection that makes the photograph both appealing visually and touching emotionally. The composition of the photograph is such that your eyes, no matter what, are drawn to hers.

A SLICE OF LIFE

Photographs with a narrative element attempt to pass along a message, even if it is a simple, everyday message such as the one in Figure 7-60, which might be, "Remember when catching butterflies was the hardest thing you had to do that day?" Slice-of-life portraits appeal to virtually every demographic. I consider this sort of personal storytelling photography to be the most important of all, as it constitutes modern folk art, which in my mind is the primary reason for creating a photo blog— to tell our stories and share our visions.

7-59

7-60

7-61

The compelling narrative photograph sets a scene such as the couple in Figure 7-61 whom I saw in a small diner in a small university town. Although you can't hear them and I can't tell you the whole story in the picture, it might not surprise you to know that he held her chair and she poured his coffee, and they held hands when they walked down the street after the last of the muffin had been shared. These are moments in the shared existence that we are richer and better for experiencing, and although a photo blog is perfect for displaying the Dramatic and the art you invent and create, it's also the perfect place to share some of these stories and moments with an appreciative audience. My blog, for example, gets almost twice the amount of views on days that I write a little narrative with a photograph that already has one built in. People like stories and even if your thing is not writing, you can tell them just as well with your images.

THE HARD STORIES

It's not always the stories of hearts and flowers and feel-good moments that we want to tell, of course. There are other moments and experiences that touch us profoundly and for which we feel the need to share with others and bring to their attention something we think is important. Irina Souiki does this with her portraits of breast cancer survivors, as shown in Figure 7-62, or many photo bloggers do with portraits of their urban surroundings.

Niches of viewers seek out this style of narrative photography. These people are after more than a

7-62

pretty picture and very often become loyal viewers if they discover a photo blog whose publisher has the same sensibilities and concerns that they have. Naturally, there is a way to make both visually appealing and socially responsible photography such as these photographers are able to manage. Even if your story or concern is less serious than cancer or urban decay, there is a way to represent it visually with photography.

A good narrative photograph directs us to the important part of the story; the critical pieces of information are all in the frame. A good example is the pictorial short story evident in the photograph shown in Figure 7-63, which I took while waiting in a line at a large mall's food court. Although it is a pleasant enough photograph with even tones and a fairly solid composition, what makes it compelling is the story it tells.

IN THE NEIGHBORHOOD

One of the most familiar and frequent uses of the narrative style of photography is in shots that come from the local environment of the photographer, whether it be urban street shots that record decline or decay or the sorts of photographs that merely record a representative moment in an everyday life (see Figure 7-64).

These are images that carry a little statement with them, imprinted subliminally in the way the image was composed — such as in Figure 7-65, where the angle cuts off the row of crushed cars and we wonder how many more might be in the collection behind that chain-link fence.

7-63

7-64

7-65

In Figure 7-66, the angle and perspective is such that the photographer might have been leaning on the counter and talking to the two subjects; the atmosphere is cozy and familiar.

In an urban, cosmopolitan setting it is often the night shots (see Figure 7-67) that command a viewer's attention. They can provide dramatic silhouette and deep contrast and bring the mood of a place to the viewer as much for what can be seen as for what cannot be seen. Images like Figure 7-68 have a combined impact in that they are visually graphic and interesting and they carry a message, however subtle and subliminal.

A Middle Eastern woman on flickr has a collection of bomb-shelter photographs where she shows variously painted and decorated shelters against events that most of us will never experience. Another woman posts photographs of the abused and abandoned cats and dogs that she rescues and nurses back to health. These are some of the uses to which narrative photography can be put; beyond the visual message, there can be a narrative one.

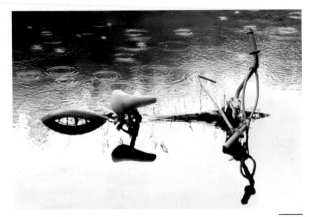

7-67

Now that you know what sort of photographs work for the general viewing public, you need to understand the basic photographic techniques used to make successful photographs. In Chapter 8 I talk about how to coax a great picture from your camera and process it for viewing on the Web.

7-68

FROM CAMERA TO BLOG:
MAKING THE MAGIC HAPPEN

8-1

I'll bet you're excited!

I'll bet you have tons of ideas for great photographs milling around in your creative mind. I bet you're looking at everything you see now like it's a good subject for a photograph. The news is good: Everything is a good subject for a photograph.

In fact, Figure 8-1 is a collection of thumbnail photographs from my archives that are all well viewed and are all subjects that might be considered too mundane for a piece of artwork.

And make no mistake: You're creating art here. Photography is one of the visual arts, and your creations are every bit as much art as your neighbor's watercolors or Rodin's sculptures.

As shown in Chapter 7, photographs can be found everywhere you look, so it's not so much a matter of what you choose as a subject, but how you present that choice.

The process of taking a photograph from an idea in your head to a page on your blog follows these basic steps:

1. **Subject and Composition:** Choose a subject and decide how to arrange it and its environment to the best advantage.

2. **Darkroom:** Process the original photograph to be suitable for blogging.

3. **Saving:** Create the uploadable photograph file for viewing on the Web.

IDENTIFYING THE SUBJECT OR AREA OF INTEREST

The subject, of course, is the main interest of the photograph. Sometimes it is abundantly clear (see Figure 8-2) and sometimes it is less clear (see Figure 8-3). Better described as an area of interest, some examples of a photographic subject are

8-2

8-3

8-4

> Light or shadow (see Figure 8-4)

> Motion (see Figure 8-5)

> An object, inanimate or animate (see Figure 8-6)

> A pattern (see Figure 8-7)

> Texture (see Figure 8-8)

> A color (see Figure 8-9)

8-5

8-6

8-7

8-8

The area of interest or subject is the reason your photograph exists, and it should be clear to the viewer whether your intention was to show the interplay of light against a reflective surface or to highlight the pretty brown of the model's eyes. Whatever it is that strikes you as the most compelling aspect of the scene should be made into the area of interest or the subject. This rule applies whether you are photographing a landscape, an abstract, or a portrait for a company brochure — find the most compelling aspect of the scene or subject, and find a way to communicate that interest inside your photograph.

UNDERSTANDING COMPOSITION

Simply, composition refers to the way that the elements in the photograph are arranged. Whether they are objects such as those in Figure 8-10 that you can arrange yourself or subjects over which you have less control, such as those in Figure 8-11, the photographer is still in charge of the lay of the land, so to speak, with every picture he or she takes.

Everything is important, of course. Focus and exposure cannot be discounted, but the great photograph is made in the visual center of your artistic mind.

8-9

8-10

8-11

Everything else you can learn by rote and experience, or you can correct it to some degree after you take the photograph. Your compositional choices are there to stay, however, except for some peripheral variations you can make by cropping parts of the image away.

The question has been dogging artists through recorded history, but like all philosophies related to the arts there are few solid answers about "right" and "wrong" in terms of composition. There are, however, a few guidelines. We know what people like and what stands the test of time — every art gallery, art book, and successful photo blog is full of examples — and from this body of work patterns emerge. These become the "rules" from which we all operate, not because they're rules, but because they work.

I say it quite often and I believe it to be true: All good photographers follow these rules instinctively. Once you get them down and understand why they work, they stop being a conscious part of the composition process. I can't remember the last time I thought about a composition in terms of the rules. In the end, all the rules in the world come down to this: It either looks good or it doesn't.

APPLYING THE RULE OF THIRDS TO COMPOSITIONS

The compositional standard is the rule of thirds, which says that a photograph's subject or center of

interest should be placed either on one of the four intersections that would occur were you to split the frame into three vertical and horizontal lines as shown in Figure 8-12, or along one of those lines such as shown in Figure 8-13, both of which are among my most-viewed photographs.

As you compose the photograph in the camera, try to imagine these lines and keep the object or area of interest within one of the intersections. Many photographers, in fact, do this naturally without ever knowing there is a rule.

While there is no doubt that the drama queen in Figure 8-12 would get attention even if I had chosen a different composition (such as that in Figure 8-14), the one I did choose falls naturally into line with the rule of thirds and creates a strong, visual impact and a very compelling photograph. Adherence or disregard of the rule of thirds won't make or break a photograph, but it can make a good one better.

As with all rules that develop from precedent and practice, dogmatically following it is often as poor a choice as completely ignoring it. George Bernard Shaw said a thing once that I like to remind myself of now and again when a rule seems unreasonable:

"A reasonable man," he said, "adapts himself to his environment. An unreasonable man persists in attempting to adapt his environment to suit himself. Therefore, all progress depends upon the unreasonable man."

8-12

8-13

8-14

8-15

In the photograph in Figure 8-15, for example, I decided the rule was unreasonable and I broke it. The result is the photograph that gets more attention and has been looked at more times than any other photograph I have ever taken. Similarly, in the photograph in Figure 8-16, I broke the rule by putting the horizon in the middle of the frame but I did so because I thought it looked better and left the visual impression I wanted to leave — it was a half-grain, half-sky location. However, I follow it with the photograph in Figure 8-17 where I place the subject on the bottom left against the negative space the sky creates and with the landscape scene in Figure 8-18 where the horizon is well inside the bottom quadrant.

The rule of thirds can also be applied when making a composition by arranging the main elements along a diagonal line that crosses two of the intersections. This same principal follows with elliptical, curved, serpentine, or zigzag shapes as well. There is not a shape or subject to which the rule of thirds cannot be applied as the four photographs in Figure 8-19 illustrate.

8-16

8-17

8-18

If you study paintings, especially those by old masters such as Dutch painter Johannes Vermeer, you will see a consistent adherence to the same principals of visual presentation as the rule of thirds suggests. In fact, most painters study this very rule as a part of their fine art education.

The Eye Path

Painters often use what is called the "eye path" to describe how a painting is composed to intentionally draw the view along a specific path. Photographs are composed in exactly the same way, albeit with slightly less control than a painter can impose. The eye path flows across all the elements in the positive space and is supposed to ignore the negative space. The background of a photograph is the negative space and is meant to be more neutral than negative, but the important point is that it is not meant to draw the viewer's eye but exists to enhance what you do want the viewer to see. Because of the way the human eye perceives space and prioritizes what it will be drawn to, painters often apply a rule of no more than a 40-percent-to-60-percent ratio of positive to negative space. In other words, the perfectly balanced visual image is not 50/50 — but is 40 percent positive space and 60 percent negative or neutral space.

8-20

In general, the rule of thirds dictates the following:

> Keep the main area of interest or the subject(s) on or at the intersections of the lines that divide the photograph into thirds (see Figure 8-20).

> Horizons, sky and water lines, or any element that divides the photograph should be in any of the outer sections and virtually never in the middle (see Figure 8-21).

> Elements in the composition should, as much as possible follow a line — straight, elliptical, or diagonal — and should cross through at least one of the intersections (see Figure 8-22).

> Moving objects should be placed as close to the outer area, which would be behind the direction of their movement so they are moving into the photograph and not out of it (see Figure 8-23).

> Avoid the center placement of any line that crosses all or a large portion of the photograph (see Figure 8-24).

> On close or abstract shots where the entire frame is filled with the subject the rule of thirds is used to dictate the position of one or more elements of the subject rather than the subject itself (see Figure 8-25).

8-22

8-23

The rule of thirds is a guideline, and you should follow it when it makes sense to your own personal aesthetic. But don't forget the unreasonable man, and remember, stiff, centered portraits were once the rule, too.

Although the rule of thirds covers how you should arrange lines, it does not convey how important lines are in any visual composition. From winding rivers, bending roads, straight fences, tiered steps, and a row of ballerina's legs, the line is an enduring graphic tool in that it directs a viewer's eye along its path. A diagonal line starting at one corner and ending in the other, for example, no matter how circuitously it travels to get there, causes the viewer's eye to follow it. Lines represents motion and movement, however passive (such as the lines of a tall ship's masts or a building's portico columns), and we naturally follow them, innately curious about where they lead. Straight lines convey strength, expanding lines such as on the underside of a mushroom cap convey grace, and winding or serpentine lines convey patience. When a clear line of any sort is part of your composition, it is usually important to give it space and not obstruct it with other objects; a broken line can present a photograph with an unclear subject and possibly an uninteresting one. If your subject, for example, is a winding river, try to capture it so that it starts in one corner, ends in the opposite corner and is visible throughout the entire photograph. Similarly, architectural shots work best when one or more unbroken lines create the photograph's structure.

8-24

8-25

8-26

MAKE YOUR SUBJECT CLEAR

The subject, or area of interest, must be prominent and clear. Viewers must understand what they are looking at, what you mean for them to see and understand. When I saw the mother and daughter in Figures 8-26 through 8-28 at the mall I was struck by their apparent closeness and synchronicity and thought they made a lovely picture of animated life against the tungsten yellow interior of the mall.

In Figure 8-26, not only is the angle bad by about 5 degrees, but the subject appears to be the light at the end, or maybe the girl's backlit shape, or the mother's parcel. Or the dark blob in the corner. It's not a very good photograph primarily because it is unclear in subject, which makes it extraordinarily visually unappealing.

In Figure 8-27, the subject is either the plant or the mother, but who can tell in that circus of elements? With the plant so strongly in the foreground it cannot be ignored and try as you might, you find your eye going back to it in the same way your eye likely kept going back to the figure entering the mall in Figure 8-26.

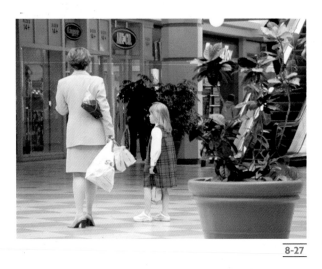

8-27

In the final example, Figure 8-28, we see not only the subjects very clearly and distinctly, the environment frames them and does not compete with them.

LIGHT, MOTION, AND PATTERN AS SUBJECTS

For some art photography, shots where texture, light, or motion is important to the composition or is the actual subject, it can be harder to keep the "subject" clear as the whole frame is effectively the subject, such as the photograph in Figure 8-29. In these cases, I recommend that you analyze the scene for what you consider the area of most interest and make it the effective subject. In this case it is the interplay of motion and light that I chose to place

8-28

slightly off-center. In these sorts of abstract photographs I tend to follow a completely artistic approach and go with "what looks good to me," but even here the rule of thirds comes into play with tonal ranges and texture variations being distinct in three more or less equal vertical layers as shown in Figure 8-30.

8-29

8-30

IN-CAMERA CROPPING

Sometimes composition choices boil down to in-camera cropping, which rectangle of the scene you choose to capture, such as the four different compositions of the colorful shopping carts I found in a hardware store parking lot shown in Figure 8-31. Eventually, I decided it was really much better without all the context and got close enough to frame the photograph as shown in Figure 8-32.

The primary reason why it looks better in Figure 8-32 than in any of the four others is that the subject or area of interest is the child's cart with the number painted on the side. Without it, this is simply a picture of some orange carts, and in all of the top four views the small cart is not prominent enough to make an impact and is, in fact, lost in the long perspective. To see how this photograph stacks up to the rule of thirds, see Figure 8-33.

8-31

Make your subjects stand out and be noticed inside of your compositions. To get your message across or for your photograph to have wide appeal you must give viewers something interesting to look at and a place to direct their attention.

It should be noted that there is no one guideline that works for everything or every photographic situation and to make a broad rule and insist it be universally applied is a bad artistic practice. There are very good photographs, such as abstracts, macros, and repeating pattern shots in which you must make decisions of taste and artistic sensibility and to which the rules are only vague guidelines. In every single one of those cases I urge you to go with both your instinct and your experience and to simply shoot the composition that most appeals to you personally.

8-32

8-33

POINT OF VIEW

The point of view is, as the name implies, the point from which the camera is viewing the subject.

When you can't affect a composition yourself by moving the subjects or shifting the light (such as when taking a photograph of a building or a landscape) it is left to you to adjust yourself and your camera to arrange the objects in the best way possible by altering the point of view.

To illustrate how a point of view can alter a photograph, Figure 8-34 shows four points of view of a floral shot, and Figure 8-35 shows four points of view of a live model, all taken within moments of each other and all from within a foot of the original position. By varying both the angle of view and the distance from the subject, four very different photographs emerge.

POV decisions are a combination of the practical and the artistic, and you make them for a variety of reasons, such as:

From Camera to Blog: Making the Magic Happen

8-34

8-35

> To remove a bad background or improve a poor background

> To allow for a closer focus on a particular aspect of the subject(s)

> To highlight or show a particular "view" or angle of the subject(s)

> To improve a composition

My theory is that every subject has an interesting POV; it's just a matter of finding what it is. The best way I know to do this is to literally stick your camera to your face and move around your subject, adjusting your height, distance, and angle, until a frame that appeals to you appears.

The two photographs of sugar-coated strawberries in Figures 8-36 and 8-37 were taken at the same time. They are the same strawberries with the same lighting and the same camera settings. The only difference is the point of view and the distance from the subject. By varying these two things, the angle at which you look at a subject and the distance you are from it, the possible compositional permutations a photograph can have is, literally, infinite.

Point of view is what separates your photographs from the next person's. The choices you make and the way you choose to display your subject, even if it is an extreme macro and you are choosing where the brightest spot should be, will distinguish your photographs from those in the pack.

8-36

8-37

My advice is to take the same photograph from many different points of view so that you can experiment with all the different things that a change in perspective alters in the photograph. Changing the point of view is the most versatile and important of all photographic compositional tools.

BASIC COMPOSITIONAL GUIDELINES

While the composition of a photograph is largely a matter of individual taste and personal appeal, there are some basic guidelines which will help you make your compositional choices.

1. Follow the rule of thirds where practical, reasonable, and within your own taste.

2. Don't clutter your photograph with too many subjects or unclear subjects.

8-38

3. Place white or negative space as if it were one of the subjects in the photograph.

4. Aim to create a space with an even tonal range — where the darker and lighter areas or the full and empty areas feel balanced. All of the photographs in Figure 8-38 are good examples of well-balanced photographs.

5. Photographs with dramatic shifts in color and texture are always visually appealing, such as the photographs in Figure 8-39.

6. Choose either very interesting subjects or present very ordinary subjects in very interesting ways.

8-39

DEPTH OF FIELD

Although common sense would seem to say that everything should be in focus sometimes it is what is not in focus that adds character and interest to a photograph.

Depth of field (DOF) refers to how much of the photograph is in focus and how much is not in focus. Specifically, it is the distance between the farthest and nearest points that are in focus. The DOF can be affected by many factors such as the lens that is used, aperture setting, and distance from subject but the application of it remains constant and is a tremendous artistic device.

8-40

Often, selecting a specific and isolated point of focus brings added interest to a photograph, such as Figure 8-40. This photograph has a very shallow depth of field in that only a small portion — that closest to the camera —is in focus while the background fades quickly into blur. In Figure 8-41, I chose the distant area to bring into focus, creating an unfocused or blurry area in front of the subject. You can selectively focus the front, back, or anywhere in the middle of a scene when taking a photograph.

When I make choices for DOF in my photographs, I employ a very simple, uncomplicated method of trial and error. I virtually never assume my first instinct is correct, and I try several combinations of distance from subject and point of view (POV). I very often go away with a different photograph than I first imagined I would take. Photography is, in some ways, about being open to possibilities. After all, you have so many variables to work with: light, distance, color, shape, texture, shadow — even temperature affects the color tone of photographs.

8-41

By creating a middle point to focus on and arranging yourself the right distance in front of the subject, you can create very stunning and compelling effects where both the front and the back of the subject are out of focus. As Figure 8-42 illustrates, this creates a three-dimensional effect that is very interesting, visually. These are the photographs — the ones with clever and creative use of DOF — that people look at the longest and ask about the most often.

8-42

Figures 8-43 and 8-44 illustrate two very simple and broad general rules for creating DOF effects:

> The closer you are to the object of focus, the more shallow the depth of field (a smaller area of the photograph is clear and focused). You can get closer to the object by moving yourself and the camera closer or by zooming in if your camera has a zoom lens. In Figure 8-43, the front blue marble is very close to the lens and is the only thing in clear focus.

> The closer you are to the level of the object and the less your camera is angled toward the subject, the more depth of field you achieve; more of your photograph will be in focus. In Figure 8-44, the closest object is about 2 feet away from the camera lens, and the camera is, in fact, sitting on the same surface as the subjects.

8-43

8-44

PRO TIP

A quick way to shorten the DOF, if you have a camera on which you can adjust the shutter speed and set to shutter priority, is to increase the shutter speed which will cause your camera to open the aperture wider (smaller f-stop). Many DOF effects are best achieved with very low f-stop settings. Traditional portraits are often taken with low f-stop settings so that the subject's face is in focus while the background fades to a blur.

8-45

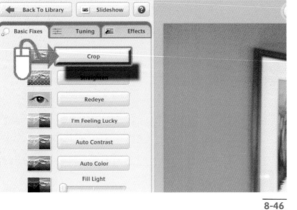

8-46

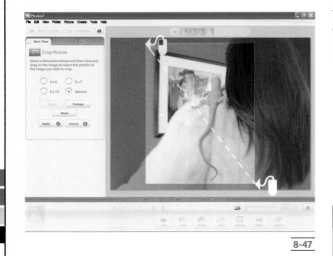

8-47

WORKING IN THE DIGITAL DARKROOM

Every professional photographer that I know either uses tools in the darkroom or uses Photoshop or some other photo-editing software to, at the very least, lift off dust and scratches or adjust tonal irregularities. Even if you wish to make the best possible photograph right in the camera, you will always need to be able to know how to crop, adjust the rotation or tilt, and do minor color correction and sharpening.

PHOTO-EDITING SOFTWARE

Many software programs are sold for editing photographs, but many bloggers use either Picasa, the photograph management and editing software that you can download free by going to www.picasa.com, or the industry standard Adobe Photoshop, which must be purchased. I actually use both programs. I find Picasa to be an incredibly valuable organizational program for keeping my photographs in order. For quick fixes like crops and simple color adjustments Picasa can't be beat, but when I need to prepare a photograph for print or professional use, I use Photoshop to take advantage of the more comprehensive editing tools.

Mastery of either of these programs is too broad a topic to be discussed here, so in the sections that follow, I discuss the three primary editing processes, in the order in which they should be performed:

1. **Cropping:** Removing peripheral parts of the photograph to provide a more pleasing composition

2. **Resizing:** Adjusting the size of the photograph for use on the Web

3. **Sharpening:** Creating a fuller focus

NOTE

Picasa does not have a facility for resizing photographs, but you can export copies of them in a different size.

From Camera to Blog: Making the Magic Happen

CROPPING

Cropping refers to the removal of a section of the photograph or a cropping away of the sides. Likely the most used editing tool universally, cropping a photograph is simply a way to improve an in-camera composition or to force a photograph to a certain dimension or shape such as square or 3:2 aspect ratio.

I like to "have a little tucked under the matte" and often take photographs with an extra area around what I think I will use. This allows me a wider range of composition choices once I am comfortably situated in my chair with a coffee in my hand and I can see the image in large size as others will see it.

To use the crop tool in Picasa, follow these steps:

1. With Picasa open to your default view, double-click on the thumbnail image you want to edit (see Figure 8-45). When it opens in large size in the viewing window a series of menu buttons will appear along the left side of the screen.

2. Click crop (see Figure 8-46).

3. Choose one of the preset sizes on the left panel or select your own crop (recommended) by clicking on the screen where you want to place one of the corners (see Figure 8-47).

4. Click and drag your mouse across the picture diagonally. The portion of your picture that will be cropped appears with an opaque overlay, and the portion that will remain is clear.

5. Modify the size or shape of the crop by clicking on any of the four sides or corners of the clear, remnant area and dragging the window into a different shape.

6. When you are satisfied, click the preview link on the left panel and see the cropped image as it will look, or click Apply and your image is cropped as you specified.

To use the crop tool in Photoshop, follow these steps:

1. Open the photograph that you want to crop in Photoshop.

2. Select the crop tool from the Toolbox (see Figure 8-48), and select the point on the photograph you want to begin your crop.

3. Click and drag your mouse across the picture diagonally. The portion of your picture that will be cropped appears darker than the portion that will remain (see Figure 8-49).

4. When you have created the crop that you prefer, press Enter. The remnant area is removed and the window adjusts to the new size.

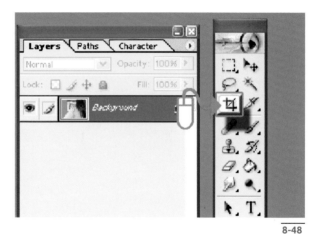

8-48

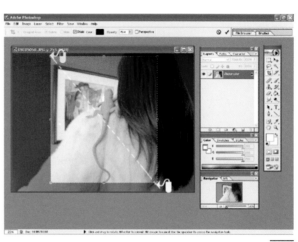

8-49

Judicious cropping can significantly improve a good shot, make a great shot brilliant, or even save a bad shot, and because you are displaying your photographs on the Web they do not need to fit into any standard matte or frame and do not need to be of any particular aspect ratio or size.

Cropping is largely an artistic process, and many photographers develop a personal style that is related to their cropping conventions and choices. I crop quite heavily and usually choose to leave only the elements in the picture that I feel add to it. Figure 8-50 shows examples of two photographs where a crop made dramatic differences.

Cropping is useful for repairing in-camera compositional problems such as corner shadows or intrusions that you could not remove with a change in POV. Because I don't worry about perfect in-camera framing I find that I make much better pictures and can concentrate more on what I do want, knowing that what I don't want is easy enough to remove.

When cropping any type of photograph it is important to remember the following:

> The ratio of the finished crop must be comfortably displayed on–screen, so very long and thin images of either orientation should be avoided.

> The rule of thirds and other compositional guidelines should stay intact.

8-50

RESIZING

I always recommend that a photograph first be cropped and then resized to the dimensions you will use on the Web. Resizing a photograph for Web viewing requires the photo-editing program to make complex calculations on a pixel-by-pixel basis, and slight deviations can occur when a large image is made much smaller — especially if you have altered the composition of the original.

The big question here is what size to make my photographs. The answer is, as you'd expect, "It depends."

Selecting the correct size for your photograph is simply a matter of knowing where you are going to put it (in your blog) and knowing what size of space you have to work with.

The included template centers your photograph in the middle of the photograph area with a white space around any excess area, so the dimensions do not have to be exact, they just cannot exceed the maximum width of the photograph area, which is 700 pixels. If your image exceeds this width the template system will automatically reduce it in width to 700 pixels.

Therefore, if you are using the supplied templates, I recommend resizing the photograph to 700 pixels. Of course, you can use whatever size you think is best.

Picasa does not allow you to resize a photograph, but it does allow you to export a copy of a processed photograph via the export function, during which you can alter the size. After you crop your image to your liking, you can save a copy of it in the final size; the rest of the processing you do for the Web should be done at the size in which it will be viewed on the Web.

RESIZING WITH PICASA

To resize a photo using Picasa's export function, follow these steps:

1. Click the Export button on the bottom-right side of the Picasa screen, as shown in Figure 8-51.

2. From the pop-up screen that appears (see Figure 8-52), select a location on your hard drive where you want to store your blog photographs, or choose one of the default locations suggested by Picasa.

3. Select the Resize to option and type the desired pixel width in the pixels field, or click and drag the slider to select the correct width.

4. Click and drag the Image Quality slider to select the image quality setting, which should be 100 percent.

WEB RESOURCE

If you designed your photo blog using Movable Type and the templates included on this book's companion Web site (www.createyourownphoto blog.com), your photographic area is a maximum of 700 pixels wide so the width of the photograph should not exceed this dimension. The template system will reduce the image to 700 pixels before displaying it but a browser does a remarkably poor job of reducing photograph size and you should endeavor to use the correct size where possible.

8-51

201

8-52

8-53

8-54

8-55

5. Click OK and your photograph is saved as a copy in the directory you selected. Your original remains intact.

6. To open it for processing, use Picasa to locate it on your hard drive, double-click on the thumbnail, and you can perform the rest of your editing and processing.

RESIZING IN PHOTOSHOP

To resize your photograph in Photoshop without having to perform a save operation, follow these steps:

1. From the Image menu select Image Size. Your photograph's Pixel Dimensions are shown in the Image Size dialog box that appears (see Figure 8-53).

2. Before making any adjustments, be sure the Constrain Proportions and Resample Image check boxes at the bottom left are selected.

3. In the Pixel Dimensions area, type the width that you want to make your photograph. Click OK as shown in Figure 8-54.

SHARPENING IN PICASA

Picasa allows the digital photography novice or new photographer to make basic fixes and alterations to a photograph. Picasa has an interesting system of three primary modes for editing. The Basic Fixes tab, shown in Figure 8-55, performs such functions as crop, straighten, red eye correction, or auto color, contrast, or an overall brightening of the entire image. These functions are extremely well calibrated, and Picasa does a credible job of making basic editing decisions. However, I urge you to experiment with the software and your photographs until you get the results that are most pleasing to you.

The Tuning tab, which is shown in Figure 8-56, is an excellent tool for creating more contrast or deeper, richer colors, or for adjusting the ambient color tone

of the photograph to a warmer (red) or a cooler (blue) tone. You can always change your mind and undo your steps, and there is no harm to the photograph in trying things to see if it improves or enhances your picture. In fact, I recommend experimentation. It is the way that most of us learn.

The Effects tab, shown in Figure 8-57, displays a series of thumbnails with an effect or filter already applied to your photograph. From a full-color desaturation to make your picture black and white to soft focus and glow effects, there are many choices and variations from which to choose to alter your photograph's general color palette or perform overall sharpening or softening.

SHARPENING IN PHOTOSHOP

To affect the sharpness in Photoshop, follow these steps:

1. Open the photograph that you want to resize and choose Filter from the top file menu and then ⇨ Sharpen ⇨ Sharpen (see Figure 8-58).

2. When you select this option, Photoshop automatically sharpens the entire image. If you find the amount of sharpening is too harsh, you can correct it by using the Fade Sharpen command, which is found in the Edit menu as shown in Figure 8-59.

The Fade command is always relative to the last edit function you performed, and you can lessen the severity of any Photoshop function by using it after you have performed an automatic process such as sharpening.

Most professionals use the Unsharp Mask command, which is located under Sharpen on the Filter menu, but it is a three-tier process that requires a fairly detailed understanding of how the mask works in order to use it well. However, it is worth experimenting with and I urge you to explore its functions

8-56

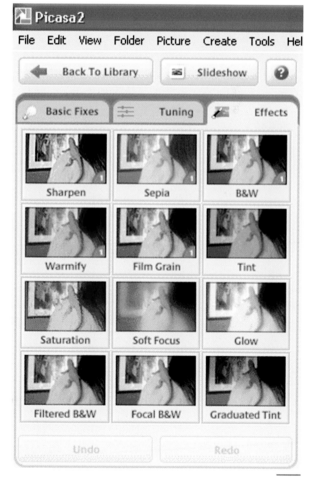

8-57

in order to make the most of the tools that Photoshop offers.

As with all things where post–processing is concerned, caution is urged; the best advice is a little goes a long way. Be careful not to push your photograph past comfortable viewing limits.

SAVING ORIGINAL PHOTOGRAPHS FOR THE WEB

The JPEG format is the only universally supported web graphic format capable of storing the complex color information required for photographs. Unlike a GIF, which can only display 256 colors, JPEG is good at compressing graphics with a natural gradient of color such as photographs or scanned artwork. Your photographs must be saved in JPEG format to use them on your blog.

8-58

8-59

NOTE

You will not even notice a repeatedly saved JPEG file degrading unless you close the file and reload it. Even if you select 100 percent image quality when saving your photographs, JPEG format loses a bit of data each time it is saved. There is no way to stop or alter this fact so you must work around it.

Unless you shoot in RAW or your camera is set to save images in TIFF, the images from your camera are already in JPEG format. Therefore, it is important that you understand how these files work.

JPEG is a lossy file type, meaning that every time you save a JPEG file you lose data. Every time you open a JPEG file and save it again, the image is compressed. If you save as you work, the file actually goes through a series of compressions and becomes more and more degraded.

Don't use JPEG format to save original images you expect to use for print later. I prefer to save my originals in a lossless format like TIFF at 300 dpi with the same name as the original JPEG that came from the camera. I then process the original JPEG for the Web while my original remains in a high-resolution file, safely on my disk.

The JPEG format was designed deliberately to be lossy, so that lower-quality but smaller-sized images could be quickly uploaded and web pages would not be bogged down by megapixel images. It was designed in the early days of the Internet when everyone was using dial–up connections and download speeds were of critical concern. Today, download speeds are vastly improved and it is acceptable to have a larger image on your website, but caution is still urged.

I calculate the loss factor I will use for JPEGs based on the file size that will be created by that loss factor. If you have a 300K resized and processed image, and you specify a 20 percent loss factor, the result is something along the lines of a 240K image.

Try not to make images larger than this because someone on a slower connection needs several seconds to see the image. In this day and age, that is almost too long. Therefore, when saving a JPEG, I select a loss factor to create an image within the 200K to 300K range, and I recommend that you stay within this general range as well. Instructions are provided in the following sections for using Picasa or Photoshop to specify a loss factor while saving the photograph.

Generally speaking, quality will not suffer too greatly (that will be visible on the Web) and you create acceptable file sizes if you stay within a 0-25 percent loss factor. However, keep in mind that you lose a percentage of data and, therefore, the overall quality of the image always suffers to some subtle degree when you choose any loss factor whatsoever. So, it pays to keep an eye on the finished appearance of your image as well as the size of it while you are making loss factor choices.

If you use Photoshop, you can see on the status bar how large the finished file will be as you make your loss factor decision. In Picasa, on the other hand, you need to save the file and then find it again from within Picasa to see what the finished size is; in some cases you may need to use a higher loss

DESIGNER TIP

If you have to choose between a file that is too large and one with poor quality, go with the one that is too large. Don't sacrifice your quality for size — just keep size and download times in mind when you save your files.

factor if the image is still larger than what you have set as your own limit.

SAVING A PHOTOGRAPH IN PICASA

Instructions for saving a photograph with Picasa with the export function were provided when you saved your working copy (see "Resizing" earlier in this chapter). Repeat that operation and save the photograph again with the JPG loss factor that you have decided upon.

SAVING A PHOTOGRAPH IN PHOTOSHOP

To save a photograph in Photoshop, follow these steps:

1. Choose File ⇨ Save As to display the Save As dialog box.

2. Type the path and filename you are going to use and select JPEG from the Format drop-down menu and then click Save (see Figure 8-60).

Download Times

Many studies have been performed on Internet speed and the habits and limits of viewers. Jakob Nielson, considered one of the foremost experts on all things Internet, says that the limit of people's ability to keep their attention focused while waiting is ten seconds.

This information was compiled for business or commercial Web browsing so the average viewer who has come to see your photography may be willing to wait for a large file to download, but I do not recommend that you put this theory to the test and that you keep your blog photographs within the reasonable size of 200K to 300K.

8-60

WEB RESOURCE

All photographs are displayed on the Web at 72 DPI regardless of the DPI you may have specified when you saved them. At this low resolution a loss factor of as much as 15% will not have a visible effect on the photograph's appearance.

3. In the JPEG Options dialog box shown in Figure 8-61, you can select the JPG loss/quality factor. The size of the JPG file based on your current loss or quality factor indicated at the bottom of the dialog box. Click and drag the slider under the Quality setting to the left until the file size is less than 300K.

4. Select either the Baseline Standard or Baseline Optimized option in the Format Options section, and then click OK.

Your photograph is now ready to use on your blog, and it can be uploaded to whatever service you use or directly to your own server.

X-REF

See Chapter 4 to upload your photographs to the Web.

8-61

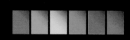

100 PHOTO IDEAS TO GET YOU SHOOTING

9-1

9-2

9-3

This chapter is intended to get you thinking about the kinds of pictures you can take and to give you a prompt on those days you can't think of an idea. Like writing prompts, they're intentionally vague so that you can use the idea in a variety of creative ways.

You are not expected to re-create the example photograph (although you may, of course), but you can use it with the text as a jump-off point for your own original ideas.

1. Put a pair of sunglasses in a bright spot where they can reflect something interesting, and take a picture from a slightly to-the-side angle (Figure 9-1). Place them on top of an interesting textured surface like the dash of your car, and place them so they throw a shadow into the frame. This same idea is good with any curved reflective surface like a car door mirror or a garden sphere.

2. Take a macro (close-up) photograph of rain or water drops on something with a rough texture such as a leaf or a piece of grainy leather (Figure 9-2). Water drops are natural magnifying lenses, and if you take the time to move around your subject area or use soft, directed light such as from a flashlight you will find many interesting patterns. Water drops do not photograph particularly well from a dead-on perspective so remember to keep low as you pan for a good composition.

3. Take a photograph of a person or people at work doing a traditional task such as painting a fence or putting up storm windows (Figure 9-3). Concentrate on the task and not the people, and avoid using too much context — just enough so the task at hand is clear.

4. Go to the zoo and take a photograph of an animal most people would consider exotic — a polar bear, a tiger, a lion. Watch the animals for a while so you can capture them in a pose or doing something that seems to illustrate their most compelling qualities: a peacock spreading its tail, a lion roaring, a polar bear's ambling stride. Hint:

the trick to taking a photograph through a chain fence is to be very close to the fence.

5. Go to a mall or other busy public place with a second-floor balcony and wait until the people below are arranged in an interesting way (Figure 9-4). Take a picture or use a long exposure and take a photograph of their motion below. Try to get as straight down a view as you can manage.

6. Photograph the motion of a normal household activity such as eggs breaking into a bowl or soup being stirred in a pot. By changing the color of the bowl and the background you can create vastly different images, and it would be interesting to see a diptych (picture made of two photos) or a triptych (picture made of three photos) made of similar splashing shots with different colors.

7. By tilting your camera to a 45-degree angle you can make a simple panning shot into a more dramatic photograph. By using a higher f/stop value such as 8 and a longer shutter speed such as 1 or 1.5 seconds, the streetlights give a golden glow to the road and the background disappears into near blackness (see Figure 9-5).

8. Pour one color liquid into another and photograph the moment they meld (Figure 9-6). If you choose a distant POV and include the vessel as context you have a still life with motion. If you use a close POV and include only the color and motion you have made an abstract. To make a very funky photograph you can use food coloring to create two or more streams of neon color.

9. Put colored, clear, or opaque objects, such as colored glasses or tinted bottles, into the bright sun in front of a white background and take photographs of the shadows. These shots are excellent ways to work on your composition skills and to teach yourself about light and color. These still-life style shots make very good prints, and I often use several configurations of the same objects to create a series of small-framed prints to use in interior decorating.

9-4

9-5

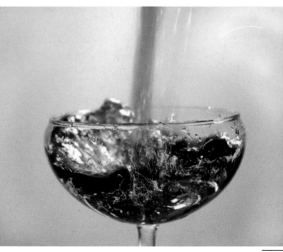

9-6

9-7

9-8

9-9

10. Bicycles are enduring viewer favorites and are always well viewed. In the late afternoon when the sun is very low but it is still bright (see Figure 9-7), wander around your neighborhood and find a bicycle or cyclist that is throwing a long, distorted shadow and take a picture that includes both the bicycle and the shadow.

11. Line up similar objects such as tacks, candies, coins, utensils, nails, or marbles in an uneven line, shine a colored light on them, and find an interesting POV. By using cheap portable spot-lights and colored bulbs you can create very interesting patterns of light that intersect with the objects and create interesting abstract photographs (Figure 9-8).

12. Find similar objects of several different bright colors such as light bulbs, glasses, or candy bowls, and use two sources of directed light to highlight the objects separately. The discordant shadows and highlights in these photographs are extremely interesting and have high thumb-nail appeal.

13. Reflect the sky in an expected surface such as corn in a pot of water, the top of a candy tin, or a broken bicycle mirror. Often done in ponds and other natural bodies of water, using an unex-pected reflector adds interest and appeal. Make a glass of lemonade, add an ice cube and see how the sky looks in it.

14. Before dinner, after you have set the table, select two or more objects, one of which is reflective or shiny such as a silver butter dish or a glass turned on its side, and one of which is colorful such as a placemat or a napkin, and create an abstracted still life. The objective of this exercise is to make a pleasant composition, regardless of subjects (see Figure 9-9).

15. Go and find some local wall art or graffiti and get close enough so the texture of the paint and the surface are apparent (Figure 9-10). Do the

unexpected; make a macro or an abstract of something usually photographed like scenery. Often you can find very compelling textures such as a dried glob of dripping paint or a fresh chip in the surface where there is no color.

16. Industrial or commercial locations like manufacturing plants, transport companies, and large retail locations often have large piles of wooden crates or pallets that can make very interesting full-frame images. Wood photographs best in bright natural light, so go during the afternoon.

17. Next time you are in a hotel, an arena, or any building with tiled or backlit ceilings look straight up and take a picture of the most interesting pattern you can find in the ceiling and the lighting. The lower you are to the ground the more interesting you can make the POV (see Figure 9-11).

18. Using a regular table lamp with an incandescent bulb (which will create a yellow cast in the photograph) to create shadow and interest, take a photograph of a ceramic or plaster sculpture from a perspective not normally seen (Figure 9-12). For the best effect, the ambient light in the room should be very low and the source of the directed light should be several feet from the subject to create soft shadows.

19. Track down all the pretty or interesting product bottles you can find and make a bottle still life. Particularly good subjects are perfume bottles, bath oil bottles, cooking oil bottles, and spice jars. Try to include empty bottles if you have any, and use a white poster board or sheet as a background. A good way to create front interest is to direct a light several feet in front of the subjects but not at the subjects.

20. On a day with a lot of color in the sky, preferably with clouds, find a model with good hair and take a photograph from very low and close (at an acute angle) so that only the shoulders and head are visible along one of the vertical

9-10

9-11

9-12

9-13

9-14

9-15

rule-of-thirds lines, as shown in Chapter 7. You are using the sky as a backdrop so move around the model in a full circle to find the best composition. To ensure that you can still see the model's features, you can use the flash function on your camera or use a piece of white poster board as a reflector, angled up towards the model's face (see Figure 9-13).

21. Stand behind someone and take a photograph of what he or she is doing, from that perspective — such as children tobogganing down a hill or people playing volleyball on the beach (Figure 9-14). Try and make a photograph that looks like it was taken from the middle of the action and provide enough background so that activity is apparent.

22. Take a photograph of a scene made entirely with shadows. Streets that run north and south are best as the longest shadows are created in late afternoon when the sun is falling in the west. Try to avoid getting anything "solid" in the shot, and seek out a building with an interesting texture on its surface.

23. Pretend you have just gotten a job for a high-end kitchen supply company. Make a product shot using pots or pans or some other set of kitchen objects. Do your best to use a very uncluttered background, and use either a very light color or a very dark color that will not compete with the subjects.

24. Take a macro shot of some colorful part of your lunch or dinner such as a bowl of soup sprinkled with herbs or a piece of blueberry pie sprinkled with confectioner's sugar. Avoid all context such as a dish or utensil; use good light and the texture will make it an interesting shot (Figure 9-15).

25. Use a martini or wine glass and a richly colored backdrop such as a painting or an art book, and create a still life with lots of shadows and dark spots. Shooting photographs through anything that distorts the background such as a stemmed glass or a magnifying glass creates an intriguing three-dimensional effect.

26. You can make a very interesting photograph by keeping one subject stationary and moving another subject around to create motion blur. A flower and person are used in Figure 9-16, but any two objects with sharply contrasting colors can be used.

9-16

27. Grocery stores and farmer's markets offer wonderful opportunities to get really excellent shots. The quantity and variety of goods allows for good use of DOF. For example, you can bring the front objects of a large quantity of the same thing into focus while the background appears to be an infinite array (Figure 9-17), or you can take advantage of neat arrangements of bottles and boxes to make interesting perspective shots.

9-17

28. Take a photograph of something that evokes the memory of a good smell or taste for people: coffee grounds or beans, vanilla beans, and cinnamon sticks are excellent choices. To make it very evocative make sure that your focus is close enough so that its unique texture is evident.

29. Go to a pet store and ask permission to take some photographs of the fish in the tanks (Figure 9-18) Exotic fish make great subjects for interesting POV shots, and most pet stores are well lit and provide a colorful environment where you can experiment with motion shots.

9-18

9-19

9-20

30. Take a photograph into (from the top) something that is usually taken from a different angle such as into a blooming plant (Figure 9-19) or a container of uncooked spaghetti or a tube of fireplace matches where the effect is that the camera is splitting the subject(s). If you use a colored poster board or a piece of fabric underneath you add interest with a complementary or contrasting color.

31. Either create or find a subject with two distinct textures such as a window against brick or stucco against metal and create a photograph which appears to be two separate things (Figure 9-20). These shots are particularly effective and artful when you can add an element of bright color or create a symmetrical composition. It is often these simple photographs with distinct color or texture divisions that are best for printing and hanging.

32. Late at night when the streets are deserted go to a store that has neon signage and create your own "lonely city street" shot (Figure 9-21). If you can manage it select a night when it has rained and you can take advantage of the moodiness that reflected neon on wet asphalt creates.

33. Go to a playground out of season and make geometric photographs by using unique POVs on the play structures and the shadows they make. Try taking a few from the POV of a child playing on the structure or snap a long exposure as you go down the slide or up on the swing.

34. Playing cards makes fascinating photographs and rarely fails to draw an audience. Make a shot

9-21

using a deck of cards in a way that most symbolizes them for you personally. This could mean creating a poker setup with a smoking cigar and a glass of cognac where the POV is the player, or showing a hand laying down an ace on a jack.

9-22

35. Go inside something with a clear top such as a mall with a skylight or an old building with a hole in the roof and take a picture pointed straight up. Often, cities retain the ruins of the original forts, churches, or cathedrals, such as in as in Figure 9-22, and these locations provide excellent opportunities for shots like this.

36. Find two or three kids playing on a sidewalk and get a close photograph of them from a street-level POV doing some activity that most people will recognize such as hopscotch or chalk drawing (Figure 9-23). Try capturing them in motion and your photograph will have a very high appeal factor.

9-23

37. Make a photograph that includes readable text such as an open fortune cookie, a street sign, a store sign, or someone reading a newspaper or magazine where a portion of the text is readable. Using the rule of thirds make the text the subject of the photograph by placing it at an intersection or along a line.

38. Put something in the sink that will not fit past your drain guard such as coins or marbles or ball bearings. Fill the sink with water, and as it drains, take a photograph of the distortion the moving water creates over the objects. These shots are best taken with a longer exposure (such as a 1-second shutter speed) and a tripod so that the full distortion effect can be recorded (Figure 9-24).

9-24

9-25

9-26

9-27

39. Make a "straw in a haystack" photo (Figure 9-25) where you use a very shallow depth of field and zone in on only one of the objects in a pile or stack of many alike objects. Any number of things that you can find in large quantity like paperclips, straight pins, peppercorns, pumpkin seeds, or nails would work. This shot works best if you are able to manually focus your camera.

40. Find an old abandoned car and take some interesting macro or close-up shots of its interior or some interesting aspect of its exterior, such as distinctive tail fins or a chrome hood ornament. Cars are both a very popular subject and offer many opportunities to experiment with POV, abstraction, and iconic representation.

41. Sometimes the hint of action is as interesting as action itself, so take a photograph that illustrates impending action such as a shadow or the tip of a hand about to pick something up such as a yo-yo (Figure 9-26) or some other easily recognizable small object. To make this work both the object and what is done with the object should be familiar to the average viewer.

42. Set up a photograph that you can capture actually "in motion" such as candles in a row being blown (Figure 9-27), someone catching a ball, or someone throwing a stick to a dog or swinging on a swing.

43. Find the local musical instrument store and ask permission to take an abstract photograph of a row of drums or a line of guitars with an extreme perspective (so that the quantity appears infinite). In general, rows or collections of things that fade off into the infinite distance make very compelling photographs, and places like music stores and discount warehouses are great places to take photographs.

44. Put a piece of tinted cellophane (such as the type many candies are wrapped in) over a

flashlight, shine it on a surface that will partially absorb and partially reflect (a zipper in the middle of cloth, a black leather belt with silver trimmings) and find a POV that shows both.

45. Put something that would not normally be in a glass into one, put the glass against a blank surface, and take a photograph from the top (Figure 9-28). You could make a variety of interesting shots using this technique including making a geometric design in the glass with two or more layered objects such as a slice of orange and cherry.

9-28

46. Take a photograph from your own personal POV and perspective while doing something you would normally not photograph, such as swinging on a swing, riding a horse or a bicycle, or climbing a tree. In these shots, it is the sense of action and adventure that makes the photograph appealing.

47. Take a photograph of something being made or a micro view of a process such as a crochet hook pushing through a ball of wool, a quilting needle pushing through cloth, a nail going into wood, a knife carving something, or a saw cutting something. Be careful not to include too much context in your composition so the action itself is the subject.

9-29

48. Take a photograph of a view through a window reflected in another surface such as sunglasses, a metal pot, or a mirror. Make sure that the view through the window is clear but do not make it the focal point of the image, rather an unexpected bonus in the image (Figure 9-29).

49. Pick an expression or a common saying and create a picture that works for it. Use a calculator and a calendar and create a "counting the days" photo or find a way to make a "face the music" photo.

9-30

9-31

50. Fresh tracks, especially if they contain a lot of negative space, are very interesting photographs (Figure 9-30). In the sand or the snow or fresh sawdust, create an interesting footstep trail and then photograph it so it tells a little story. For added interest, include two sets of tracks such as from a small child, a dog, or a cat.

51. Women's shoes often have great curves and shapes and make excellent abstracts and still-life photographs, which are always very popular (Figure 9-31). They're excellent props to use to create a still life or a symmetrical abstract as they come in pairs and the left and right have complementary curves.

52. Grab a handful of silver utensils or pieces of cutlery. Arrange them in the sunlight or in good directed light and take a photograph of the best angle using a very shallow DOF (only the very closest piece of the nearest utensil is in focus). For best effect make sure that one or more of the pieces are reflecting against each other, as shown in Figure 9-32.

9-32

53. Silhouettes and shadows are always very eye catching and quite easy to make. If you light or use a lighted background such as a store window and keep the foreground dark by taking it at night, you will have the best results. So, grab a coffee, stake out an interesting retail window, and wait for someone interesting to walk by (see Figure 9-33).

54. Using song lyric and literary references in photography is an excellent way to get ideas even if all you use is the notion or concept such as in Figure 9-34, where I used, "Leaving on a jet plane, don't know when I'll be back again." Lyrics, poems, and quotes often give you a kernel of an idea that you can run with, and I often scour my bookshelves when I am looking for an idea for a photograph.

55. Make a handprint, a footprint, a face print, or some other identifiable shape against a frosted or steamed piece of glass such as a frosted window in the winter or a bathroom mirror after a shower. Using the rule of thirds and taking advantage of the available negative space, create a high-impact photo by using only one clear symbol against the void.

9-33

9-34

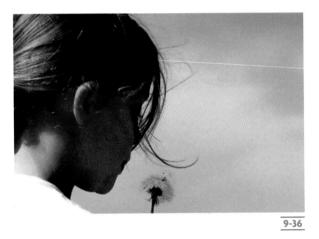

9-35

56. Make a collage of two interesting but unrelated objects — like a feather and a CD or a tube of paint and an old book of poems — and take a close-up photograph in either sepia or black-and-white mode (Figure 9-35). The objective is to create a composition that makes people stop and look because it seems so incongruous.

57. Using a lot of negative space and a looking-up perspective, take a photograph of a normal childhood activity such as blowing dandelion seeds or making bubbles (Figure 9-36). Photographs that remind us of happy memories or which are of atypical childhood activities are usually very well viewed, and it is a good opportunity for the photographer to practice creating images that are intended to be emotionally evocative and resonate with readers through the use of symbolism.

58. Using an interesting or colorful object like a candy wrapped in cellophane or a hair clip that has some opaque parts against a smooth white surface, shine direct light until it throws a pleasing colored shadow and make the colored shadow the subject of the photograph (Figure 9-37).

9-36

9-37

59. Christmas ornaments make great subjects for extreme DOF photographs because they are very recognizable and usually pretty or shiny or both. Select a single-color ornament and find some other textured and single-colored object like oranges or apples, and arrange them so that you can make a photo where only a small portion of the ornament is in focus (Figure 9-38).

9-38

60. Take a photograph through your car's windshield on a rainy day, as shown in Figure 9-39. In fact, shots taken through car windows, especially while the car is in motion, always have high appeal. Whether you take them dead on at the road as it unfolds or out the window, they can be very interesting studies in motion and color blur.

61. The next time you have a spectacular sunset, discern which way the clouds seem to be flowing and as you take the photograph move your arm and your camera in the same direction of the clouds as in Figure 9-40. These shots require a long exposure so set your camera for something in the 1 second range.

9-39

62. There are dozens of stores that specialize in small, cheap trinkets, and you can often find very interesting items that make excellent photographs. For under $10, I was able to buy a fish bowl and several glass fish that I suspended with fishing line to create this abstract still life. Very often store owners will let you take photographs of individual items in the store, if you ask politely.

9-40

9-41

63. Take a close abstract shot of a power grid or transformer station and make a square crop that looks like a technical drawing. You can make some very interesting patterns and designs with wires and power stations and other similar structures with repeating patterns such as radio towers and water towers.

64. It seems obvious, but it's amazing how many people go for the posed kid shots when they are usually at their most charming doing the completely unimaginable things they do when they think you're not looking. I could never, for example, come up with something as creative as making goggles from orange peels (Figure 9-41). Catch the kids at their silly best.

9-42

65. From ground level, take a photograph of three or four people walking away into the shadows. If you can manage a collection of interesting shoes or feet in the mix such as Carolyn Primeau does with this shot (see Figure 9-42) of the retreating feet at a music concert, all the better. Almost any public place where you can get a fairly long view across a large space will work.

66. You can make very appealing photographs through a fence where the fence is part of the composition and something interesting is on the other side of the fence, as in Figure 9-43. Another very effective idea is to use a wooden fence that has a missing board or a hole in the wood.

67. Tunnels and hallways, especially if there is a light at the end of them, never fail to draw viewers. Many people make them and you see them very often but each one is unique and offers a fresh perspective. Bright, blurry colors, as from a shot captured while in motion give a very surreal effect to tunnel or hallway shots.

9-43

68. The view into a window (where you are not infringing upon someone's privacy) is a most compelling one, and often the combination of the reflection in the glass and the scene behind the window serves to create a double-exposure effect that adds a great deal of subtle visual interest that many viewers enjoy (Figure 9-44).

9-44

69. We move into and out of spaces through doors. They are portals, and a door, especially if the photograph is composed so the door is the primary subject, serves as what I call a "poetic photograph" in that it symbolizes some aspect of our existence — in this case the human curiosity that always wonders what is on the other side of that door.

70. Fire escapes and maintenance ladders on brick buildings make great architectural shots because they have their own repeating pattern (Figure 9-45). Given their size, you can create a large number of interesting perspectives by varying your distance from the building and the POV you choose to use. For a variation, try capturing some of the sky in the shot.

9-45

71. Playbills, lost kitten posters, fast-food menus, Shakespeare in the Park programs — these bits and pieces of our urban culture make great pho- tographs especially when you can find a post or a board with many layers that create their own collage of color and text.

72. Using black and white or sepia, take a close-up photograph of a portion of a familiar object that makes sound such as the bell of a bicycle (Figure 9-46), the strings of a guitar, or the keys of a piano. Make sure that the portion you are showing is identifiable and is familiar to most people.

9-46

9-47

9-48

9-49

73. Go find a large field of flowers — dandelions will do — and get very close to ground level. Adjust your POV until you can take a photograph of half sky, half flowers. This is a good opportunity to experiment with DOF. You can select different portions of the flowers to bring into focus and see which effect you like best.

74. Usually done in vivid color, try taking a flower macro in black and white (Figure 9-47). Select flowers that are naturally light-colored and have very distinct petals or leaves, and concentrate on photographing the shape and texture of the flower instead of the usual emphasis on color.

75. Take a photo from the bottom of a ladder so that the sky is visible at the top (Figure 9-48). You can improve this shot immensely by adding a subject or area of interest to the top such as a foot about to step on the ladder or a head poking out over the edge. These shots, which employ the use of a long, straight subject, are very good teachers of perspective and distortion and will train your eye to see "straighter" when composing shots.

76. Take a shot of a ball, piece of fruit, or other heavy object landing in something that is soft and mutable such as sand, flour, or sugar (Figure 9-49). Compose the photograph so that the action is the subject, and try to time your shot so you capture the moment of actual impact. You will need a lot of light and a fast camera to make these shots work because you need to use a high shutter speed to capture the fraction of a second with a minimum of blur.

77. Make a photograph of a single iconic subject (Coke bottle, Converse sneaker, Levi's jeans) against a high-contrast background. Poster boards, smooth fabrics, and blank walls make

good backgrounds, and you can add interest by shining a light near the frame (but not in it) to create a gradient effect in the background.

78. Take a picture of a car with great wheels from a perspective where you can really only see the tires and the ground (Figure 9-50). If you select a sunny late afternoon and find a car parked with its side facing west you can create a very compelling abstract with a lot of interest in the way the light is reflected and absorbed by the different parts of the car.

9-50

79. Use your shadow as a character in a still shot (Figure 9-51). It's shadow puppets for adults with cameras and they are very popular shots because they are very interesting for the viewer to decipher. Try using your shadow with another subject such as a bench or a chair, which distorts the shadow and provides color and texture contrast to the matte darkness of a shadow.

80. Take a photograph of a colored bulb inside of a pretty lampshade. Bulbs make excellent props for many photograph ideas. Try putting one in front of someone's eye and taking a photo through it, or use one in a place you wouldn't expect it like inside a pocket or purse or arranged with a bouquet of flowers.

9-51

81. The next time the sky is moody with dark and light patches find a tall building, stand at the corner and arrange your POV so you can split a dark portion and a light portion of the sky with the corner of the building (Figure 9-52). Look for the most ominous-appearing POV and set your camera for a slightly faster shutter speed than the available light would normally call for, which will add character to the sky.

9-52

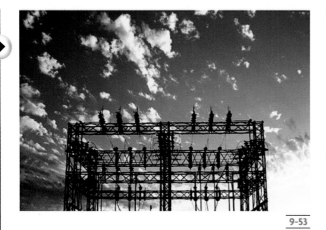

9-53

82. On a day when the sky has clouds find a power station or large transformer and lie flat on the ground about 50 feet away. By angling up and leaving the top half of the frame filled with sky, you create the ominous impression of fast-moving clouds even if they are barely moving (Figure 9-53).

83. Find the highest piece of land near your city, wait for a pretty sky, and take a skyscape (Figure 9-54). Crop the photograph into a film-frame shape by making it almost twice as long as it is high and adding a white border that is wider at the top and bottom than on the sides. You will have a shot of your local skyline that is suitable for framing.

9-54

84. Put a colorful object that has deep texture such as a crumpled silk scarf or a vase of flowers into a place where they are half in bright sun and half in shade. Take a photograph from the top from an angle that enables you to have either the light or the dark portion in focus while the other remains out of focus (Figure 9-55).

85. The next time it rains and your windshield gets foggy, wipe a portion of it clear and take a photograph through the clear portion with some of the foggy portion still visible. You can use this same idea on a shower stall door, a kitchen window, or a side-view mirror clouded over with morning frost.

9-55

86. Take a photograph at dusk or against a cloudy sky with only a portion of a street or other sign at an acute angle. Make sure that the sign is recognizable. Good ideas are yield signs, signs with arrows, neon signs, and railway crossing signs.

87. Take a photograph of something reflected in a rain puddle (Figure 9-56). You can do dark and somber like the public telephones shown or something playful and fun like a child in a colorful pair of rain boots or the reflection of a polka-dotted umbrella. If the puddle is not fresh and the sky is blue and bright try dropping a penny into the puddle and taking a photo of the ripples.

88. Put several glasses or glass decanters in the foreground (items that can be seen through) and a person in the background, and select a DOF that provides only a hint of the background while the foreground is in sharp and clear focus (Figure 9-57). It helps if you can add direct light to the front (with a small spotlight or even flashlight) of the frame without changing the ambient light at the back.

89. Find a service station or other commercial or industrial area late at night when it is deserted and barren (Figure 9-58). Because of the very austere way that most commercial locations are designed and the fact that they are often off the beaten path and don't have a lot of background light you can take very compelling shots that seem a little like architectural models.

9-56

9-57

9-58

9-59

9-60

9-61

90. Malls and other public spaces such as libraries and community clubs often have great common area displays. Find a mall or club that is having an event, and take a photo of the most colorful display (Figure 9-59). The best time of year to make these shots is just before school opens in the fall when the stores are having back-to-school specials and sales.

91. Stand at the bottom of an upward-moving escalator, ask someone you know to get on it, and take a picture of their hands on the railing (Figure 9-60) or their feet on the steps. Or stand at the top and take a photograph downwards. Try to not include any extraneous context such as overhead lighting or floorspace; keep the composition tight to the escalator.

92. Water birds such as pelicans, geese, swans, or ducks that gather in small groups make excellent subjects for photographs. Find a small lake or pond where they gather and wait for them to form a good composition (Figure 9-61). If you have someone throw cracker or unleavened bread crumbs in the water ahead of where you are focused you will be able to get a good frame as they swim past you toward the food.

93. Silhouettes usually make good shots, and silhouettes of birds make particularly good ones, and when they gather in large groups in trees you can get a very interesting composition. Go where the birds go near dusk, hang out, and wait. These shots are best when there are no

100 Photo Ideas to Get You Shooting

leaves on the trees or anything else that distracts from the shapes of the birds (Figure 9-62).

94. Skateboard and other sporting goods stores that cater to the hip, young crowd have great displays of boards and other colorful things like wheels, stickers, T-shirts, and sneakers. When taking shots of quantities of things, the trick to making that quantity look endless is to include nothing else in the shot except the items and to keep your framing tight to the most interesting visual area (Figure 9-63).

95. Mannequins and wig heads, rows of colorful jars with shiny ribbons, stacks of candy boxes, and candle sticks — these are some of the things you can find behind department store windows. Very often you can capture an ironic or humorous reflection and add interest to an already interesting photograph.

96. Take a photograph of two people interacting so that it is a photograph of the activity, not the people. Playing a game of cards, sharing a cup of tea, making a quilt, sharing a popsicle, playing catch. To add drama to a game-of-catch shot, stand just behind and a little to the left or right of one of the players and get a shot as he or she catches the ball.

97. Find someone with long hair and either using natural motion (harder) or a hair dryer or fan (easier) make a "wild hair" shot as you might use on a shampoo commercial (Figure 9-64). If you have the model stand in front of the a window in an unlit room you can achieve the silhouette effect on the face and still get the detail in the hair.

9-62

9-63

9-64

98. Antique stores always have something interesting to photograph, and in the summer often display items on the sidewalk. Find an interesting-looking

9-65

9-66

display and take a photograph in sepia or black and white.

99. Not only do art books offer one of the best resources available for learning about composition and framing, they also make great props for creating interesting still-life photographs (Figure 9-65). Get someone to hold a book open to a colorful page, hold the strongest pair of glasses you can get your hands on in front of the page, and position yourself so you can take a photograph of both the page and the page through the glasses.

100. Panning shots are universally popular and one that is well done is a sure way to attract viewers (Figure 9-66). The trick to them is timing and smoothness of motion. Track your subject for as long as you can through your viewfinder to get a feel for his speed. To follow the motion, rotate your upper body and keep your feet stationary. Waiting until you are moving at the same speed as the subject, press the shutter button while maintaining your upper-body rotation. When the shutter button is pressed you will lose sight of the subject but if you have tracked him well you won't need to see him as the image exposes. Be careful not to move faster or slower when pressing the shutter button. As with all processes that rely on timing, it may take a little practice to get good panning shots but they are well worth the effort.

Public Photography

Many of these prompts suggest that you take photographs in a public place. It is important that you make yourself aware of the laws in your state, province, or country that govern the taking of photographs in public places.

However the laws work in your area, there are still considerations that are universally true, and I urge you to be respectful of people's wishes when using your camera to record the world around you. In other words,

if someone says, "Don't take my picture," then don't. It is generally a good practice to avoid taking candid photographs of recognizable people without their permission.

Similarly, you should ask permission before taking photographs in a restaurant, store, or other business establishment.

As a rule, you should never take photographs of children without the explicit written permission of the parent or guardian.

LETTING PEOPLE KNOW
YOU'VE ARRIVED

Chapter 10

Creating an audience takes a combination of an accessible and well-designed blog, consistently interesting photography, and being in the right places and doing the right things to get noticed. In the previous sections of the book, I cover the first two aspects of a successful photo blog. In this section, I cover getting your blog noticed and linked.

BEFORE YOU GO PUBLIC

Before you start submitting your website to search engines and other index or portal sites, you need to prepare yourself in order to get the maximum benefit from those services. You need to make sure your blog has plenty of quality content, that all the links work, and that you are "ready for company" before you link out and join portal sites. The old adage **is** true: You never get a second chance at a first impression.

ENSURE YOU HAVE PLENTY OF CONTENT

Not only must you make sure that all of your links work and your content is appearing how you want it to, but you must have a reasonable collection of entries before you start an active publicity campaign for your new blog. I recommend no less than fifty entries or photographs and a completed Links and About page as a minimum.

MAKE A GOOD DESCRIPTION FOR YOUR BLOG

Many indexes have URL submission forms that ask for description information relating to the site, so it pays to think a little about it before submitting your blog. If you have a basic description prepared that you can modify on the fly, you benefit from a reasonably uniform presentation of your site and a much better chance of being noticed and remembered.

By keeping your sentences simple, highlighting your site's strengths, and injecting a little of your own personality, you can create a very compelling description paragraph. The description for my site, as an example, could read something like this:

Utata is a celebration of the art in everyday life. A reflection in the circadian pool, it contains both narrative and photography with an emphasis on the positive and a reliance on the fortunate.

Your first sentence should declare strongly and simply what your site is. Your second sentence should contain a little bit of information about the content of your site. If, for example, you specialize in street photography or garden shots, you should make this clear in your description. If you (like me) have no specialization, simply describe what you aim to do with your photography, even if that is something like "(site name)'s purpose is to show you the pretty pictures I took that day and to share some of my life with you."

USE ACCURATE KEYWORDS

Keywords are another item that will be asked for frequently when registering your blog with community sites and, as with your description, it is wise to have a list prepared.

The most important keywords for your photo blog are *photography, photo, photograph, photoblog,* and *photo blog.*

Keywords are usually typed separated by commas and are meant to provide newsreaders, users, and search engines with ways to categorize your blog properly so that it turns up in search requests. The more matches a search engine makes with your keywords, the higher it will return you in the results and the more hits you will get.

Use words that are descriptive and provide a good picture of the uniqueness of your blog. I take a lot of staged portraiture shots, for example, so I often use staged portraits, portraits, staged, portraiture, and staged portraiture when registering my blog.

A few tips for keywords include

> If your name is known at all, or you have a lot of online contacts already, use your name in your keywords, and if you have an online or screen name that you use frequently, include it as well.

> Very common search words for photography include scene, scenery, and landscape. If you have a lot of these types of photographs, use one or more of these words.

> If you have room, include the name of your blog as a keyword.

> Do not try to boost hits by using keywords that have nothing to do with your blog but are known to attract viewers such as nude, nudes, naked, breast, sex, or any of the less polite variations; both search engines and most portal sites have sophisticated software to ferret out these

inappropriate uses of keywords. If you do have photographs of nudes on your site, by all means say so, but be cautious and appropriate.

> If you have won any familiar awards, mention them as separate keywords and include the word professional if you are one.

> Include the make and model of your camera(s) as keywords. A great number of people search to find information about, or other photographs taken with, the same camera they own.

EMBED META TAGS

Inside the header of each of your web pages, you can place what are called meta tags, where you can specify information about the information contained on the page.

Meta tags were the original way that search engines discovered what your site contained and what it was about. You'd create a brief description and a series of keywords, put them into meta tags in the header of your HTML document, and a search engine would send robots and spiders to "index" your page and would then file your site accordingly. However, many bloggers saw this system as an opportunity to gain a higher return rating by adding keywords that did not pertain to the content of their pages.

Google, the most used search engine on the Internet, changed all of that by not assigning meta tag information a high place in its calculations and instead based its categorizations primarily on the text that made up the page. Since then, every major search engine has adopted this policy of ignoring the meta tag information inside a "keywords" tag. However, search engines use the "Description" meta tag to describe your site. The next section explains how to make this tag helpful in getting your photo blog indexed on the Web.

To add the description you created earlier in this chapter as a meta tag in your blog perform the following steps.

1. From the Movable Type Interface, click SETTINGS as shown in Figure 10-1.

2. Under the General tab you will see a space (see Figure 10-2), where your description can be placed.

3. Type the description you created earlier into the space provided.

4. Click the Save button at the bottom of the page.

5. You will be asked to rebuild your site. Click Rebuild my site (see Figure 10-3) and your description is added to all of your template pages and appears in your RSS feed files.

GOING PUBLIC

Once your blog is populated with your best pictures and you're sure that all your links work and your data is showing up the way it is supposed to, you're ready to generate some publicity for it.

Publicity on the Internet can happen in several ways:

> **Systematically:** Through code you put into your web pages, such as the meta tag you added in the previous section, that are read automatically by programs called spiders and robots, you can get the Internet to work for you.

> **Being Active In Community:** By joining groups and communities, being active on message boards, entering memes and contests, visiting and commenting on other blogs, your name and blog will become familiar to many people.

10-1

Screenshot 10-2

MAIN MENU | SYSTEM OVERVIEW | HELP Welcome **Melody** | **Logout**

Weblogs: [How To Make A Photoblo ▾] [Go]

Posting
NEW ENTRY
ENTRIES
UPLOAD FILE
Community
COMMENTS
COMMENTERS
TRACKBACKS
NOTIFICATIONS
Configure
TEMPLATES
CATEGORIES
SETTINGS
Utilities
SEARCH
ACTIVITY LOG
IMPORT / EXPORT
REBUILD SITE
VIEW SITE »

Main Menu > How To Make A Photoblog > **General Settings** View Site »

General Settings: How To Make A Photoblog

[Search Entries]

This screen allows you to control general weblog settings, default weblog display settings, and third-party service settings.

General New Entry Defaults Feedback Publishing Plugins

Weblog Settings

Weblog Name: [How To Make A Photoblog]
Name your weblog. The weblog name can be changed at any time. [?]

Description: [Utata is a celebration of the art in everyday life. A reflection in the circadian pool, it contains both narrative and photography with an emphasis on the positive and a reliance on the fortunate.]
Enter a description for your weblog. [?]

Timezone: [UTC+0 (Universal Time Coordinated) ▾]
Select your timezone from the pulldown menu. [?]

Default Weblog Display Settings

Entries to Display: [7] [Days ▾]

10-2

Screenshot 10-3

MOVABLETYPE™ Publishing **Platform**

MAIN MENU | SYSTEM OVERVIEW | HELP Welcome **Melody** | **Logout**

Weblogs: [How To Make A Photoblo ▾] [Go]

Posting
NEW ENTRY
ENTRIES
UPLOAD FILE
Community
COMMENTS
COMMENTERS
TRACKBACKS
NOTIFICATIONS
Configure
TEMPLATES
CATEGORIES
SETTINGS
Utilities
SEARCH
ACTIVITY LOG
IMPORT / EXPORT
REBUILD SITE
VIEW SITE »

Main Menu > How To Make A Photoblog > **General Settings** View Site »

General Settings: How To Make A Photoblog

[Search Entries]

This screen allows you to control general weblog settings, default weblog display settings, and third-party service settings.

General New Entry Defaults Feedback Publishing Plugins

Your blog preferences have been saved. To see the changes reflected on your public site, you should rebuild your site now. [Rebuild my site]

Weblog Settings

Weblog Name: [How To Make A Photoblog]
Name your weblog. The weblog name can be changed at any time. [?]

Description: [Utata is a celebration of the art in everyday life. A reflection in the circadian pool, it contains both narrative and photography with an emphasis on the positive and a reliance on the fortunate.]
Enter a description for your weblog. [?]

Timezone: [UTC+0 (Universal Time Coordinated) ▾]
Select your timezone from the pulldown menu. [?]

10-3

> **With RSS and Atom feeds:** Syndicating your site will allow people to subscribe to your work and be notified when you update.

> **Through Submissions:** By submitting your site to the various listings, indexes, and portals that exist for photo blogs and/or your area of interest you will come to the attention of many other photo bloggers as well as the photography-seeking audience.

BE ACTIVE IN THE COMMUNITY

By far the most effective method of promoting your photo blog is to participate actively in the community. The community, in this context, is the collection of people and sites that are published by, frequented by, or of interest to photography enthusiasts and now that you have a photoblog you are automatically part of the photography community. The more you participate, the more the community will notice you. A community is like any other relationship and you tend to get from it what you put into it.

Start threads in groups and respond to other people's threads, enter photographs in projects and pools, and start your own projects. All of these "appearances" can help you attract an audience and get your name known.

As an example, the item in Figure 10-4 is a post I made to my flickr stream indicating that one of my groups had published a photography project. Figure 10-5 shows the same "publicity post" on my own

10-4

10-5

personal site. Figure 10-6 shows the actual project page, and Figure 10-7 shows the results. The bar graph highlighted is for the project site on the same day that I made a publicity post to flickr and put up a similar post on my own blog.

10-6

NOTE

Although competitions can be a good way to publicize yourself and your blog, be careful to read all of the fine print to ensure that you are not giving up the rights to your photograph when you enter it in a competition. Think carefully about any contest requiring an entry fee.

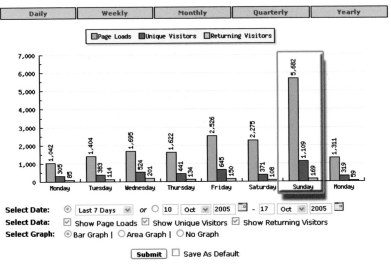

ıl This stat is based on all traffic recorded to date.

TIP Don't forget about the rest of stats we offer. Look to the left menu to get visitor/browser/came from/keyword stats and a whole lot more!

10-7

10-8

MEMES AND COMPETITIONS

One of the most compelling things about publishing to the Internet is the wide array of places where you can submit your photographs so that many others can see them.

A meme is, in the most simple terms, a contagious idea that spreads and evolves. In the context of a photo blog it is a site that collects comparable photographs, usually in a theme. For example, one of the most popular meme sites seems to be Photo Friday (www.photofriday.com), where a theme is announced each Friday and you have from that Friday until the next to post a photograph that fits with the theme. Photographs are often viewed hundreds of times from the Photo Friday site. At the end of the week, the participants can vote for the most outstanding entries. If your photograph is selected, it will likely be viewed thousands of times.

Entering memes such as the ever-popular Mirror Project (www.mirrorproject.com) published by Heather Powazek Champ (shown in Figure 10-8), is an excellent way to not only get your photo blog

visited, but to create a general awareness of your name and existence within the community. Familiarity is an important part of publicity.

For an excellent list of current memes available for participation visit `www.photomemes.org`, where you will find an extensive list of the many meme and group sites being published including the wonderful A Picture's Worth (`www.1000words.net`), shown in Figure 10-9.

If you're interested in competitions, many photography-related competitions such as that at iphoto contest (`www.iphotocontest.com`) have excellent prizes for the winners (see Figure 10-10).

LINKING

Linking remains one of the most enduring methods of personal publicity and is, in many ways, the currency of the Web. As discussed in the section "Getting Rated on Search Engines," Google uses linking to determine a page's rank. Many people like to check out the links page of a blog and follow those that seem interesting. Link to those blogs that inspire or interest you (and tell people why they inspire or interest you) and to the sites of the people you know or respect.

If people follow your links and the publishers of the sites you have linked to check their referral logs, you may get a return link if the person finds your blog worthy.

When linking, keep these guidelines in mind:

> Have all the details of the linked site accurate (spelling, URL, name of publisher).

> Identify to what type of site you are linking (photo blog, text blog, community site).

> Your links list should be reviewed regularly to make sure you have no dead links (incorrect or outdated URLS resulting in an error message when clicked).

> Link only to those sites that you genuinely want to recommend and avoid linking to a site simply because it linked to you.

10-9

10-10

NOTE

Do not alter the default RSS templates unless you have a thorough understanding of both HTML and RSS formatting.

NOTE

Most services do not require that you ping and will find your updates automatically once you have posted a new item to your registered RSS files. However, certain sites such as blo.gs, weblogs.com, or technorati.com can be pinged directly from the MT interface. When you ping these services, your blog is added to their indexes of recently updated sites, and many people will have access to your URL.

10-11

10-12

10-13

To check who has linked to your site, you can look through the referral logs that are located on your Web Host account. If you are using Nexcess, log on to your account and click the Stats link (see Figure 10-11) and select which of the four statistics services you wish to view. You will be able to tell who has linked to your site from this information.

RSS AND SYNDICATION

RSS is a text-based format, a file created with a type of XML (extensible markup language) that allows people to see what items you have posted to your blog. It is a method of distributing information and providing links to the content on your website.

Viewers can subscribe to your RSS feed in a variety of ways, from belonging to a feed service such as Bloglines.com (see Figure 10-12) to clicking the live bookmark link on their Firefox browser screen (see Figure 10-13). In other words, an RSS file is a mechanism to syndicate your content.

Although you can use other syndication formats such as Atom, RSS is by far the most widely used and supported today. RSS files do not have a common file extension, although they frequently end in .xml, .rss, or .rdf.

YOUR RSS AND ATOM FEEDS

If you are using the Movable Type interface and the templates provided on the book website to operate your blog, your RSS and Atom feeds are generated automatically when you update your site. They contain information such as your blog name and description, the title of the entry, and any text you have added.

PINGING

Pinging is a process whereby you alert the newsreader services that list your blog that you have updated by sending a piece of code to their listing servers. Each service has a different process to use and will contain instructions for pinging with Movable Type.

AUTOMATIC PINGING

You can set the MT interface to ping automatically so that each time you make an entry, MT will advise the services you identify that your blog has a new entry. Here's how:

1. Click SETTINGS on the left menu (refer to Figure 10-1).

2. Click New Entry Defaults (see Figure 10-14) and scroll down to the Publicity/Remote Interfaces section.

3. Click any of the three default ping sites that you want to use (I recommend selecting all three) and enter any other services that you use or are registered for in the input area (see Figure 10-15).

4. Click Save Changes and rebuild your blog. The next time you update, these services will be notified or pinged.

X-REF

To rebuild your blog, see "Rebuilding Your Site" in Chapter 4.

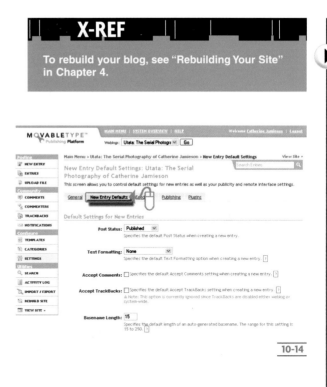

10-14

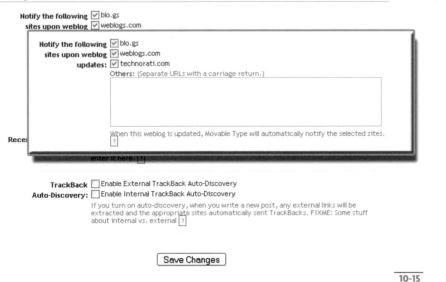

10-15

10-16

10-17

When you update and these sites are pinged, the MT interface alerts you that it is notifying these services. Sometimes, due to high traffic or network delays, a ping is not delivered and MT alerts you that a certain service is unavailable. Even though this is not a frequent occurrence, it happens from time to time and should not be a cause for concern. Simply ping again the next time you update or go directly to the service's URL and add your update manually.

WEB RESOURCE

For a list of competition sites, visit `http://dmoz.org/Arts/Photography/Contests/` **and select from some of the many sites listed there.**

GETTING YOUR RSS FEED INDEXED

One of the best ways to get information about your blog into the loop of web data is by adding your RSS URL to a newsreader service, which is a site that collects and sorts RSS feeds.

If you already use a newsreader or aggregator such as Bloglines or Agent, simply add your URL to your own list of feeds and your aggregator adds your site to the feeds it indexes.

A free MyYahoo! page (see Figure 10-16) is such a service and perhaps the best one to use, as Yahoo! has some 500 million users; once it begins to index your feed, it will be available to every one of those subscribers.

To create a MyYahoo! page, follow these steps:

1. Go to `http://my.yahoo.com`.

2. Click the Sign Up Now - It's Free link shown in Figure 10-17. The information screen in Figure 10-18 appears.

3. Fill in all the information and accept the Terms of Service by clicking I Agree, and Yahoo! generates your MyYahoo! page.

4. Once your page is set up, go to it and click the Add Content link shown in Figure 10-19. The next page displays a large Find Content field.

5. Click the Add RSS by URL link to the right of the Find button as shown in Figure 10-20.

6. Type your RSS URL and click Add, as shown in Figure 10-20. You'll notice that the only difference between your regular URL and your RSS URL is the .xml on the end. As an example, my site's URL is `http://www.catherinejamieson.com/index.html`, and my RSS URL is `http://www.catherinejamieson.com/index.xml`.

10-18

10-19

10-20

10-21

10-22

Yahoo! now "carries your feed" and will index your pages regularly to keep your MyYahoo! feed page updated for you. You do not need to ping Yahoo! (see the section "Pinging" for details) as it has a dedicated system of robots that work to keep all its subscribers's feeds up to date; once you have subscribed to your own site, Yahoo! checks regularly for updates. Yahoo! has a self-scheduling agent that periodically checks for updated RSS feeds. The frequency of these periodic checks is based on a history of how often content changes, so if you update regularly, Yahoo! checks more frequently.

You can easily allow MyYahoo! users to add your site to their subscriptions by visiting the page `http://my.yahoo.com/s/button.html` and following the instructions for creating a Subscribe button (see Figure 10-22). You could then add this button to your about.html page under the subscribe category.

DESIGNER TIP

If you have a page or pages you do not want indexed by search engines, there is a method of asking robots and spiders not to record the page or use it in searches. Create a file called robots.txt and place a command in your header to tell all robots where to find it. In this document, you can specify what robots may or may not use. Go to `www.google.com/bot.html` to read about these files and their uses.

Getting Rated on Search Engines

There is a myth that you can fool search engines, and I have seen many people try very hard to do so. You can't because they have a lot more information than you do, and I have never once seen the effort return a positive result.

Google (www.google.com) is the most widely used search engine and the gold standard for evaluating a page's usefulness and popularity.

Google not only doesn't pay any attention to most meta tags, but it doesn't pay a lot of attention to you, either, in terms of how highly it ranks you. It pays attention to whoever pays attention to you.

Google works on a system of page ranking. When a person submits a query for "photography," for example, Google finds all the sites it considers related to photography and then presents them in order of their page rank, with the highest-ranked pages first.

To rank pages, Google interprets links. A link from one site to another has a certain base value. If the linking page is highly rated, it will increase the value of the link and the linked page will improve in rating.

In other words, if IBM links to you, your rating will go way up. If your ten best friends link to you from their favorite community forum, your rating will likely remain unchanged.

If you want to improve your site's search engine ranking, try this:

> Listings on places like photoblogs.org, flickr.com, and the Yahoo! directory will count as links in search engine algorithms.

> Include text content on all your pages that identifies your site name and the keywords you would use to describe it (which you did previously by adding a description to your blog settings).

> Provide good alternate caption text with your images as this counts as page text and will often contain search phrases people look for such as "mountains at sunset" or "child playing in sand."

> Submit your photographs to a meme or competition site such as Photofriday (www.photofriday.com) as shown in Figure 10-23 or JPG Magazine (www.jpgmag.com), as shown in Figure 10-24.

10-23

10-24

SUBMITTING YOUR SITE TO INDEX AND PORTAL SITES

Many portal sites like MSN, Alta Vista, and Lycos simply list your blog once you have made the information submission. Sometimes, such as at photoblogs.org, you need to add a piece of code to your blog to be recognized as a member. Some portals like DMOZ require you to apply and then wait for approval.

The most important thing to remember about submitting your site and starting a publicity campaign is that your blog must be ready. This means that not only do you need to have a fully functional and attractive site, but you also need a fairly substantial amount of content before you will be considered. Second applications from an already denied site are not processed quickly, so try to get it right the first time.

SELECT APPROPRIATE CATEGORIES

It will be helpful to have an idea of what categories your site would fit into under a hierarchical menuing system such as that used by myYahoo! If a user were looking for photo blog content to add to his myYahoo! page, as an example, the categories would be

> **Top level:** Entertainment and Arts or Arts

> **Second level:** Visual Arts or Photography

> **Third level:** Photography or photoblog or even weblog

At most portal sites, photo blogs and other photography sites are located under "Arts," "Arts and Humanities," or "Arts and Entertainment," but check under "computers and Internet" and "blogs" as well as there is often a category there into which you can slot a photo blog.

GETTING LISTED ON DMOZ

The Open Directory Project is the largest, human-edited directory on the Internet. It is constructed and maintained by a community of volunteer editors and is, perhaps, the most important place for your blog to be listed. The information in the Open Directory feeds the core directory services for many of the Internet's largest and most used search engines and portals, including Netscape, AOL, Google, Lycos, HotBot, DirectHit, and hundreds of others.

You are not automatically listed in the DMOZ directory when you apply. As an illustration, at the time of writing, there were only 91 sites listed under the photoblogs category at DMOZ, while photoblogs.org lists more than 11,000. A human editor must verify your site before it can be included in the directory.

To suggest your site for inclusion in DMOZ, go to their site at www.dmoz.org/Arts/Photography/Weblogs/Photoblogs/, click the "suggest URL" link shown in Figure 10-25. A screen appears with a list of fields for you to complete.

If you type the word *photoblog* into Google's search box, photoblogs.org is the first site that appears, which means that people looking for photo blogs to view go there first, generally. It is the most likely and efficient way to get your photo blog noticed.

Complete the submission form with the following in mind:

> **Select the right directory category.** Photo blogs belong in the DMOZ directory Arts ⇨ Photography ⇨ Weblogs ⇨ Photoblogs.

> **Make sure your description is personal in nature and not overtly promotional.** This is particularly important to the DMOZ editors.

PHOTOBLOGS.ORG

Photoblogs.org (`www.photoblogs.org`), as shown in Figure 10-26, is the brainchild of talented photographer Brandon Stone. His is a community portal site that, among other things, keeps an index of photoblogs. At the time of printing there were more than 11,000 listed; this site is the de facto headquarters of the photo blogging community.

Photoblogs.org has a wide variety of useful services such as wiki sites on photoblogging (`http://wiki.photoblogs.org/`) as shown in Figure 10-27 and cameras (`www.camerapedia.org/`) as well as a blog filled with useful information (`http://blog.photoblogs.org/`) on which you can participate if you are a member.

YAHOO!

Yahoo! is a large organization that has both a search engine and a directory of sites. The search engine works like Google, and you do not have to do anything to get into it except exist in RSS format, which your blog does if you built your blog with the templates supplied on the book's companion website.

10-25

10-26

10-27

10-28

10-29

The Yahoo! robots go around the Web in the same way that Google's do, and Yahoo's search will pick you up eventually. However, if you want to get into the directory, you need to make an application to Yahoo! Point your browser to `http://add .yahoo.com/fast/add?88342251` to submit your blog to Yahoo! (see Figure 10-28).

FLICKR

While you do not submit your photo blog to flickr, per se, there are ways to bring traffic to your site from your flickr stream. Flickr, as shown in Figure 10-29, has some half-million users, according to conventional wisdom, and all of them are interested in photography so it stands to reason that a large potential audience exists in this community.

Here are a few ideas to promote yourself and your blog on flickr.

> Add your URL to your profile.

> Add the URL of your blog entry to the photograph's description.

> Join some of the groups that specialize in blogging.

Joining the In Crowd

The main benefit of a Yahoo! directory listing is not the traffic but to have a link from a high-quality directory that may give your site credibility in the eyes of other search engines like Google or MSN. Google places big emphasis on who is linking to you.

Complete the submission form with the following in mind:

> Make sure you are in the right directory category. Photo blogs belong in the Yahoo! directory as Directory ⇨ Computers and Internet ⇨ Internet ⇨ World Wide Web ⇨ Weblogs ⇨ Photography.

> Make sure the title you type is the actual title of your site or Yahoo! will not process the application.

> Keep your description under 15 words if possible. This is about the length of a good first sentence of the description outlined earlier.

> Make sure your description is personal in nature and not overtly promotional. Avoid phrases like "the best."

X-REF

See Chapter 11 to navigate and take full advantage of all the features of both flickr and photoblogs.org.

PERSONAL PUBLICITY

You are your own best publicist and many people will visit your blog if they find you interesting as a person. Some of the best methods of personal publicity include

> Joining portal sites such as photoblogs.org and being active on their blog by making comments.

> Joining community groups such as flickr.com and being active by making comments, participating in group pools, and favoriting those photographs that you genuinely admire.

> Adding text content regularly to your blog and talking about interesting or informative things.

Business Cards

I had my local quick printer make me cheap business cards from their available stock with my site name, my name, my site URL, and my email address. I give them to people wherever I go and when people ask me what I am taking photographs for, if I am in a public place, I always leave them one of my cards. Not only are cards an excellent tool for publicity for your blog, they are useful for making contact with potential models, other photographers, and local photographic opportunities.

FLICKR

As the grid of images in Figure 11-1 illustrates, flickr offers something for everyone's photographic tastes and interests, from black-and-white street photography to flower macros. It provides an excellent environment where you can not only store your photographs but where you can participate in a wide variety of groups, make sets of your similar photographs, learn new techniques and skills, and share your photography experience with other like-minded people.

Participating in a community such as flickr makes sense to the photographer who wants to build an online presence or simply maximize his photography experience. Prominently, of course, is the fact that flickr has some half-million members and thus, some half-million potential viewers and, in a manner, teachers. Flickr presents a wide range of activities that can help in making you both a better photographer and photo blogger, and help you get the most satisfaction from your photographic hobby.

STORING YOUR PHOTOS

Although you can store your photos on your own server, it makes a great deal of sense to keep them in a single location from which you can organize and manage them and use them on your blog or for other purposes. Flickr has two account types to meet your needs and budget. A free account limits you to 200 visible photographs and limits your monthly uploads to 20MB. A pro or paid account, on the other hand, offers a massive upload allowance of 2GB and lets you store an unlimited number of stored/visible photographs; the pro account also frees you of any bandwidth limitations.

11-1

Flickr supports JPEGs, PNGs, and nonanimated GIFs. With a free account, each photo you upload must be less than 5MB in size. With a pro (paid) account, each file must be less than 10MB. This will allow you to upload both original JPEG and the JPEG files extracted from RAW images produced by today's popular cameras in their from-the-camera-size, if you choose.

Original photos are copied, compressed, and resized by Flickr, and are stored in the following sizes:

> **Square thumbnail:** 75 x 75 pixels

> **Proportional thumbnail:** 120 pixels on the longest side

> **Medium or illustration size:** 240 pixels on the longest side

> **Standard size:** 500 pixels on the longest side (see Figure 11-2)

> **Large size:** 1024 pixels on the largest side

If you hold a pro account your original is kept intact and stored as you uploaded it with no compression whatsoever and is available for you to use in its original state.

You can access all of these copies of your photos by using the link on top of the photo labeled All sizes, as shown in Figure 11-3.

11-2

11-3

11-4

11-5

11-6

Compare the two presentations of the same photograph in Figures 11-4 and 11-5. In the first, it is smaller than optimum for photography viewing, and you cannot control how large it appears on your home page. It is always in that order and in that size. In the second, which is shown on my blog, it is displayed inside of my design in an order I choose, and I can move it to the front page or the last page, show it at 700 pixels wide or 250 pixels wide, or put a dashed pink border around it, if I choose.

The templates included with this book do not rely upon flickr, nor do you have to use flickr to use the templates to create your own blog; if you do use flickr, however, the templates allow you to use flickr with them as effectively as possible. flickr is actually designed to share photos, and, because the most common method of sharing online data is through blogs, you can use it as a clever enhancement to your own blog.

In Chapter 3, I cover signing up for flickr and creating a basic account; the rest of this chapter assumes that you have registered with flickr and are ready to explore the site itself.

Go to www.flickr.com, as shown in Figure 11-6, and sign on using the username and password you registered with or register now to go through the processes in this chapter and get a hands-on feel for the interface and the opportunities.

NOTE

If you have not signed up for flickr, I urge you to do so now and find out what it has to offer. It has become a very important aspect of the photo-blogging experience.

NOTE

Only the last 200 of your photographs are viewable by the public, but you can access all of them yourself.

UPLOADING YOUR PHOTOS

You may choose one of three options to get your photos onto flickr's servers:

> Upload using a program called Uploadr that you download and install.

> Use the flickr online interface.

> Send photographs to flickr by way of email.

INSTALLING THE UPLOADR

Uploadr is program flickr provides for users to upload single or batched photographs stored on their hard drives. To find the installation file, point your browser to `www.flickr.com/tools`. Then click a pink link to download the version of Uploadr that's appropriate for your operating system (see Figure 11-7). A download screen appears and you can proceed to download the file to your own computer.

After the file has completely downloaded, open it by clicking it from the folder to which you downloaded it and a setup wizard appears. Proceed through the setup, which is very straightforward and for which you can use the defaults suggested by the installation procedure. When you are done, your uploading tool will be ready to use.

11-7

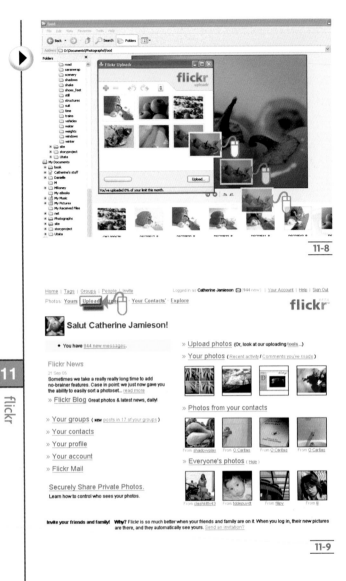

11-8

11-9

USING THE UPLOADR

To use the Uploadr, click the flickr Uploadr icon that was installed when you completed the setup program. As shown in Figure 11-8, simply click and drag the images from your folder to the Uploadr and drop them in. When you are done, click Upload and your photographs are sent to your stream on flickr. The first time you use the Uploadr you fill in your account and password details so your system can complete the handshake with flickr's computers to ensure that your photos get to the correct place.

The Uploadr is an excellent tool to keep on your desktop as you go through your folders and decide which of your photographs you want to keep on flickr. You just add images to the Uploadr by dragging and dropping or by using the +/- icons on the toolbar; when you're done, you can upload the batch.

UPLOADING WITH THE WEB UPLOAD PAGE

The upload page on the flickr website is another way that you can upload photographs. Its primary restriction is that you can only upload six photographs at a time, but often you are only uploading one or two and this poses no real inconvenience. Of course, you can upload as many batches of six as you choose.

To upload photos using the upload page, follow these steps:

1. From your main flickr page or any flickr page (once you are logged in) click Upload as shown in Figure 11-9.

DESIGNER TIP

Remember that when you upload photographs to flickr, using any of the means available, they will forever be in the order you placed them — you cannot move photographs around in your stream. Take care when uploading that if you want them in a particular order, or wish to have one photograph come before or after another one, that you upload them in that order.

2. A screen appears as shown in Figure 11-10. Click Browse next to the first box and find the photograph on your computer that you want to upload to flickr. Repeat this procedure up to six photographs you want to upload.

3. You can choose tags that go with all the photographs you upload in this batch but it is often better to tag each photograph separately unless they are all connected in some specific way. A tag is the rough equivalent of a keyword — a word that is used to identify this photograph's attributes. See the section "Tags" later in this chapter for a more complete explanation.

4. As shown in Figure 11-11, choose the privacy settings — whether you want them to be visible to the public (recommended) or whether you want to keep them private or visible only to selected viewers.

5. Click Upload.

6. A new screen appears that tells you that the system is processing your upload and then the image(s) you uploaded is shown in small format. As shown in Figure 11-12, you may add or edit the information in the Title, Description, and Tags boxes. When uploading, flickr uses the name of the file as a default title.

7. Click Save and your images are added to your stream and are visible to any flickr viewer.

Upload photos to Flickr

You have used

0%

of your upload capacity for this month.

(You have a limit of 2 GB per month.)

Your upload limit is measured in bandwidth, or "throughput", **not** actual storage space. More information...

Uploading tools

We provide tools for Mac and Windows to make it easy to upload a batch of photos all at once.

Find the image(s) you want on your computer

1. [] Browse...
2. [] Browse...
3. [] Browse...
4. [] Browse...
5. [] Browse...
6. [] Browse...

Add tags for ALL these images [?]

[]

Choose the privacy settings [?]

○ Private
 ☐ Visible to Friends
 ☐ Visible to Family
● Public

UPLOAD

Or, cancel and return to your photos.

11-10

Upload photos to Flickr

You have used

0%

of your upload capacity for this month.

(You have a limit of 2 GB per month.)

Your upload limit is measured in bandwidth, or "throughput", **not** actual storage space. More information...

Uploading tools

We provide tools for Mac and Windows to make it easy to upload a batch of photos all at once.

Find the image(s) you want on your computer

1. [] Browse...
2. [] Browse...
3. [] Browse...
4. [] Browse...
5. [] Browse...
6. [] Browse...

Add tags for ALL these images [?]

[]

Choose the privacy settings [?]

○ Private
 ☐ Visible to Friends
 ☐ Visible to Family
● Public

UPLOAD

Or, cancel and return to your photos.

11-11

Describe your photos

Add a title and description below:

Title: DSC03518

Description:

Tags [?]:

SAVE

Or, go to your photos page.

Your Photos
- Your Photo page
- Recent Activity
- Your Tags
- Your Sets
- Upload form
- Uploading Tools
- Organizr

Your Account
- Account page
- Edit Profile
- Profile Privacy
- Photo Privacy
- Upload-by-email
- Buy a Pro Account
- Order History

Explore
- Explore page
- Most recent uploads
- Comments you've made
- Everyone's tags
- Photo Search
- Creative Commons
- Group Listings

People
- Your contacts
- Contacts' photos
- People Search
- Invite
- Your Groups
- FlickrMail

Support
- FAQ
- Support Forums
 - FlickrHelp
 - FlickrIdeas
 - FlickrBugs
- Help by email
- "Get the most out of Flickr"

11-12

DESIGNER TIP

Tags are not just for viewers. You can also use them for your own purposes. If you use flickr, for example, to store stock photos that you hope to sell one day, you can give them specific tags so you can locate them easily in your stream. I use tags to identify the universal filename of the photo I am storing so I can quickly locate the original on my computer or blog.

USING TAGS TO GET NOTICED

Tags are the new tool of the social Web and are gathering increasing usage across the Internet. Simply, a tag is a descriptive word that you associate with your photograph. They are used by a variety of interfaces and programs (such as technorati, flickr, and del.icio.us) and act a lot like keywords. They provide search hooks for programs to use to find items people are looking for. As shown in Figure 11-13, flickr keeps a page of popular tags with each tag's popularity indicated by the size of the font used to display the tag name. It is an excellent way to not only discover what people are posting and what is popular but to get a good feel for what sorts of words people are typing into search engines to find photographs on the Web. This can help you develop your own tagging and keyword practices.

Hot tags

In the last 24 hours

lappop, barcamp, sexta, barcampamsterdam, sextaposer, yale brewery, hurricanewilma, kreuzberg, furryfriday, musik, sin, low, blumen, okinawa, bologna, orangutan, mediumformat, wilma, picasso

Over the last week

birdsstamps, barcampamsterdam, euroia2005, blogon2005, eurooscon, hurricanewilma max2005, zombiewalk, cameratoss, cameratossblogged, deyoungmuseum, wilma, barcamp, canondigitalrebel, festivaloflights, deyoung, shozu, digitallife, sidekick2, elora

All time most popular tags

amsterdam animal animals april architecture art australia baby barcelona beach berlin bird birthday black blackandwhite blue boston bridge building bw california cameraphone camping canada car cat cats chicago china christmas church city clouds color colorado concert day dc dog dogs england europe family festival fireworks florida flower flowers food france friends fun garden geotagged germany girl graduation graffiti green hawaii holiday home honeymoon house india ireland italy japan july june kids lake landscape light london losangeles macro march may me mexico moblog mountains museum music nature new newyork newyorkcity newzealand night nyc ocean orange oregon paris park party people phone photo pink portrait red reflection river roadtrip rock rome sanfrancisco school scotland sea seattle sign sky snow spain spring street summer sun sunset taiwan texas thailand tokyo toronto travel tree trees trip uk unfound urban usa vacation vancouver washington water wedding white winter yellow zoo

11-13

To browse all the tags, click the Tags link on the top menu bar of any flickr page. This shows you a page like the one in Figure 11-14. To use and search your own tags you must be on the Your Photos screen, which you get to by clicking the Home link at the top of each flickr page and then click the Your Photos link. As shown in Figure 11-14, you can search your photographs using your own tags by typing in your search word(s) in the Search By Tag search box or by clicking the "Browse By...Your Tags" link.

I highly recommend that you employ a practice of careful tagging. Although it seems like you will always remember the title of this or that photograph, as you gather an archive of stored photos you will be glad that you tagged them carefully when you're trying to find, for example, that one you took last spring of that little red rowboat.

Home | Tags | Groups | People | Invite Logged in as Catherine Jamieson. (952 new) | Your Account | Help | Sign Out
Photos. Yours · Upload · Organize · Your Contacts' · Explore

flickr

 Your photos pro

Garden Wallpaper

On The Refrigerator Door
18 photos | Edit

I looked out my office window this morning and _
(10 comments / 86 views)
This photo is public (set privacy)
Uploaded on Oct 21, 2005 | Delete

Our Favorites
188 photos | Edit

Outer Selves

» Upload
» Your sets
» Your favorites
» Your profile

✎ Edit these as a batch?

Search by tag
[] [SEARCH]
Or, browse by...
• Your tags
• Archives (1710 photos)

Your popular photos
• Most views
• Most "favorited"
• Most comments
• Most interesting

Your photostream has been viewed

11-14

In the last 24 hours
lappop, barcamp, sexta, barcampamsterdam, sexdaposer, yale
brewery, hurricanewilma, kreuzberg, furryfriday, musik, sin, low, blumen, okinawa, bologna, orangutan, mediumformat, wilma, picasso

Over the last week
birdsstamps, barcampamsterdam, euroia2005, blogon2005, eurooscon, hurricanewilma
max2005, zombiewalk, cameratoss, cameratossblogged, deyoungmuseum, wilma, barcamp, canondigitalrebel, festivaloflights, devoung, shozu, digitallife, sidekick2, elora

All time most popular tags

amsterdam animal animals april architecture art australia baby barcelona beach berlin bird birthday black blackandwhite blue boston bridge building bw california cameraphone camping canada car cat cats chicago china christmas church city clouds color colorado concert day dc dog dogs england europe family festival fireworks florida flower flowers food france friends fun garden geotagged germany girl graduation graffiti green hawaii holiday home honeymoon house india ireland italy japan july june kids lake landscape light london losangeles macro march may me mexico moblog mountains museum music nature new newyork newyorkcity newzealand night nyc ocean orange oregon paris park party people phone photo pink portrait red reflection river roadtrip rock rome sanfrancisco school scotland sea seattle sign sky snow spain spring street summer sun sunset taiwan texas thailand tokyo toronto travel tree trees trip uk unfound urban usa vacation vancouver washington water wedding white winter yellow zoo

11-15

Tags are used extensively by flickr users and have become a very popular way of navigating the Web — my own site gets several hits a day from search engines where the searcher has used a word that appears in one of my image tags.

ORGANIZE AND MANAGE YOUR PHOTOS

One of flickr's most compelling attributes is the Organizer function. As shown in Figure 11-15 flickr offers an excellent organizational tool you can use to browse your photographs by date or set and search by title or keyword as well as putting your photos into sets.

Sets are groups of similar photographs that you keep together so they can be viewed together. Examples of set names might be macro or scenery and can be anything at all although I recommend using names that have meaning to a broad range of people.

Clicking the Organize link on the top of any of your flickr pages takes you to the organizer area where you can:

> Organize your photos in sets or add them to pools of groups to which you belong.

> Create new sets or groups of similar photographs and arrange them inside the set in any order you choose.

> Rearrange the order in which your sets appear to viewers and their names and descriptions. You can add a hyperlink back to a similar set on your blog, for example.

> Delete photographs from your stream.

> Add tags and descriptions to photographs or alter their privacy status.

CREATING, JOINING, AND PARTICIPATING IN GROUPS

Groups are a mainstay of flickr's immense popularity. A group is a gathering of people and photographs that have a common theme or interest. There were some 40,000 groups active on flickr when this book was printed, and hundreds more are started each day.

You are required to join a group if you want to submit pictures. Each group has its own pool of photos and a forum where conversation threads can be started. Joining groups is quick and easy and, of course, you can quit them at any time.

There is an upside and a downside to this plethora of choices. On the one hand, there is a group for practically everything. There are the general groups such as the one called FlickrSoup for the Soul (see Figure 11-16), which states it is, "A REMINDER of the important things in life – love, connection and gratitude" to the more specific such as the group called Hydrants (see Figure 11-17), which says only this in its description: "Hydrants for everyone!"

Some of the more interesting groups combine purposes and are not just about photography but about poetry, collections, sports, hobbies, other art forms, politics, or literature such as the group Six Word Stories. Six Word Stories allows only photographs whose titles contain six words and tell a story such as the photo entitled "Traffic Jam In The Park Today" (see Figure 11-18).

Working with Photographs

11-16

11-17

11-18

DESIGNER TIP

If you choose your groups well, you will find that your views increase as others in the group come to view photos you have added to the pool. To this end, follow these guidelines: Don't post a single photograph to too many pools — it tends to get overlooked in all of them. Don't post too many at once to any pool as they, too, tend to get overlooked.

On the other hand, there is sometimes not only **a** group for everything, there are often two or more groups for everything. There are no restrictions on groups — members can start as many as they like and join as many or few as suit them personally. They're easy to create and they're easy to join. When choosing which groups to join and participate in, go through the group pool first and see whether you feel your photographs fit with that mix. Read the message threads, and make sure the tone and environment are suitable for your personality.

JOINING A GROUP

Whatever your interest might be, whether it's medium format black-and-white or snapshots of your favorite pets, there is likely a group on flickr that is about that very thing. If there isn't, you can start one.

1. Once you log on, click Your Groups on the bottom right side of the main page, just under the thumbnails of the latest uploads. A group index page appears that is similar to the one in Figure 11-19. It lists all of the groups to which you belong or have been invited.

2. To search for a group that interests you, type your query into the Search for a group box, which is located on the upper-right side of the screen. For search queries, it is best to be as specific as possible. There are a lot of groups and a vague query returns many pages of results.

3. Go through the list of groups that match your search query. Read the titles and descriptions to find something that interests you. As an example, in Figure 11-20 I use the search string "children portrait," which returns three pages of results. After reviewing the list of results, click the group name to go to a group that seems to best suit your interests; you can view the pool and/or read the threads. For this example, I selected the first group listed, which is called Children's Portraits and which has, at this point, 1,427 members.

4. The group's home page appears (see Figure 11-21). If you decide the group is suitable and you think you can add something to it or get something from it, click the Join this group? link on the right side of the page.

11-19

11

flickr

Your search results

✅ **Your search for "children portrait" yielded 1161 results.**

1. **CHILDREN'S PORTRAITS** (1427 members)
 - As children who spread both joy and sorrow constantly surround me in my daily work,...

2. **Children are taking photos** (158 members)
 - This group is only for photos took by children. Only one rule: Photos took by real...

3. **The Child's World** (17 members)
 - Natural shots of kids doing things and expressing things in a way only kids would do....

4. **Crianças/Children** (113 members)
 - Fotos de crianças All photos of children

5. **School Portraits** (133 members)
 - Scan in or photograph a shot of your school portrait (K-12), and share with the world...

6. **Portrait** (2860 members)
 - Here <i>Portrait</i> refers to any photo that depicts the face and/or adjacent...

7. **KIDPIX** (448 members)
 - Welcome to KIDPIX. A new pool for sharing your best «CHILDREN» photos with other...

8. **Two Faces** (141 members)
 - This group is for photos of two people whose faces are: - seen full front - seen...

9. **Faces (Only Human Faces)** (1090 members)
 - Only faces Uman Faces. No animals, no flowers, no mannequins, no statues....

10. **Latinoamericanos!** (174 members)
 - Un club para flickreños latinoamericanos! Seas de Brasil, Mexico, Chile, Argentina,...

11. **how I used to be** (200 members)
 - <i>What do you see in the images of your past, through the lens of an older, hopefully...

12. **Childhood (my childhood)** (78 members)
 - Here you can add photos of your own childhood. Please set <u>only</u>...

11-20

Photos: **Yours** · Upload · Organize · Your Contacts' · Explore

flickr

 CHILDREN'S PORTRAITS

Group Photo Pool (**See all 11067 photos**)

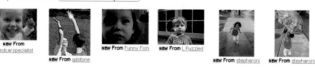

NEW From usedcarspecialist

NEW From gdstone

NEW From Funny Fish

NEW From I, Puzzled

NEW From stepharoni

NEW From stepharoni

Discuss

More...

Title	Author	Replies	Latest Post
WELCOME to Children's Portraits!	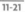 carf	75	7 days ago
Do You Focus On Orphans?	camera_rwanda	3	2 weeks ago
Group shots?	phraseling	3	2 weeks ago
UNITED CHILDREN OF THE WORLD FotoBlog	carf	1	2 months ago
Newbie to group!	schmatzy	0	2 months ago
What kind of profile do we expect of this group?	carf	6	2 months ago

» **The group pool**
(11067 photos)

» **Join this group?**

» **1427 members**

Search discussions

[SEARCH]

(Or, browse all topics.)

6 of 9 posts | Read all CHILDREN'S PORTRAITS's discussions

11-21

5. A verification screen appears where you can verify that you want to join the group (see Figure 11-22).

Once you perform the verification step you are a member of the group and can add photographs to the pool or participate in discussions.

As soon as you have joined a group, its name appears on the list when you click the My Groups link from your flickr home page so it will always be easy to keep track of all your groups.

PRACTICING GOOD ETIQUETTE

Before adding photographs to group pools and participating in threads you need to understand some of the unspoken rules that seem to work not only at flickr but on any community site:

> Don't inundate the pool with a lot of photographs at once or a lot of similar photographs from the same shoot.

> Read the group guidelines located on the bottom of the group's home page carefully before submitting; submit only photographs that meet the stated criteria and only the quantity allowed. Many groups have daily quotas for additions to the pool by an individual. Some groups require that you add special tags on any photos you submit to their pools.

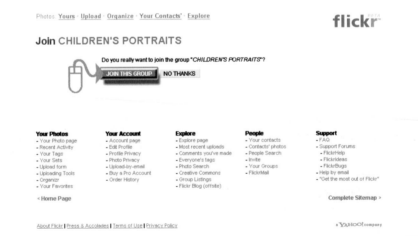

11-22

> A person who starts a group is called an administrator. He or she can promote any number of other people to be administrators as well. These people own the group and they may make any rules they so desire. A group is not a democracy but rather more like a private club, and it is important that you treat the administrator with respect inside of his or her group.

> All standard social rules of interpersonal communication apply: no name-calling, no ad hominem remarks. Providing a critique on another person's photo should only be done when requested or specifically allowed. Some groups exist in order to provide a forum for critique, but others do not abide it at all.

PARTICIPATING IN DISCUSSIONS

To take part in group discussions, follow these steps:

1. Click one of the thread names under Title on the group's home page if you find a topic that interests you (refer to Figure 11-21). The latest pictures added to the pool as well as the latest threads or topics posted to the forum are listed.

2. To add to the discussion in the thread you're reading, scroll to the bottom. In the Reply to this topic? Test box type your reply (see Figure 11-23). Click POST NOW when you are done and your reply is added to the thread.

CREATING A NEW TOPIC

Although many groups barely discuss anything at all, the most interesting groups are those that have regular discussions. You may find that you have a question you want to ask or an on-topic story that you wish to relate to others in the group, and you will need to start a new topic thread. Here's how:

1. On the group's home page, click Post a new topic. A screen similar to that shown in Figure 11-24 appears.

www.catherinejamieson.com/verbiage/artists.html#carljohnson

Base list:
www.catherinejamieson.com/verbiage/artists.html

A note about the list:

the list is sorted alphabetically and while I will likely figure a hack someday to fix it, it is sorted by default in a case sensitive way - in other words there are two "A" sections - an "A" and an "a". So, as a straight alpha index it's a little confusing. Sorry about that. Someday ...
Originally posted 79 minutes ago. (permalink | delete | edit)
Catherine Jamieson (a group admin) edited this post 74 minutes ago.

alterednate pro **says:**

Indeed, I've spent a while looking at the growing collection over the last few days. Great idea & execution, Catherine!!
Posted 24 minutes ago. (permalink | delete | edit)

Reply to this topic?

(Some HTML is OK.)

PREVIEW OR POST NOW

11-23

Home | Tags | Groups | People | Invite Logged in as **Catherine Jamieson** (952 new) | Your Account | Help | Sign Out
Photos: **Yours** · **Upload** · **Organize** · **Your Contacts** · **Explore**

flickr

Utata / **Post a new topic**

Subject:

Your Post:

(Some HTML is OK.)

PREVIEW OR START TOPIC

Or, return to the group page.

11-24

11-25

11-26

2. Type your subject in the Subject field. When selecting a subject for your post, make it descriptive so that it makes sense to the casual reader who may be reviewing the group before joining.

3. Type your message in the Your Post field. When starting topics or replying to messages in groups, take the time to read the board or review the other messages so you are not duplicating someone else's general post. It seems like a natural thing, but you might be surprised how often people simply do not verify that a topic has not already been raised or a question already asked.

4. Click START TOPIC (see Figure 11-24).

ADDING PHOTOS TO A POOL

The primary reason, of course, to join a group is to share your photographs with other group members. You do this by adding your photographs to the group pool:

1. From your main flickr page, click Your photos (see Figure 11-25). A page showing your latest uploaded images appears.

2. Choose the photo you want to add to a group and click it as shown in Figure 11-26. The photo's individual page appears. Most individual photo operations such as adding a photo to a group or viewing all of the available sizes is done on the photograph's actual page.

DESIGNER TIP

When participating in groups on flickr or any other community site it is a truism that you get out of groups what you are willing to put into them. If you reply to questions or respond to comments then yours are more likely to be answered as well. One of the best ways to attract people to your stream or blog to view your photography is to make a positive impression in one or more groups.

3. From the menu above the photograph, click SEND TO GROUP (see Figure 11-27). A drop-down menu appears with all of your groups listed. Select the group to which you want to add the photograph and click the name. A confirmation appears telling you that your photo has been added to the selected group. Click OK and the photograph is part of that group's pool. A notation appears on the right side of the photo alerting viewers to which groups it belongs.

CHECKING FOR ACTIVITY IN YOUR GROUPS

If there has been activity recently in any of your groups, the system alerts you on your main flickr page with the linked notation that there are "New posts in X of your groups." Click the link, and your groups page appears. It lists all the groups of which you are a member in the order that they have been posted to, with the one most recently posted to being the first on the list. From here you can click on the groups you want to visit.

USING THE FLICKR COMMENT SYSTEM

The processes for adding and reading comments are very self-explanatory. They work much like adding posts to groups except you are adding to a person's photograph history.

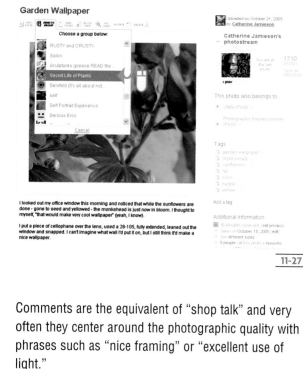

11-27

Comments are the equivalent of "shop talk" and very often they center around the photographic quality with phrases such as "nice framing" or "excellent use of light."

There are also, of course, "wow," "amazing," and "nice" comments or other single-word compliments but most comments tend to be more specific in nature.

Of course, you are free to make any sort of comments you like but, there are some generally accepted practices.

Generally, the rule about comments is that if you make a lot, you receive a lot. Getting feedback from comments is a very important aspect of the flickr experience. Comments can be both difficult and cumbersome to manage on a blog but in the spam-free environment of flickr, in the openness of the community, comments are plentiful and generally very rewarding.

USING THE FLICKR CONTACT SYSTEM

Contacts are flickr's way of organizing social relationships. There are three types of relationship (regular contact, friend, and family), and you can organize your photographs so that only your friends, for example, can see certain images that you can then hide from both the general public and your regular contacts.

If you list someone as a contact you can see his or her latest images on your main page under the Photos from your contacts heading (see Figure 11-28). Those you list as contacts can see your latest images in the same place when they log on. Although your photos also appear under the Everyone's photos heading on the main page, so many people post so many photographs to flickr that nothing stays there more than a few seconds so it is important to establish contact relationships.

ADDING A CONTACT

Listing people as contacts means that you are interested in their photographs. As you find people who post the sort of photographs that you admire, you will want a way to follow their work. As people who admire the sort of work that you do find your photographs, they will want to add you as a contact.

1. On the main page of the person's stream, click the person's buddy icon as shown in Figure 11-29. Click the pink box that asks, "Add _____ as a contact?"

11-28

11-29

11-30

2. A gray layer appears on the screen as shown in Figure 11-30, with an input box in the middle. Click OK to add the person as a regular contact. You can also select the Mark as **Friend**? or Mark as **Family**? check boxes if you want to make this person one of these types of contacts.

VIEWING YOUR CONTACTS

From your main page, click the People link along the top. A page appears that lists all your contacts by the type of contact relationship. To see the complete list of each type of contact that you have click the more... link below each grouping.

VIEWING YOUR CONTACT STATUS

From your main page, click the People link along the top. On the contact screen that appears click the Who counts you as a contact? link on the top right. All the people who list you as a contact appear.

PLAYING FAVORITES IN FLICKR

Favoriting a photo is just that — it indicates that you consider it one of your favorites. You like it. Similarly, when others favorite one of your photographs it means that they like it. It's an excellent system of providing an "atta boy" to a photographer as well as gauging which of your own photographs make the most impact on viewers.

Favoriting a photograph is simply a matter of clicking the Add to Faves star above the photograph that you like as shown in Figure 11-31.

Next to the Your photos link on your flickr main page there is a link called NEW comments that allows you to see any comments made to your photographs since the last time you looked as well as alerting you to whether someone has favorited one of your photographs.

MAKING A BUDDY ICON

When you sign up, flickr assigns you the default buddy icon, which is a dull-looking gray face that you will likely want to change right away to something that better reflects your personality or photographic interests. Your icon will represent you on flickr; it shows up next to your images, your comments, and your posts in groups so it is wise to choose it carefully.

1. From your main flickr page, click the gray box with the face next to the greeting and your name as shown in Figure 11-32.

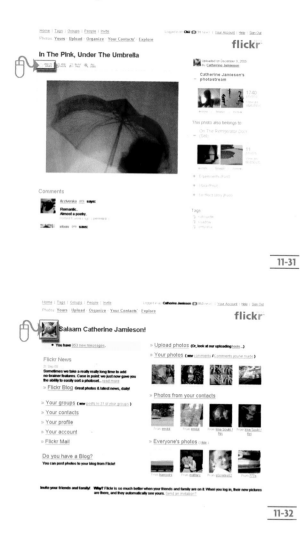

11-31

11-32

2. A new screen appears (see Figure 11-33). Choose the location of the photo you would want to make into your icon by clicking the "In my Flickr photos," "On my computer," or "On the web" link. Don't worry about the size of the photo. The icon tool allows you to resize or crop to fit.

3. Upload the photograph by using the browse function. Using the guides, create your icon inside the dotted-line square as shown in Figure 11-34.

4. Click MAKE THE ICON and your icon is created and will appear on all of your photographs and posts. Icons are retroactive; your current icon appears on all of your comments, posts and photographs, regardless of when you made them or what icon you were using at that time.

Edit your profile / **Your buddy icon**

Your buddy icon is what we use to represent you when you're in Flickr.

48x48

Your icon is
48 X 48 pixels in size.

This is your buddy icon at the moment.

DELETE

Where's the image you'd like to use?

- In my Flickr photos
- On my computer
- On the web

OR If you have a 48x48 icon ready, upload it here.

Browse...

UPLOAD

11-33

Edit your profile / **Your buddy icon**

To the left is what your buddy icon will look like. You can drag around and resize the square below to get it just how you like it. When you are happy with your icon, click the pink button to the right.

☒ constrain selection to square

MAKE THE ICON

CANCEL

11-34

MAKING YOUR PROFILE

Your flickr profile is an important piece of information as it is looked at frequently. Generally speaking, your profile is seen by anyone considering adding you as a contact so it pays to take the time to write one that is appealing and interesting.

Click the Your profile link on your main flickr page. A screen appears with a straightforward series of information fields that can be filled out. You can add your own personalized text information as well as a link to your own blog. All member profiles appear in the format shown in Figure 11-35.

Using Figure 11-35 as a guideline, it is a good idea to create a profile that can be seen on the screen without scrolling — a reader does not want to feel daunted by the sheer volume of information.

Keep it simple, make it informative, and be sure to include links to any of your groups that you might wish to promote, and, of course, your photo blog. Most people who read your profile will, at the very least, click the link to see your blog.

Photos: **Yours** · **Upload** · **Organize** · **Your Contacts'** · **Explore**

flickr

(This is how you appear when someone views your profile. Edit your profile here.)

Catherine Jamieson / Catherine Jamieson pro

Photography, for me, is about so many things that I become Whitman's contradiction when I speak of it. It's to tell stories. It's to make pretty, meaningless art. It's about making statements about our world, our society, ourselves. It's about concept and metaphor. It's about narrative and documentation. It's about art and snapshots and silly experiments and fun things you do with your friends. It's about a lot of things and I like to explore all of them.

A basic bio exists on my site which will tell you about me and my work.

Utata is the same of my site as well as a group which is like coming to my home for a party. A civilized party. With occassional ... hilarity. And very good discussions. There are some very interesting people in my dining room right now I bet. If you like smart people and good conversation, come on over and join us, we'd love to have you.

I have several accounts, which I use for several purposes. I am one of those busy bee sort of people, doing all sorts of projects and sticking my fingers in all sorts of pies, so if you see me in other outfits don't be alarmed. I'm not stalking YOU in particular :)

I'm **Female** and **43**.

Utata
Winnipeg, Canada

» **Photos**

Testimonials

Manage your testimonials

Liisa says:
"The first thing which caught my eye about Catherine was her first name because my younger sister has the same and I don't hear or see someone with this name too often. So I went to check what kind of images a person with this name might take and I was caught by her images right away. She is a true artist and knows how to take quality images. She has a unique eye on the world and it's beauty. I also like that she knows what her strengths are and how to throw them in and how to delegate what others might be more able to do as well as her efforts here at flickr and at other places of the internet. And of course I like that she likes cats as much as I do. :)"

11-35

This chapter is really something of an extension of Chapter 11 in that the things you decide to do on or with your blog will have a great deal of impact on how many people want to look at it and, better yet, tell their friends about it.

Of course, it's a given that one has to have a blog that is functional and pleasing to visit as well as good photography to show. If those things are in place and you've published your syndication feeds, listed your blog with all the directories and portal sites that cater to photo blogs, joined a few community sites such as photoblogs.org and flickr, and told all your friends and family, you've done all the necessary steps and your photo blog should do fine. This chapter is about the extra steps you can take to set your photo blog apart from the pack.

SELLING YOUR PRINTS

One of the things that appeals to many photographers is the prospect of selling their work through their blogs. Many people, such as Noah Grey of Grey Expectations (http://greyexpectations.com/) as shown in Figure 12-1 and David Nightingale of Chromasia (www.chromasia.com/) as shown in Figure 12-2 do so successfully from their sites.

ORGANIZING PRINTS ON YOUR SITE

You will need some way to indicate to people which of your photographs are for sale.

There are several possibilities for performing this function. The easiest is making a simple statement on your about page as to which of your sets or photographs are available as prints, including the blanket statement that any original item on your blog will be sold as a print upon viewer request.

PRINT ORDERING

$39.00 — 8.5" x 11" Glossy Finish		Place Order
$39.00 — 8.5" x 11" Matte Finish		Place Order
$59.00 — 11.7" x 16.5" Glossy Finish		Place Order
$59.00 — 11.7" x 16.5" Matte Finish		Place Order
$79.00 — 13" x 19" Glossy Finish		Place Order
$79.00 — 13" x 19" Matte Finish		Place Order

click thumbnail to view image

"Pixel, October 2005"
Grey Expectations #573

ABOUT NOAH GREY PRINTS

Thank you for your interest in purchasing a Noah Grey print! All prints are **personally crafted and mailed by the artist**, produced with a seven-ink process using archival inks on professional-grade luster or matte paper, for images that will **last a lifetime** with superior texture and appearance. In addition, each print is **hand-signed** and created directly from the full-resolution, uncompressed

12-1

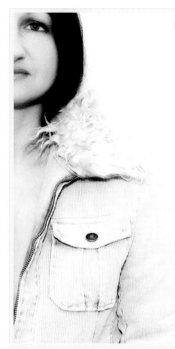

purchasing prints
If you'd like to purchase a print of any of my images, many of them are available in a variety of sizes and prices including 11.25" by 7.8" (approx.) for £17.50, and 16" by 10.7" (approx.) for £30.00 (<u>currency exchange rates here</u>). The former are printed on A4 paper and the latter on A3, both with a small border to aid mounting and framing. All prints are archival quality (i.e. they will still look great 50 years from now) and are produced on an Epson 2100 (a seven ink printer) on Epson Premium Gloss, Semigloss, or Matte paper, and can be shipped worldwide. If you'd like a print in a different format or different size to those mentioned above, please ask and I'll probably be able to arrange it.

One thing you should note: while I try to ensure that a print is identical to its on-screen counterpart an exact match isn't always 100% possible. If I think that a given image will be more than marginally different from the onscreen version I will let you know.

postage, packaging, and other costs
Postage and packaging for 11.25" by 7.8" prints is £3.00 within the UK, £3.50 for any destination in Europe, and £4.00 for the USA and elsewhere. Please add another £2.00 for 16" by 10.7" prints (the cardboard rolls I use to send these are heavier and cost more to post). If you wish to use PayPal to pay for your prints (payable to paypal AT chromasia DOT com) a 5% (five percent) surcharge will be added to the total cost.

purchasing digital files
If you'd like to purchase any of my images as digital files or web-ready graphics please get in touch and we can discuss format, licensing and pricing.

commission me
If you like my work and want to commission me for one of your own projects, please get in touch.

contact
<u>Email me</u> if you're interested in any of the above or have any further questions.

copyright
<u>David J. Nightingale © 2003-05</u> (all rights reserved).

12-2

Here are some additional ideas for indicating which of your images are available as prints:

> Create a new category called "prints" and assign each image you feel would make a good print to it. This new category will show as a sets page as shown in Figure 12-3 and viewers can view all of your prints in the same way they could view all your sets of similar images.

> In the keywords section of the Movable Type entry interface, you can use the common phrase "available as print" or something similar and then instruct readers to type that phrase into your search function to locate a list of all images that you will sell as prints.

> If you use flickr, you can create a set on your account of all of the photographs that you will sell as prints. You can then create a link to this page on your blog in your sidebar, in the navigation menu, or on the about page, which will direct readers to this set of printable images.

The first thing to do is to create a page onto which you can put all of the information regarding how your print business works. If you are using the supplied templates you can use the links or about template as a model and create a prints page by copying the basic layout, creating a new file, and altering the information on the new page to contain the information about your print business.

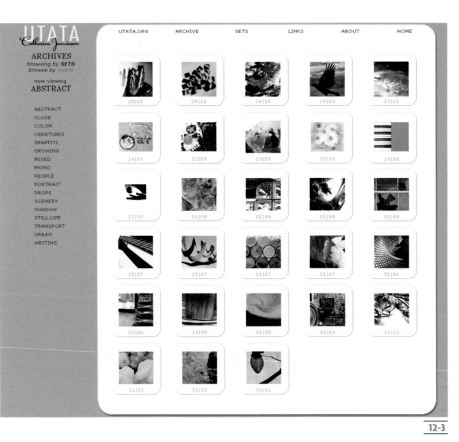

12-3

DESIGNING A PRINT INFORMATION PAGE

On the page you create to hold your print information you should, at a minimum, include the following information:

> The printing method (professionally printed at a lab, printed by you on what equipment)

> The paper and inks being used if not professionally printed

> The sizes available and their specifications – whether there is a margin or matte area, and so on

> How you ship them (flat in envelopes, matted, via courier, UPS, and so on)

> Shipping and processing costs, if any

> How much they cost

> How payment can be made

> How long it will take to process and ship

> Whether or not you provide a Certificate of Authenticity and/or sign your work

> Whether you confer any rights upon the buyer

> Whether you perform any custom photography work or are available for photography assignments

> An email address to which inquiries regarding prints can be made

There are several ways to go about selling prints via your blog, from shopping cart installations to online printing services to simple email systems.

WEB RESOURCE

To locate the resources for Nexcess shopping carts, go to www.nexcess.net/hosting/support/tutorials.

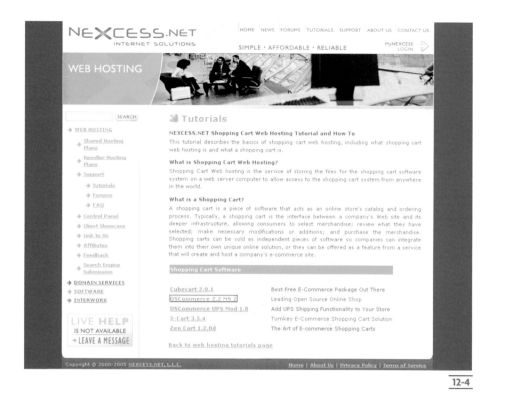

12-4

SELLING PRINTS WITH AN EMAIL SYSTEM

The email system is a simple one. You indicate that you sell your prints on your about page or in your sidebar and an interested viewer can view your information page and contact you at a certain email address to arrange a purchase. It is a good idea to set up a separate email address to deal with incoming print requests so that you can keep accurate records of your orders.

I recommend that you start with an email system as described previously that will allow you to test the waters and get your feet wet before you go through the process of setting up a shopping cart.

When you are ready to install a shopping cart system, Nexcess offers excellent shopping cart support as well as excellent tutorials, shown in Figure 12-4, on setting these systems up on your Nexcess account.

12-5

12-6

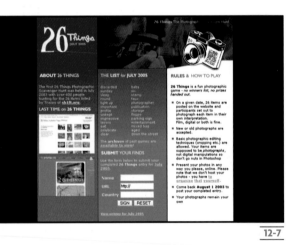

12-7

A FEW PRINT TIPS FROM THE PROS

It can be daunting to "go into business," particularly when you have created the product yourself. Luckily, selling prints online is now a fairly common practice, and in addition to the conventional wisdom gleaned through experience, there are a lot of resources available to assist you.

> If you're printing yourself, ensure you use archival quality inks and papers and that you let people know that you are printing at home. I recommend that you do not produce prints yourself but use a professional lab.

> It is a good idea to offer printing through an online service where the buyer pays you and you send the electronic negative to a print service of his or her choice. One service is offered by Kodak (see Figure 12-5) located at www.kodak. com/eknec/PageQuerier.jhtml?pq-path= 167&pq-locale=en_US. For an excellent overview on available printing services, visit smugmug's online photo comparison (see Figure 12-6) at www.smugmug.com/prints/digital prints.mg.

> If you are going to sign the front of your photographs, ensure that you leave a wide enough matte so that your signature does not occupy any of the photograph space

> If you are shipping yourself, be sure to use solid packing materials such as foamcore or cardboard and tape the print securely to a piece of matting or heavy stock to ensure that it arrives undamaged.

> When pricing your artwork make sure that you always cover all of the costs associated with creating it and price it to be in general accordance with the existing market. In other words, check around and see how much others are charging for images of a similar size and quality and stay within this range.

12-8

CREATING PROJECTS, COLLABORATIONS, AND COLLECTIONS

It's a fact, based on my own empirical analysis of statistics on several sites, that people love collaborations, galleries of similar images, projects, and themed collections. Art books on Impressionism or large picture books on cars, wars, airplanes, trains, quilts, or old farmhouses, as examples, are popular and sell well in bookstores because they bring together many similar items of interest. They are, in a sense, a sort of buffet at which a prospective viewer can see many perspectives, aside from your own, on a topic that may interest them. The system of groups at flickr is similar to a group project except that there is no ability to manage the material or present it in any way other than as it appears on the group's page.

Projects, such as the professional and organized 26 Things at www.sh1ft.org/26things/ (see Figure 12-7) or the Picture Projects site at www.picture-projects.com/ (see Figure 12-8), have a tremendous appeal with viewers and have the unique characteristic of maintaining popular appeal for a much longer time than even the most compelling of single image entries.

SET UP A PROJECT

As an example, presume that you have an interest in muscle or street-racing cars. You have several good pictures, and they seem popular with your viewers. By performing careful searches on search engines, tag searches on flickr or technorati (www.technorati.com), and keyword searches at portal sites such as photoblogs.org you can likely compose a very good list of other photographers who have a similar interest and whose pictures you like.

Select several photographers and/or photographs that you especially admire and write them an email asking them if they would be interested in participating in your project. Explain briefly how you envision producing and publishing this show and ask them if they would like to participate. Most photographers are pleased to be a part of something that they think will improve the exposure of their work and if your offer seems like it might do this, then you're likely to get more positive than negative responses. Most people, in my experience, are happy and even excited to participate in something other than the daily post to their own blogs.

You have two main options for creating project(s):

> Create a new project blog, store it in a separate directory (be careful not to write over your existing blog by trying to store them in the same place!), create your project on it, and then link to the new project blog from your main blog.

> Create a new category to hold all your collected images, create new entries for each image on your main blog, and assign them to this new category. The main entry you create to announce the project and hold the project's home page can link to this set/category page.

PROJECT/COLLABORATION TIPS

Although publishing projects is both fun and rewarding, there are a few guidelines that are important to follow. When publishing the work of others it is especially vital that you observe certain conventions as you have become, to some degree, a curator, and the artists will rely upon you to present and protect their work within those conventions.

> Always provide attribution. Make sure the photographer's name and a link to his site(s) are clearly visible on all project pages so that there is no confusion as to whom the work belongs.

> Promote your projects. Put screen shots and links on your flickr stream or make posts to your groups and clubs. Ensure that you publish a good front or main project page with a clear text description so your rss feed will attract viewers. Find any clubs, groups, or community sites that are related to the subject of your project and make a post to their community boards.

> Cull submissions to your own taste. If images are submitted that you do not feel are appropriate for your project, then don't publish them or ask the artist for alternates.

> Projects that contain some narrative element — even something simple like archival quotes — tend to be more popular with viewers than those that contain only photographs, and those that actually contain stories or other forms of literature are immensely popular.

> Do not "hot link" from a participant's site — that is have your web page call for the photograph from the participant's server. If the participant stores photos on a public service such as flickr it is appropriate to use them from there but if stored on a personal server, it is better for you to request a copy to store on your server for use in the project. Load times are made much slower when several servers have to be consulted.

> Create a links and resources page for each project where you can offer a list of links to all the places that might be of interest to project viewers. You can include, as examples, the places where you promoted your project and any sites you found while researching the idea. Don't forget: Every time someone goes from your page to another he or she leaves a trail; very often, that trail leads others back to you.

PROVIDING AN ONLINE RESUME/ PORTFOLIO

An online resume or portfolio is different from the everyday publication of your blog. While you put only your best shots on your blog, it is set up for viewers to progress through chronologically and will not provide the correct environment for a portfolio. A portfolio that you would carry with you to show a prospective client would contain ten to 15 items,

selected carefully for the type of work being offered. For example, if you use your portfolio to vie for portrait or event work you would select portraits and event shots from your archives and use them in your portfolio for that particular interview. I have a separate portfolio for portraits, commercial, stock, and photographic art, and thus, my online portfolio reflects these diverse professional interests.

You could create a portfolio online, such as the one I have on my own site (see Figure 12-9), which contains several separate portfolio packages for each of the types of work that I do. Portfolios should be a little dramatic such as Chelsea Hewitt 's site (www. chelseahewittphotography.com/), which is distinct, clean and elegant (see Figure 12-10) and very eye-catching. Industrial photographer Fernando Bergamaschi (www.photoindustrial.com/ index.html), whose portfolio site is shown in Figure 12-11 has done a splendid job of re-creating the look and feel of a high-end brochure with his compelling portfolio site.

There are many different ways you can create a portfolio, including creating an additional blog on your site and designing your own portfolio from the base templates provided or locating a template from the Web that has been specifically designed for photographic portfolios.

In fact, the site design for the templates provided with this book were created as an expanded form of an online portfolio, and to create a portfolio separate from your blog all you really have to do is create a second blog and use it to store only those photographs that you would use in an actual portfolio. This way you can send prospective clients to your portfolio to see the "best of the best." From there, of course, they can go to your blog to see the rest of the best, as it were. It is quite important when presenting work to prospective clients that you do not inundate them with too much information and that you present material in a controlled order.

Doing Cool Things with Your Blog

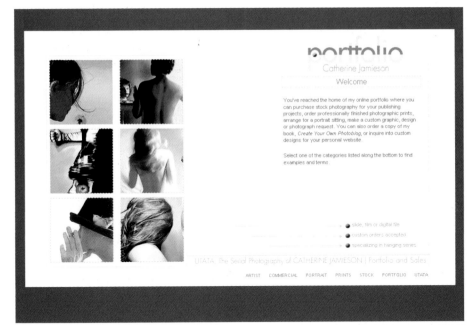

12-9

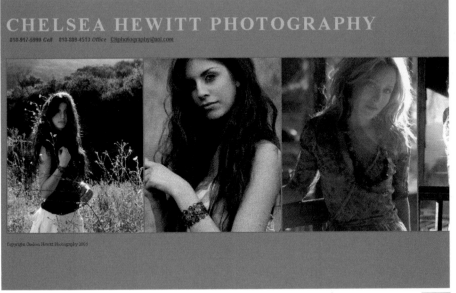

12-10

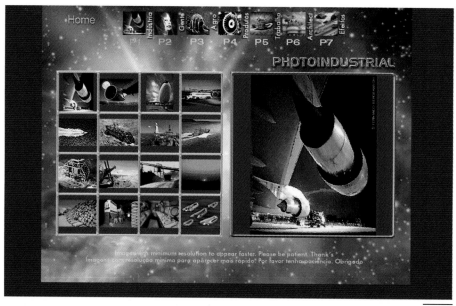

12-11

Throwaway Email Accounts

Many people keep a "throwaway" email address, a second account on gmail or Hotmail that they can use when filling out forms and signing up for services on the Web. This way, if you get a lot of spam mails as a result of these activities, they go to this throwaway account and you can delete them easily every once in a while.

Although most reputable companies and services claim not to sell or use email addresses, it is my experience that a "better safe than sorry" approach be adopted regarding spam as having a lot of spam come to your regular business or personal email address can be very annoying.

CREATING CUSTOM MAIL PAGES

One of the more popular customizations for blogs is a custom mail page. For a variety of reasons, most notably that email spam is a genuine problem on the Internet, using a mail form or a service such as flickr that has built-in spam protection is the preferred way to get feedback from viewers. The one that I use (see Figure 12-12) is simply made with a Movable Type template and uses a very basic mail script. A FormMail script, as they are called, converts the user's entered text into a format that can be sent via email and then sends it to an email

address specified in the script. I have never once been spammed via my form mail and as I have never typed my actual email address anywhere on my web pages, I have never had more than one or two pieces of email spam altogether.

One of the primary reasons that I selected Nexcess. net as my preferred and recommended hosting service is that it has excellent resources where you can locate the URLs of companies that offer add-on programs and services that might interest you as well as read comprehensive tutorials on how to install and use these programs. Even if you are using a different web

hosting service, the tutorials and resources available on Nexcess's site are well worth visiting and reviewing.

In the case of adding a custom mail page to your site, go to the Nexcess tutorial index located at `http://nexcess.net/hosting/support/tutorials/`. Scroll down to the Scripts section (see Figure 12-13), and click the FormMail link. A tutorial page appears where you can learn about how to use a FormMail script. Clicking on the FormMail link in the body of the tutorial (see Figure 12-14) takes you to the actual FormMail site (see Figure 12-15), where you can download the scripts and documentation to set up a FormMail page.

USING ENTRY KEYWORDS TO MAXIMIZE EXPOSURE

If you are using the Movable Type content management system there is a way for you to turn on and use the entry Keywords field. Keywords that are a part of each entry and are specific to that entry are different from the general keywords discussed in Chapter 11, which are for your blog site and which are not related to any particular entry or photograph.

The entry keywords field is important for several reasons:

> This list of words indexed by search engines and other indexing robots and individual entries can be found by the general public.

> You can use these keywords to isolate specific entries on your site so that a local search, using your own search page, will find all images that, for example, are taken with slide film or cross-processed.

> Keywords will be added to your rss and atom feed files automatically, and anyone with a news-reader can find your images and/or blog through keyword searches.

12-12

12-13

12-14

12-15

12-16

12-17

TURNING ON AND USING KEYWORDS

To turn on and access the keywords field in Movable Type, perform the following steps.

1. From the Movable Type interface, click the New Entry link as shown in Figure 12-16.

2. At the bottom of the entry page click the Customize the display of this page. link.

3. A screen appears (see Figure 12-17) that allows you to alter the display of the entry screen by using check boxes.

4. Select the Custom: show the following fields: radio button and then make sure that the check boxes for these fields are selected:

 > Category

 > Extended Entry

 > Excerpt

 > Keywords

 > Allow Comments (if you are using comments)

5. Click Save and your settings will be used the next time you create a new entry. To add keywords to an entry, simply type each keyword, separated by a comma, in the keyword space.

KEYWORD TIPS AND HINTS

Keywords are critical to your blog's success — whether they are the type that you type as part of the main blog description or as part of each entry.

Typically (although not always), a photo blog does not contain very much text information and thus there is nothing for the search engine robots to hook onto and use as a search term or keyword. By using keywords with each entry you can control, to some degree, how your entries are indexed, which very much affects how they are visited.

As an example, during the last 12 hours, my site was accessed from search engines where the top three primary search words were

> **Photography:** 15 separate hits, 58 pages viewed

> **Photoblogging:** 11 separate hits, 71 pages viewed

> **Scenery:** 9 separate hits, 105 pages viewed

Except for two examples, none of the entries accessed via the search word contained any text whatsoever beyond the keywords and navigational text.

My method is quite simple. I select a series of "master keywords" that I always use, which form the core of all entries, and then I add to this set for each individual entry.

CREATING A LIST OF MASTER KEYWORDS

I recommend adding the following base list of master keywords to all of your entries:

> Your name — first and last as well as any names by which you are known on the Internet.

> The words photography, photos, photoblog, and photo blog.

> The make and model of the camera you usually use such as Canon 300D or Sony F717.

> Several words that describe the type or style of photography that you generally do such as "urban" or "abstract." Even though these words may not apply specifically to each and every entry, if they are pervasive enough as a style, it is perfectly acceptable to use them as keywords on entries.

> The name of your blog and any other sites that you publish or with which you are affiliated.

By carefully watching your referral logs to discover what words are being used to find your site, and tracking the tag usage at sites like flickr and technorati, you will soon discover what patterns are in common use and can govern your keyword practices accordingly.

Keyword tips and hints

To maximize the effectiveness of your keywords, try these tips. Avoid "net words," slang, and abbreviations such as "foto" and "pic."

Use plurals as much as possible. While the majority of search terms are entered in the singular format, they will still be located in their plural form but the reverse is not true. For example, a search for "photograph" will find both "photograph" and "photographs," but a search for "photographs" will not find "photograph."

There is no limit on keywords but they are viewed as being "in order of importance"

by search engines and thus you should put the most descriptive ones first. Don't be shy — if it is a photograph of a red dahlia in a blue vase in front of a window use the keywords red, dahlia, blue, vase, window, flower, floral, growing, and anything else that might be in the photograph. The more keywords you use, the more likely you are of getting hits from search engines.

Do not use words that have nothing to do with the photo but which might gain attention such as "nude" or "naked."

IMG_0723 Properties

General | Summary

Property	Value
Width	690 pixels
Height	460 pixels
Horizontal Resolution	96 dpi
Vertical Resolution	96 dpi
Bit Depth	24
Frame Count	1
Equipment Make	Canon
Camera Model	Canon EOS DIGITAL REBEL
Color Representation	sRGB
Shutter Speed	
Lens Aperture	F/5.6
Flash Mode	No Flash
Focal Length	45 mm
F-Number	F/5.6
Exposure Time	1/100 sec.
ISO Speed	ISO-100
Metering Mode	Average
Exposure Compensation	0 step
Date Picture Taken	8/15/2004 11:14 AM

<< Simple

OK | Cancel | Apply

12-18

Graphics Software

EXIF Software - EXIF Readers, Editors & Extraction Tools

Almost all digital cameras store extra information with your pictures. This extra information is called EXIF data, which stands for Exchangeable Image File Format. While most current photo manipulation software supports the reading of this information, there are many specialized tools for reading, editing, extracting and converting EXIF information. The software listed here is designed solely for working with EXIF metadata.

Articles & Resources
Sort By : Guide Picks | Alphabetical | Recent

More Categories Up a category

☐ About EXIF Information in JPEGs

BR's EXIF extractor (Win)
"BR's EXIF extractor is a simple freeware tool that will extract the EXIF information from all JPG files in a directory and save the data in a CSV-file (Comma Separated Values)." Freeware.

DateTree (Mac)
"Organize files, movies or photos by date on Mac OS X. Copies your files into folders named by date. Reads dates that cameras store inside images (EXIF)."

EasyExif (Win)
"EasyExif is a program that analyzes the Exif tags created by digital cameras in JPEG files. It has the ability to export these tags as text files, CSV text, or XML files" Freeware.

EXIF Image Viewer and EXIF InfoTip (Win)
A simple image viewer for photos taken with digital cameras. It's capable of reading EXIF information embedded in photos as well as a little thumbnail. EXIF viewer also displays image histogram and features copying/moving and deleting of selected photos. Also available is EXIF InfoTip, a shell extension to display EXIF information in a tooltip in Windows Explorer. Both are freeware.

Exif Reader (Win)
This software analyzes JPEG files created by digital cameras and displays the shutter speed, flash condition, focal length, and other image information. Freeware.

11 more Articles & Resources below

12-19

USING AND DISPLAYING EXIF DATA

Some viewers will be very interested in your exif data — that is the information your camera stores regarding the settings and specifications of your photograph.

Typically, exif data contains information such as shutter speed, aperture setting, lens used, focal length, metering mode, and so on, and is useful for people who are teaching themselves photography.

Exif data is stored as part of the original file and is easy to extract using one of several tools available on the Web and from many popular programs. Photoshop, for example, reads EXIF data, as does Windows Explorer (see Figure 12-18) by using the File ⇨ Properties menu, and flickr provides an option to display your exif data with uploaded photographs.

About.com, a terrific Web resource for almost anything, has a great page of resources (see Figure 12-19) for programs that you can use to display EXIF data on your site. You can find it at `http://graphicssoft.about.com/od/exifsoftware/`.

HAVING FUN WITH YOUR IMAGES

There are a large number of tools and little programs available that you can use to do any number of things from making a motivational poster of one of your images, like the one in Figure 12-20, to creating a slide show of a specific set of your photographs.

Fd's flickr toys, shown in Figure 12-21, the site located at `http://flagrantdisregard.com/flickr/` is one of the most fun and interesting that I have visited and inside of the "toys" I found several neat things including the framer application with which you can make a number of interesting graphics to use as a logo or a banner on your blog such as those shown in Figure 12-22.

E-Cards

E-Cards are very popular with viewers and every day millions of e-cards are mailed all over the Internet. You can allow your photographs to be used in e-cards that your viewers can mail from your site with the installation of a simple e-card program from any number of providers. A popular one that many people use is Bravenet (located at `www.bravenet.com/webtools/postcard/index.php` and shown in Figure 12-23). Bravenet has many interesting tools and add-ons, such as a daily cartoon (see Figure 12-24) which you can add to your site for your viewer's entertainment and is located at `www.bravenet.com/webtools/cartoon/index.php`.

12-20

Calendar pages

Make monthly calendar pages that show a photograph for each day of the month, such as this one from flickr (see Figure 12-25). You can easily link to this calendar from your blog or duplicate it on your blog with a little CSS and HTML experimentation.

Hindsight is 20/20

Go back "a year ago today." After you publish your blog for a while, readers may want to see what you were up to a year ago on the same date. You can add a link to your sidebar or navigational menu that will direct viewers to the entry made on the same date a year ago. It's also useful to keep track, for your own enlightenment, how much your style has changed in a year.

Bulletin board

Have all your readers send Polaroid shots of themselves that you can post on their pages with links to their sites, if they have one. They can even create a Polaroid-style photograph from any regular image (see Figure 12-26), by going to a "polaroidonizer" site such as `http://polaroidonizer.b3ta.org` and completing the instructions.

12-21

287

12-22

12-23

12-24

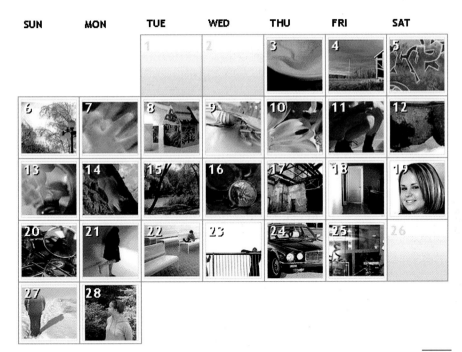

12-25

Polaroid-o-nizer™

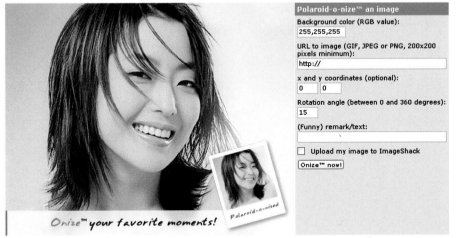

Onize™ your favorite moments!

Polaroid-o-nized

Polaroid-o-nize™ an image

Background color (RGB value):

255,255,255

URL to image (GIF, JPEG or PNG, 200x200 pixels minimum):

http://

x and y coordinates (optional):

0 0

Rotation angle (between 0 and 360 degrees):

15

(Funny) remark/text:

☐ Upload my image to ImageShack

Onize™ now!

The Polaroid-o-nizer™ team cannot be held responsible for anything created with the Polaroid-o-nizer™. Use at own risk! Polaroid-o-nizer™ is in no way affiliated, endorsed or sponsored by Polaroid Corporation.

Copyright 2004-2005 Polaroid-o-nizer™ (v.0.6 / August 7th, 2005)

12-26

289

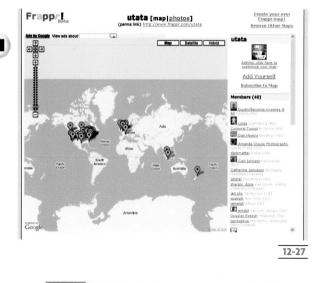

12-27

12-28

OTHER COOL PROJECTS

> Create one of the maps available on the Web from such sites as www.frappr.com (see Figure 12-27), that allows your readers to pinpoint their locations.

> Create wallpapers from your favorite photographs and store them in a special set so people can easily locate and download them.

> Print postcards and offer to send them, signed by you, to readers who request them.

> Using your own photographs and/or original writing, create a series of greeting cards and calendars to sell on your site or offer to readers as giveaways in contests or promotions. There are many resources available to create such items, including Future Shop (see Figure 12-28), which is an easy-to-use and intuitive site located at http://pix.futureshop.ca/en.

Doing Cool Things with Your Blog

index

continued

continued

continued